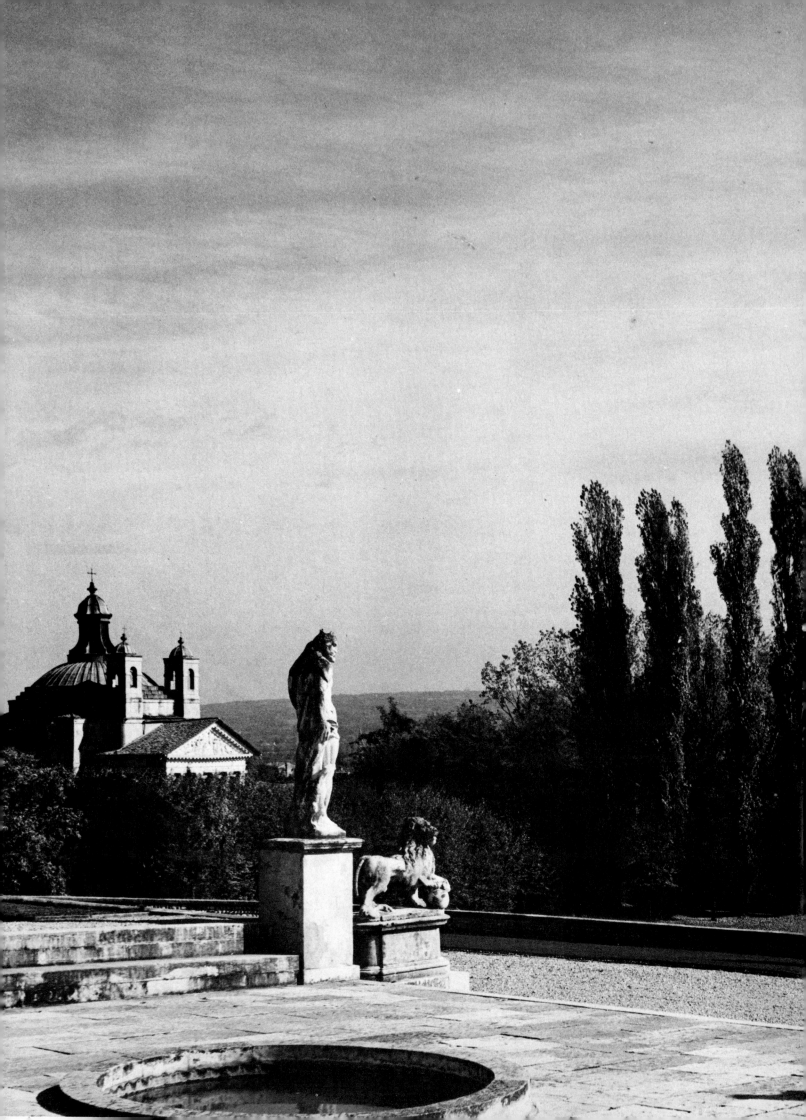

PALLADIO'S ARCHITECTURE AND ITS INFLUENCE

A PHOTOGRAPHIC GUIDE

Photographs by
JOSEPH C. FARBER

Text by
HENRY HOPE REED

DOVER PUBLICATIONS, INC.
New York

Copyright © 1980 by Dover Publications, Inc.
All rights reserved under Pan American and International Copyright Conventions.

Published in Canada by General Publishing Company, Ltd., 30 Lesmill Road, Don Mills, Toronto, Ontario.
Published in the United Kingdom by Constable and Company, Ltd., 10 Orange Street, London WC2H 7EG.

Palladio's Architecture and Its Influence: A Photographic Guide is a new work, first published by Dover Publications, Inc., in 1980.

Book Design by Carol Belanger Grafton

International Standard Book Number: 0-486-23922-5
Library of Congress Catalog Card Number: 79-90613

Manufactured in the United States of America
Dover Publications, Inc.
180 Varick Street
New York, N.Y. 10014

Acknowledgements

It was Thomas Jefferson who introduced me to Andrea Palladio. Jefferson, the first person in America to own a copy of Palladio's *Four Books of Architecture*, was greatly influenced by the work. During his short stay in England he saw many of the buildings designed by architects who were inspired by Palladio.

Wendell D. Garrett, with whom I have had the pleasure of collaborating on a book about Jefferson, encouraged me to pursue my interest in extensively photographing Palladio's buildings that are still standing.

Frederick D. Nichols, whose 1973 article about Palladio's villas in *Antiques* magazine used a number of my photographs, graciously arranged for me to meet R. Cevese and F. Rigon of the Centro Internazionale di Studi di Architettura Andrea Palladio in Vicenza; these scholars invited me to join a seminar about Palladio involving visits to many of his structures. They also arranged permission for me to take photographs at restricted sites and gave me much invaluable information about his work.

The Architect and Society by James Ackerman is a standard guide for nearly every present-day student of Palladio, and I used it extensively.

Adolf Placzek has been especially kind in giving both scholarly and practical advice. At nearly every site in Italy, Great Britain and the United States the curators or people in charge cooperated to make this book possible. The final stimulus to complete the work came from the staff of the Cooper-Hewitt Museum, particularly Lisa Taylor, Richard Oliver, Dorothy Globus and Elaine Dee.

JOSEPH C. FARBER

For assistance in obtaining information for the Introduction, text and the captions I would like to thank Paola dal Cortivo of the Ente Provinciale di Turismo di Vicenza and Giuseppe Roi, also of Vicenza; Dr. Lorenzo Sorbini of the Museo Civico di Storia Naturale of Verona; Leonard Schurman of Rome; Professor Hugh Davis of Lemoyne College, Syracuse, New York; John Barrington Bayley of Newport, Rhode Island; and Professor John Patton, State Geologist, State of Indiana.

HENRY HOPE REED

Contents

INTRODUCTION *page* ix

VILLAS 1

 VILLA PISANI 3

 VILLA VALMARANA 4

 VILLA MARCELLO 5

 VILLA SARACENO 6

 VILLA CALDOGNO 9

 VILLA POIANA 10

 VILLA PISANI (MONTAGNANA) 12

 VILLA CORNARO 15

 VILLA BADOER 16

 VILLA BARBARO (AND THE TEMPIETTO) 19

 VILLA FOSCARI ("LA MALCONTENTA") 33

 VILLA EMO 37

 VILLA ROTONDA 39

 VILLA TRISSINO 42

 VILLA SAREGO 42

PALACES 43

 THE BASILICA 45

 LOGGIA DEL CAPITANIATO 47

 PALAZZO THIENE 49

PALAZZO DA PORTO FESTA *page* 53

PALAZZO CHIERICATI 55

PALAZZO VALMARANA 61

PALAZZO DA PORTO BREGANZE 62

PALAZZO BARBARANO 62

A CONVENT & THREE CHURCHES 65

 SANTA MARIA DELLA CARITÀ 67

 SAN GIORGIO MAGGIORE 69

 SAN FRANCESCO DELLA VIGNA 73

 IL REDENTORE 75

TEATRO OLIMPICO 77

PALLADIO'S INFLUENCE IN
ENGLAND AND SCOTLAND 81

 THE QUEEN'S HOUSE 82

 THE BANQUETING HOUSE 84

 ST. PAUL'S CHURCH 86

 ST. PAUL'S CATHEDRAL 87

 THE HORSE GUARDS 88

 SOMERSET HOUSE 90

 THE ROYAL OPERA HOUSE 90

 CHISWICK HOUSE 92

The Jones Gate *page* 92

Radcliffe Camera 95

Ditchley 95

Blenheim Palace 96

Stowe 97

Mansion House, York 99

The Assembly Room, York 99

Pulteney Bridge, Bath 99

Prior Park, Bath 102

Mereworth 103

Hopetoun House 104

High School, Edinburgh 104

PALLADIO'S INFLUENCE IN
THE UNITED STATES 107

Redwood Library 109

The Brick Market 110

King's Chapel, Boston *page* 111

State House, Boston 113

Bremo 115

Poplar Forest 115

Oak Hill 117

Monticello 117

The University of Virginia 119

The White House 120

New York City Hall 121

The Criminal Court Building 123

The Appellate Court 123

The Villard Houses 124

The Otto Kahn Residence 125

The Frick Collection 126

Tennis House, Prospect Park 127

The Metropolitan Museum of Art 129

Introduction

The Life and Times of Andrea Palladio

One of the most extraordinary developments in Western civilization was the rebirth of the classical tradition in Italy in the fifteenth century. The artistic heritage of the Roman Empire, which had faded for a millennium, returned with such force that it was to last into our time before being thrust aside once again, this time by Modern Art.

It is easy enough to appreciate the strength of this revival of classicism. It suffices merely to list some of the names which brought it glory: Alberti, Raphael, Sansovino, Giulio Romano, Mantegna, Vignola, Michelangelo. The artistic heaven was all stars from 1450 to 1600, and they are there still because their works shine on with undiminished power.

Among the brightest stars was that of Andrea Palladio. In his own time, to be sure, he was just one of many and, remarkably, a provincial one at that: most of his buildings are to be found in Vicenza, a small town forty miles west of Venice. Other buildings by him are scattered over the nearby countryside, a majority of them off the main roads. His two churches in Venice are far more accessible, although many persons who see them today remain ignorant of their architect's name.

Provincial though he may have been, this designer was to capture the imagination of a fair part of the Western World. Of the many architects nurtured by the Italian Renaissance, he was among those with widespread influence, first in England and then where the English presence was felt—in Scotland, Ireland and the United States. Palladio also proved to be a force to the east, in Poland and Russia.

He was born in 1508 as Andrea di Pietro della Gondola in the university city of Padua. His father was a miller in modest circumstances. As was customary in those days, the future architect was apprenticed, in this case to a leading Paduan stone carver, at the age of thirteen. Three years later, in 1524, he was in Vicenza in a stone-carving and masonry shop which is now credited with much of the elaborate Vicentine stonework of the period. In the same year he was admitted to the Guild of Masons and Stonecarvers. Palladio prospered to the extent that he was able to marry in 1534, by which time he

must have become the equivalent of a builder, as well as being a mason and stone carver.

"Guided by a natural inclination, I gave myself up in my most early years to the study of architecture," he recalled in his *Four Books of Architecture* (as translated in the Ware edition), "and as it was always my opinion, that the antient Romans, as in many other things, so in building well, vastly excelled all those who have been since their time, I proposed to myself Vitruvius for my master and guide . . . " There is no reason to doubt him, for as early as 1511 an illustrated edition of the Roman architect's *De architectura* had been published, and an Italian translation was executed under Raphael's supervision in about 1520.

Although Palladio was given the title of architect in 1540, his early work shows little evidence of his later mastery of the art. His earliest building, Villa Godi (1537), is a simple structure, not far removed from the plain villas already to be found in the Veneto.

With a growing reputation and with a certain precocity in his learning for a man of his station, Palladio came to the attention of Count Giangiorgio Trissino, who was to be his first patron. Trissino, a member of Vicenza's Ghibelline nobility (those whose families had a tradition of loyalty to the Holy Roman Emperor) was absorbed in reviving the ancient world, as were so many others in the Italian Renaissance. He wrote an epic called *L'Italia Liberata dai Goti*, a title which could have served as motto for the artists of the sixteenth century. Quite in keeping with the times he baptized his new architect friend "Palladio" in allusion to Pallas Athena, goddess of wisdom.

During this period, Andrea della Gondola—now Palladio—must have seen the published portions of Sebastiano Serlio's *L'Architettura*, published in 1537 and 1540. The book's importance lies in its illustrations, several of which were to have a direct influence on Palladio's work, such as the Basilica (page 45). Through the book the newly baptised architect came to know the works of "modern" Rome—those of Raphael, Bramante and Peruzzi—which he was soon to see together with the ancient monuments of the city.

The decade of the 1530s proved, for Palladio, to be

The Villa Godi (1537) at Lonedo di Lugo Vicentino (Vicenza) was Palladio's first villa. Executed before his first Roman journey in 1840, it hardly bears comparison with those which followed.

preparation for the pilgrimage to Rome. In 1540, in the company of Count Trissino, he made the first of five Roman journeys, the others taking place in 1545–46, 1546–47, 1549 and 1554.

Rome, the Holy City, the ancient *Urbs*, had loomed over Europe for centuries, both spiritually and politically. Now it was to be the goal of the artist. With the coming of the Renaissance its ancient grandeur overwhelmed the European imagination. We can catch the magnetism in a translation, by Ormonde de Kay, Jr., of a sonnet from Joachim du Bellay's *Les Antiquités de Rome:*

Neither the fury of the raging flame,
Nor the incision by the victor's blade,
Nor the destruction furious soldiers made,
Who've sacked you, Rome, so often, shame on shame,
 Nor blow on blow depleting your good name,
Nor the invidious ages' slow abrade,
Nor the ill will both men and gods betrayed,
Nor at yourself your own might taking aim,
 Nor shakings loose by high wind's fusillade,
Nor the deluge that wily god's conveyed
So often, floods that over you have swirled—
 None's so abased your pride but that the same
Grandeur of nil they've left you does proclaim
Your glory still, the wonder of the world.

Like architects from Leon Battista Alberti onwards, Palladio measured and drew the half-buried ruins. He also made reconstructions which have proven more inventive than accurate but which were themselves to have influence. Nor did he confine himself to the ancient buildings such as the Pantheon; he also turned to the work of Raphael and Bramante.

The effect of the first journey to Rome was immediate. At the Villa Marcello at Bertesina (page 5), done in 1542, shortly after his return to Vicenza, we find a pediment, a row of Corinthian pilasters, pedimented windows and an arcaded porch with keystones and imposts at the arches, as well as a flight of steps—all of which, either severally or altogether, were to be his signature. Palladio now commanded the Roman vocabulary, a command reinforced every time he went to Rome or when he sought ancient monuments as far away as Nîmes in Provence. He was the first to adopt a columned and pedimented portico for a country house and it proved to be his most imitated device.

An early palace, the Palazzo Thiene, now the Banca Popolare di Vicenza, shows Roman influence, not so much the ancient as the "modern." An upper story of Corinthian pilasters set on a rusticated wall reflects the Cancelleria, the Papal Chancellory which is said to have inspired the Villard houses on New York's Madison Avenue behind St. Patrick's Cathedral. The first story of the Palazzo Thiene, with rusticated pitted stone, owes more to Giulio Romano's famous Palazzo del Te in Mantua than to any Roman building, but the large court with superimposed arcades links it to "modern" Rome.

What is fascinating about Palladio's work is his freedom in making use of whatever source took his fancy. That he made the designs his own goes without saying. The interplay of influence among the artists of his century was widespread without impinging on individuality. All of Italy was in movement, all was classical, and yet each city was going its own way. Again and again in the sixteenth century and the subsequent centuries influenced by classicism down to our own American Renaissance of the 1900s, the wealth of the classical language, infinite in its variety, is underscored.

Palladio never rested after 1542. Commission after commission came to him, and he moved among the grandees of Vicenza and Venice. In 1570, towards the end of his life, he was named architectural adviser to the Republic. A prosperous generation made for a flourishing practice.

Palladio died on August 9, 1580, and lies buried in the Church of San Corona in Vicenza.

One cannot examine the works of Palladio without first considering some of his clients. We have met with Count Giangiorgio Trissino; we would be remiss if we did not also tell of the brothers Barbaro, builders of the great villa at Maser in the Province of Treviso. Daniele Barbaro (1513–70) and Marcantonio Barbaro (1518–95) came from a leading Venetian family. Both went to the University of Padua, which was the seat of learning of the Republic; both went on to impressive public careers. Of the two, the elder was the more important. In 1545 he financed and supervised the construction of Padua's Botanical Garden, the world's oldest. In 1549 he was in London as ambassador of the Republic. His report or *Relations* on England and the English is considered outstanding among many sent back by Venetian ambassadors. While there, he was named Patriarch-Elect of Aquileia and became the official historian of the Republic, succeeding Cardinal Bembo. In 1554 he was with Palladio in Rome, and two years later there appeared his translation of Vitruvius with illustrations by the master. (His other contribution to art was his *La Pratica della Perspettiva*, 1568.)

Marcantonio Barbaro's path was not too different from his brother's. In 1556 he was sent on a special mission to Charles IX of France; between 1568 and 1573 he went on missions to Constantinople as ambassador. In 1572 he was made a Procurator of St. Mark. The office of Procurator—there were nine altogether—sprang out of the Church of San Marco, the Doge's church which is the chief ornament of the Piazza San Marco. It was his responsibility to oversee the church's extensive properties, both in the city and throughout the Venetian Empire. In addition, he and his associates administered trust funds and wills and held as wards minors and those of unsound mind. The Procurators of San Marco were also privileged to use the funds in their care for the construction of churches, public buildings, even fortresses—in fact, any structure of public utility. The best-known of their works are the offices on the Piazza San

Marco: the Procuratie Vecchie (north side) and the Procuratie Nuove (south side), the great campanile, and, by installing drainage and paving it, giving the square itself its present shape. As Procurator, Marcantonio Barbaro obtained for Palladio the commission to do the Church of the Redeemer (Il Redentore). He was also responsible for the construction of the stone bridge at the Rialto; here Palladio lost out in the competition although his design, illustrated in *The Four Books*, was executed at Stowe, England (page 97). Marcantonio Barbaro was also responsible for the fortress-town of Palmanova in the northern reaches of the Republic, an early example of Renaissance town planning. When Barbaro died in 1595, he was buried in the family chapel in San Francesca della Vigna. He was well named Il Costruttore.

The Work of Palladio

Palladio's achievements in architecture can be divided into three main categories: villas, palaces and churches. He also designed a theater and authored several books.

The villas are the product of a specific moment in the history of the Veneto. Until the sixteenth century the merchants and statesmen of Venice had looked seaward, where their fortune lay. Although the Republic had already expanded on the mainland—Vicenza, Verona and Padua were taken in 1404–06—*terra firma*, as these holdings were called, was valued for reasons of defense rather than for their economic potential. This attitude changed with the loss of the old food sources in the East. The other causes of change were an awareness of the value of land reclamation by means of drainage canals, the application of improved methods of agriculture, the use of the abundant streams and rivers for grain and spinning mills and, not least by any means, the substitution of Indian corn from America for the traditional millet. The former, which the Italians came to call *grano turco* in the belief that the plant was of Turkish origin, provided a much better grain than the millet. It meant a change in diet and dishes of corn meal, called *polenta*, became a staple. In developing their lands, both Vicentines and Venetians built country residences which were in part farmhouses or which had attached outbuildings for farm use. Crops would be stored in the villa itself. In those days it was customary for the landowner to be in residence at spring sowing and at harvest; *villegiatura*, or summer vacation, did not come into fashion until the eighteenth century, as we know from the plays of the great Venetian writer Carlo Goldoni.

The palaces of Palladio are very much in the Italian tradition: monumental facades on narrow streets (which remind us of Wall Street in New York, La Salle Street in Chicago and several streets in downtown Philadelphia); and monumental interior courts. An overpowering ef-fect is always the object of the design. Because it is principally the villas that have found imitations in other countries, we tend to forget the palaces. Also, the palaces are concentrated in Vicenza—there is not one in Venice—and Vicenza is too often bypassed by the traveler as he hurries on to the Queen of the Adriatic. The distinguishing device Palladio used in the palace was a tall column or pilaster set on a high base or a rusticated first story. Or he might adopt, as he did on some of his villas, two stories of superimposed colonnades. The most famous of these city buildings is Vicenza's Palazzo della Ragione, better known as the Basilica. The imposing structure was the seat of the Council of the Four Hundred which ruled the city. Palladio's contribution was actually limited to giving an old building new facades on three sides.

The most prominent of Palladio's churches is the Church of San Giorgio Maggiore in Venice, which stands on an island across the Basin of St. Mark from the Doge's Palace. It identifies the city as does the Statue of Liberty in New York, if not quite so spectacularly. Another church, Il Redentore, lifts its high facade across a wide canal in that part of the city called the Giudecca. Both have interiors which derive from the Roman basilica: a barrel vault pierced by semicircular windows and resting on piers with engaged columns and pilasters. Domes rise above crossings, and high columns with pediments shape facades. San Giorgio Maggiore's silhouette is especially effective with its pediment, dome, statues, small towers and campanile. These churches represent Palladio's conquest of Venice. He had been denied commissions in the city for most of his career and not until 1570 was he named architectural advisor to the Republic, replacing Jacopo Sansovino.

One famous commission awaited him in his last years, the Teatro Olimpico. In 1555 there had been formed in Vicenza the Accademia Olimpica, an assembly of scholars, literati, mathematicians and one artist—Palladio. Among other activities it sponsored theatrical performances for which Palladio designed temporary stages. In 1580 they decided to build a theater in the manner of the ancients. The result is a fantasy that has fascinated architectural pilgrims and tourists over the centuries.

Palladio also produced several books in his lifetime, and one published posthumously. The first was *Le antichità di Roma*, which appeared in 1554, shortly after his last Roman journey. It was the first brief, reliable guide to the ancient ruins. He did a translation of Caesar's *Commentaries*. Most important of all was his *I Quattro Libri dell'Architettura* or *The Four Books of Architecture*, published in Venice in 1570. In it he was not shy of boasting of his work, saying that it consisted of "the noblest and most beautiful buildings erected since the time of the antients." The second of *The Four Books* was wholly devoted to his buildings.

OPPOSITE: *A statue of Andrea Palladio, executed by Vincenzo Galassi in 1859, stands next to the Basilica in Vicenza.*

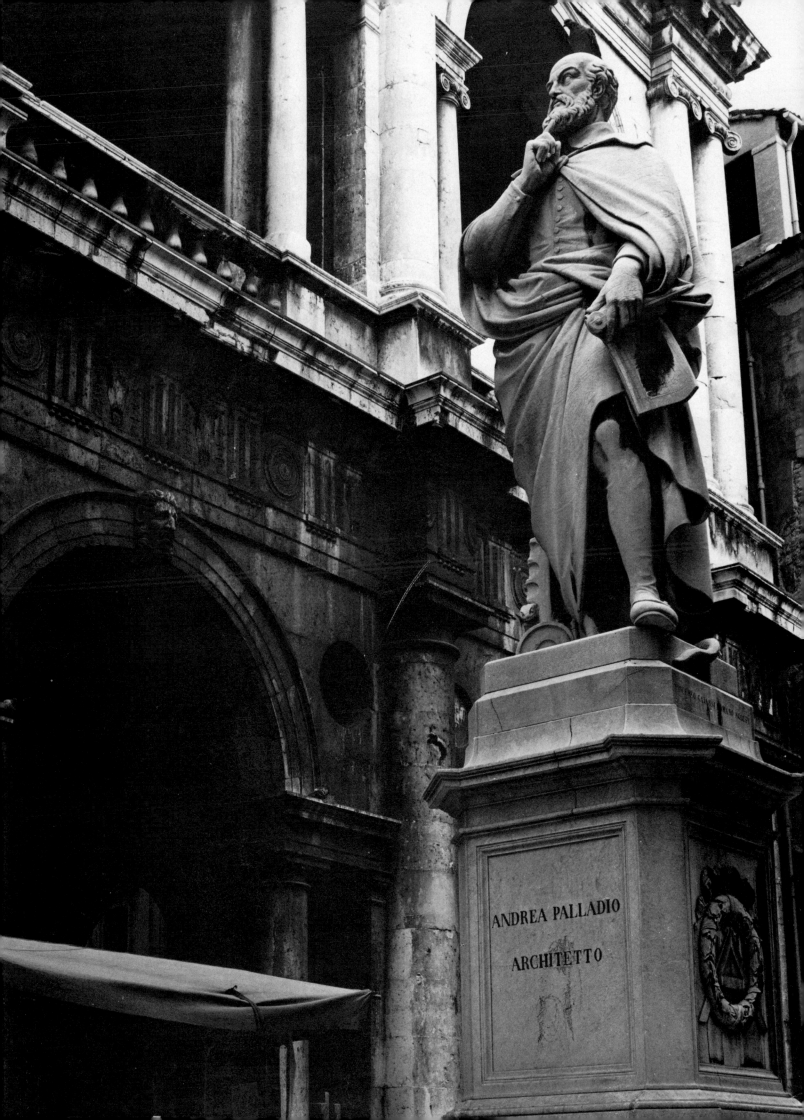

ANDREA PALLADIO

ARCHITETTO

Some Observations

The work of Palladio offers a number of surprises. One of them is the frequent use of brick covered with stucco in imitation of stone. Even whole shafts of columns and pilasters and deeply rusticated walls are of the two materials. So beautifully handled was this way of building that, to a seventeenth-century Englishman, the imitation surpassed stone, "showing how in truth we want rather *art* than *stuff* to satisfy our greatest fancy."

Certainly there is art in Palladio's ability to attain the right proportions in his treatment of facades and interiors. Again and again this is remarked on, and some students note that his skill stemmed from a system of harmonious proportions which he related to music. He was neither the first nor the last architect to be captivated by the possible link between architecture and music. When it came to actual practice, however, Palladio put theory aside. He offers, for example, numerical methods for obtaining the right ceiling height and then promptly discards them, saying that "there are also other heights for vaults which do not come under any rule, and are therefore left for the architect to make use of as necessity required, and according to his own judgment." Or he will announce that a column height should be ten times the diameter and, in practice, disregard his own premise. We must be cautious whenever an architect makes rules because he is invariably the first to break them. Palladio achieved his wonderful proportions by continuous study of the ancient models and by sticking close to certain canons of design, for which he has been accused of pedantry.

Another surprise in his buildings is the opulence of the interiors by comparison with the often severe exteriors. Of the Palazzo Thiene he writes that "the rooms of this fabric . . . have been adorned with the most beautiful stuccos by Messer Alessandro Vittoria and Messer Bartolomeo Ridolfi and with paintings by Messer Anselmo Canera and Messer Bernardino India of Verona, not inferior to any of the present age." Palladio, in a sense, did not work alone, at least on the villas and palaces. Certainly the most famous example of a Palladian interior is that of Villa Barbaro at Maser, where wall and ceiling are covered in frescoes by Veronese. On the other hand, Palladio forbade mural decoration in his churches. He followed his own rule at the churches of San Giorgio Maggiore, Il Redentore and the Tempietto Barbaro.

Not all of Palladio's designs in *The Four Books* were executed, and many of them were built only in part. There is good reason for this; many of his schemes were big. The design for the Villa Trissino is vast, as can be seen from the photograph of the model, built, as were all the models in this book, by the Centro Internazionale di Studi di Architettura Andrea Palladio. The model conveys the scale on which he was able to conceive his work.

Palladio was one of the most influential architects of all times. What carried his fame to the world was *The Four Books of Architecture*. It was only one of many architectural treatises modeled on that of Vitruvius, the Roman architect who lived at the time of Augustus. Leon Battista Alberti, Sebastiano Serlio, and Vignola, to name only three, wrote treatises. Vignola's *Regole delli Cinque Ordini d'Architettura* outpaced *The Four Books* for several generations and even then was only passed by the latter in England in the eighteenth century, but this was sufficient for it to conquer a good portion of the globe. Joseph C. Farber's beautiful photographs supplement *The Four Books* and, in so doing, help us to see afresh the wonders of the great architect.

NOTE

All citations from *The Four Books of Architecture*, including page and book references following some captions, are from the Isaac Ware edition of 1738. A reprint of that edition, with an introduction by Adolf K. Placzek, is available from Dover Publications, Inc. (21308-0).

Villas

The word *villa* originated in ancient Rome. It identified both the landowner's residence on his country property and the property itself, which could range in size from the immense, such as the Emperor Hadrian's near Tivoli, outside Rome, to simple seaside houses. No matter the size there was always some land for growing food, keeping livestock and housing slaves. Home and service quarters were joined in one unit, if only around a yard, and were, in a sense, "nothing other than a small city," as Palladio described his own villas. With the breakdown of the Roman Empire many of the big villas were fortified, becoming walled towns and giving rise to the French word for city, *ville*.

As country residence, the villa disappeared in the Middle Ages only to come back with the Renaissance. The villas around Rome were pleasure houses located in the nearby hills, refuges from the summer heat. Many were set in ample formal gardens, the most elaborate being the Villa d'Este at Tivoli. If the property was farmed, the farm buildings were some distance from the house. In the Veneto, on the other hand, the villas were very much a part of working farmland to the extent of having the farm quarters as part of the main house.

Because the villas were part of the farm property, the land was (and still is) worked up to the villa walls. Only small areas are set aside in front and at the back for gardens, and a portion of these would be used as kitchen gardens. Even La Rotonda (page 39), the most famous of Palladio's villas, which is actually a pleasure pavilion, is set on the edge of intensely farmed land. There are none of the vast spreading lawns found on estates of Northern Europe, where fashion for the picturesque dictated that the house be set in the middle of a man-made park. Quite the contrary. The landowners of the Veneto were solidly fixed in a Virgilian landscape, that of the working farm which the Augustan poet pictured in his *Georgics*.

Before Palladio's time, the country houses of the Veneto looked like fortified manor houses, simple rectangular boxes with stylized battlements. The great Venetian architect Jacopo Sansovino designed a villa which resembled a palace that had wandered into the countryside. What Palladio succeeded in creating was a distinctive building type, a proper villa. In his plans he adopted a standard ordonnance: a central hall which could be round, square, rectangular or cross-shaped; off it were customarily four rooms fitting in four corners of a rectangular frame. The interior stairways were always small, concealed in the massive walls. What holds the visitor's attention far more than the plan is Palladio's use of the temple front to adorn the villa's center as well as the wings, if they were present. Palladio adopted the device because columned porches "add very much to the grandeur and magnificence of the work." The entrance was underscored by being high. Another common device, sometimes necessitated by a high water table, was setting the structure on a platform to command a view of the surrounding countryside. A third was the insistence on symmetry to be found on the exterior as well as in the plan; the parts of a front always balance. To achieve the symmetry Palladio used whatever classical details best served his purpose, notably the column, the pilaster and rustication.

A fourth device was height, a prime means by which Palladio attained such successful proportions. The columns and doorways are high and so are the ceilings. In the descriptions of the pictures which follow, as many dimensions as possible are given. Palladio used no formula to attain these dimensions, despite his interest in relating architectural and musical harmonies. He chose, as mentioned earlier, according to the demands of the eye.

Palladio's clients tolerated high ceilings in a climate which can be very cold because they stayed in the villas only for short periods in the spring and the fall, and like him, his clients were enamored of the beauty based on the dimensions of ancient Roman monuments.

This brings us to one of the main distinctions of Palladio in the history of architecture: he was a conservative. Geoffrey Scott, in his *Architecture of Humanism*, speaks of "the academic yoke of Palladio." Actually, what the great architect did was to abide by the rules of the ancients more than any other architects of his time. In spite of his conservatism it is interesting to observe that, of all the great classical architects, he is the one who has gained the most attention among the devotees of Modern architecture.

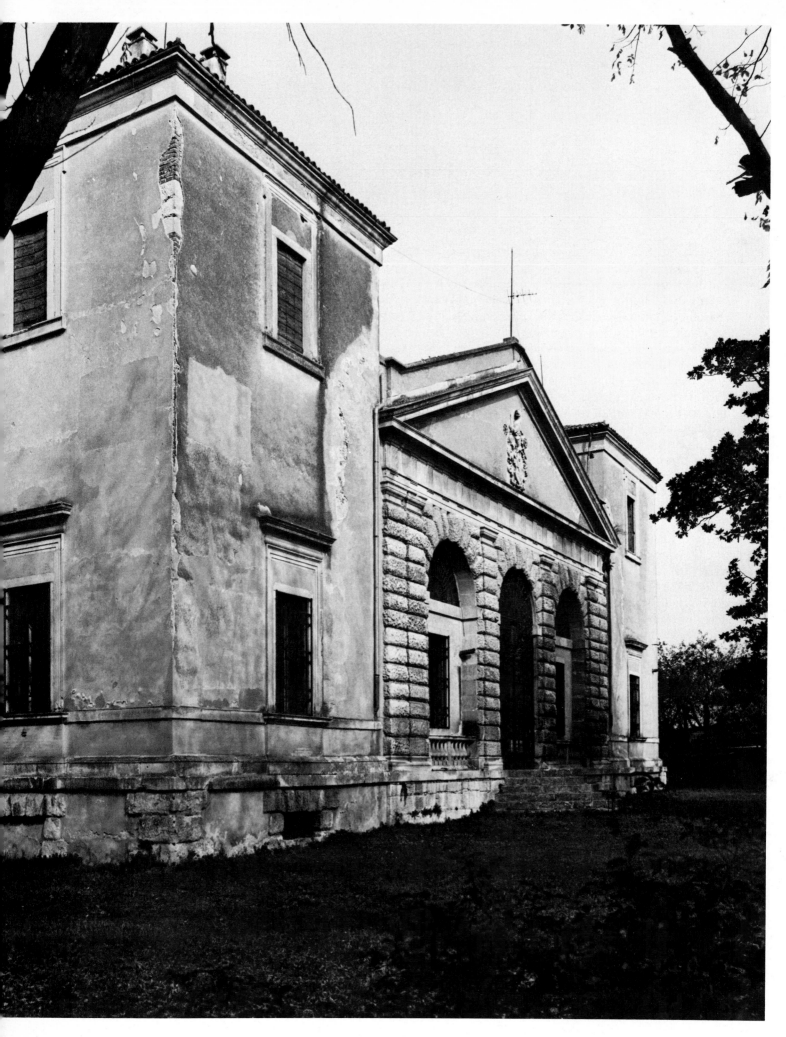

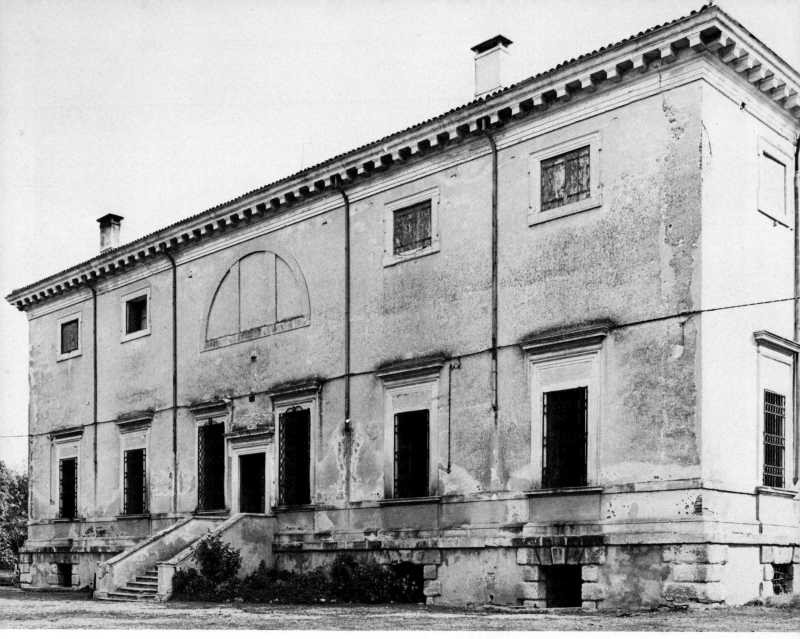

VILLA PISANI

At Bagnolo di Lonigo (Vicenza), the Villa Pisani (1542–45) represents an early break from the medieval style of the Veneto in which Palladio designed the Villa Godi (page x). As in his palaces, Villa Pisani, whose main facade is seen opposite, is a mixture of the influence of ancient Rome and that of his near contemporaries, notably Giulio Romano, the master of rustication. The adoption of the pediment, although without columns, was a nod to the temple of the ancients. This villa is typical in that the kitchen was in the basement and the granaries in the attic. The final design did not follow the original as found in Plate XXX of Book II. (Book II, page 48).

The back of the Villa Pisani (*above*) overlooks a working farm as it did in the old days. There was no more need for a porch here than there was at the rear of houses in small American towns when the backyard was purely utilitarian. Decorative touches are found in the rusticated framing of the basement windows and the framing and entablatures of the upper windows and the door.

The high ceilings of the Villa Pisani (*right*), made up of groined and barrel vaults, were eminently suited for mural decoration. Both wall and ceiling are frescoed in trompe l'oeil as well as grotesques, figures and arabesques. As if that was not enough, a landscape also fills the lunette over the door.

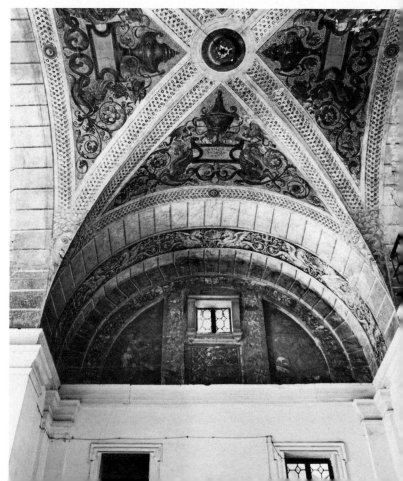

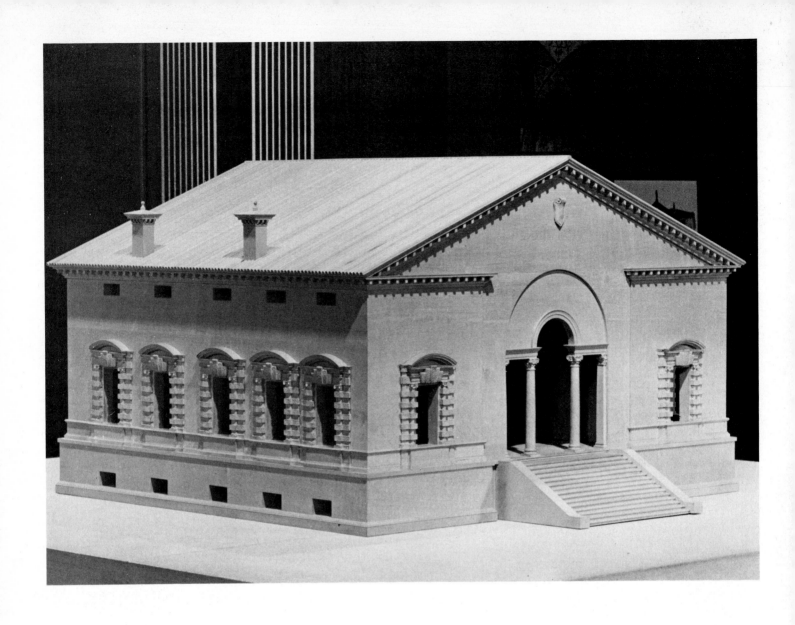

VILLA VALMARANA

The model of the original design of the Villa Valmarana is based on a drawing by Palladio now in the Royal Institute of British Architects in London. The design was much more elaborate than the villa as it was built in Vigardolo di Monticello Co. Otto (Vicenza) in 1541. The Palladian doorway set in the broken pediment, much like the one at the Villa Poiana, and the elaborate framing of the windows make the front of more than ordinary interest.

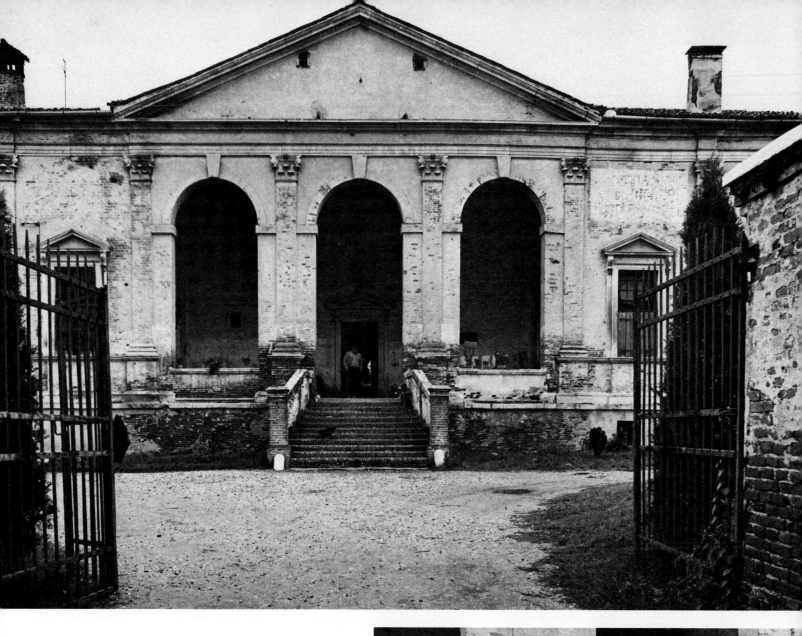

VILLA MARCELLO

Built at Bertesina (Vicenza) in 1542, the Villa Marcello (*above*) reveals Palladio's ease in creating a monumental facade for a small building early in his career. He divided the front with tall Composite pilasters placed on a base above the course of the cellar. The center, with its three arched openings, has a pediment which was always Palladio's mark in villa design. The flight of steps (*left*), narrowing from bottom to top, is among his simplest. Palladio took such pains with stairways that no two are the same.

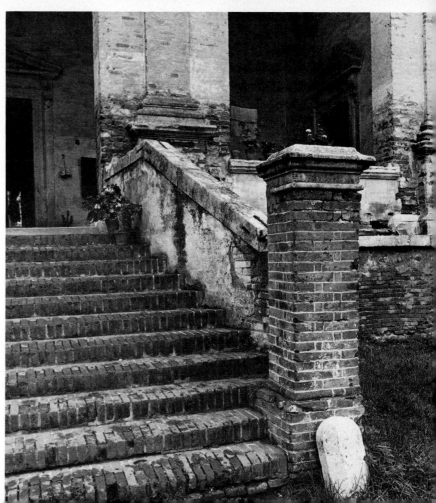

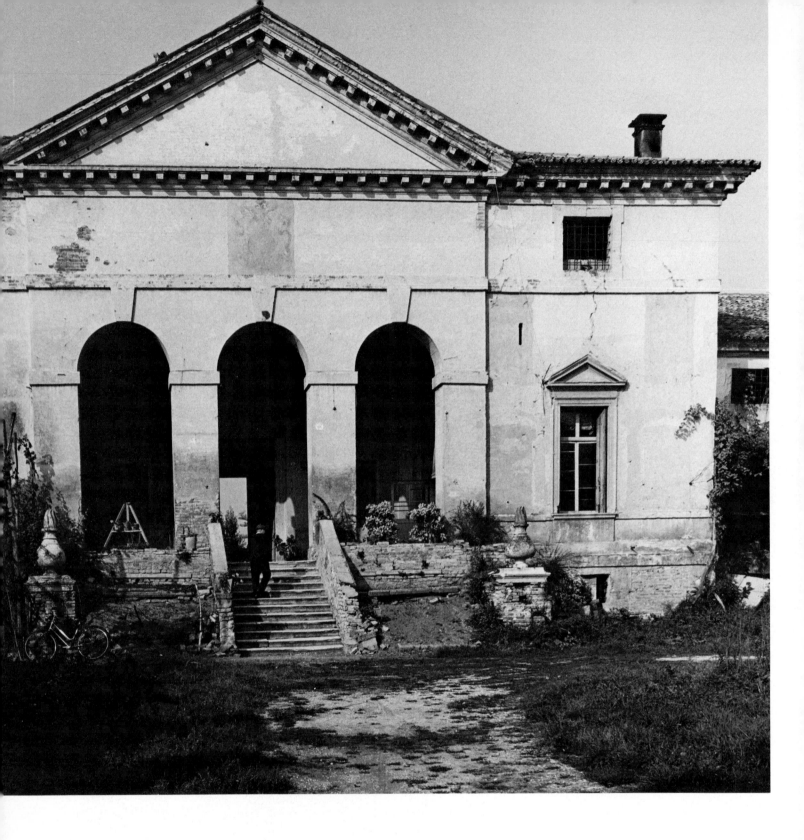

VILLA SARACENO

The absence of pilasters or columns at the Villa Saraceno (*above*; ca. 1545) at Finale di Agugliaro (Vicenza) creates an accent on the horizontal. The imposts of three central arches, the course dividing the first story from the attic, and the cornice produce the horizontality. (Book II, page 50.)

The practical side of Palladio's villas is seen in the wing of the Villa Saraceno (*opposite, top*), where farm machinery is stored beneath a vine trellis.

The farm building at the end of the wing (*opposite, bottom*) is linked visually to the rest of the building by the tile roof.

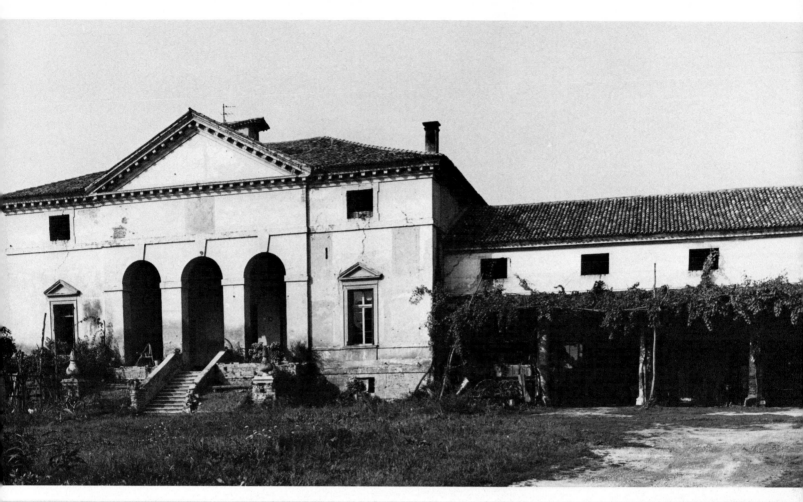

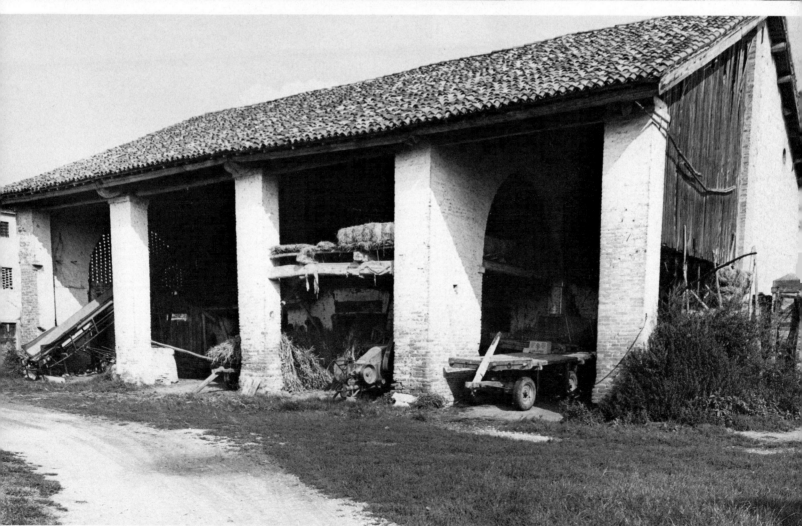

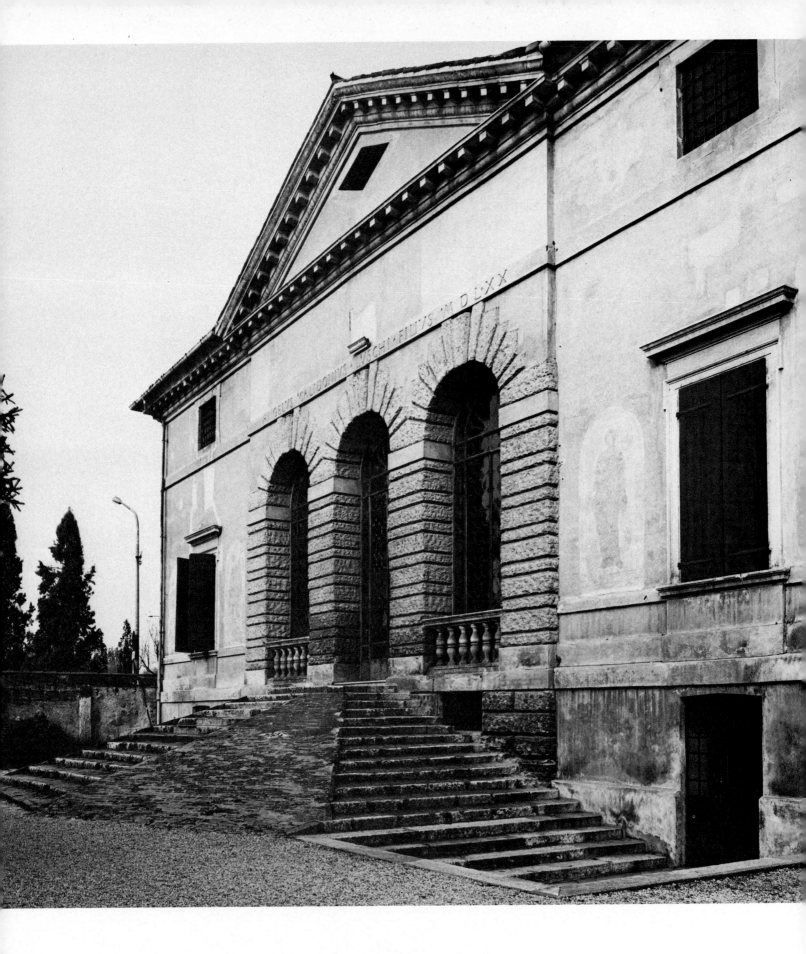

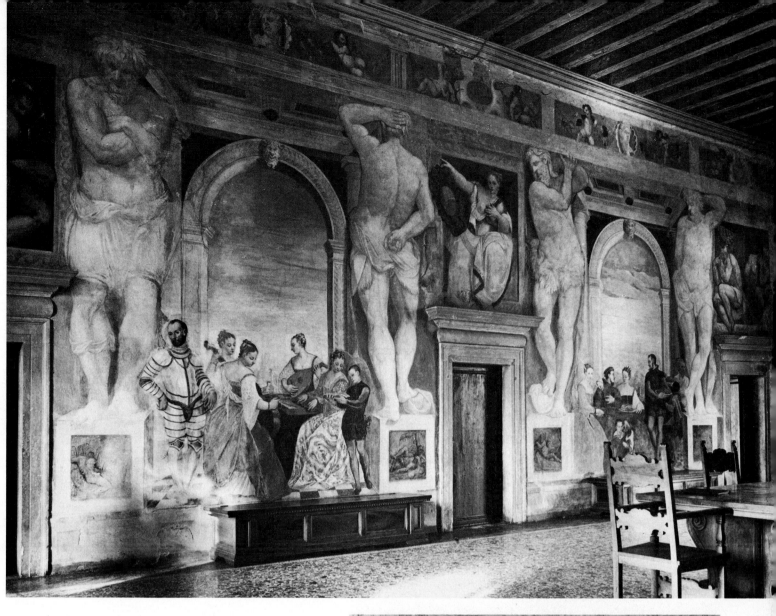

VILLA CALDOGNO

The design of Villa Caldogno (*opposite*; ca. 1545) at Caldogno (Vicenza) is a mixture of the Villa Pisani at Bagnolo and the Villa Saraceno. Again the three open bays (now glazed) have rustication which is repeated even on the wall inside the porch. The pediment, instead of resting on the bays, is raised above a wide band running across the facade. A flight of steps, in yet another design, greets the visitor.

The frescoes at the Villa Caldogno were by Antonio Fasolo, Giovanni Battista Zellotti and Giulio Carpioni. One wall in the dining room (*above*) is divided by giant atlantes separating scenes depicting people. The furniture shown here, the simple wood chairs, the table and the large chests, are no doubt very close to what was originally in the room. The floor is in terrazzo.

A fresco inside the porch (*right*) depicts figures around a table in front of Doric columns. The barrel vault is also frescoed. Every inch is decorated.

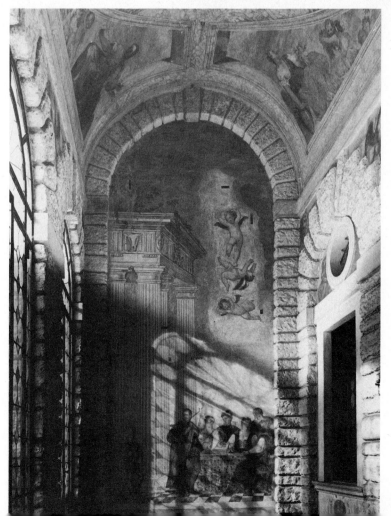

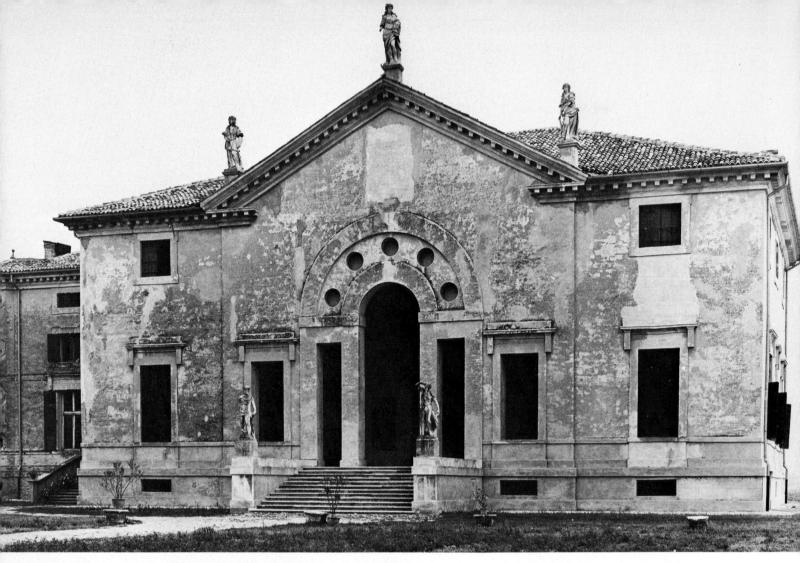

VILLA POIANA

The Villa Poiana (*above*; 1548–49), at Poiana Maggiore (Vicenza), stands several hundred feet from the road. The farm buildings extend in a wing to one side; a complementary wing on the other side was never built. The charm of the facade is the Palladian bay of the entrance with the odd device of five oculi, or holes, in a panel between the arches. The pediment is broken, as if to make room for the high outer arch over the entrance. (Book II, page 51.)

The groined vault with fresco (*left*) is a fine example of mural decoration by Bernardino India and Anselmo Canera (with stucco by Bartolomeo Ridolfi). It is in two styles: arabesques and delicate figures on a white ground reveal a Roman influence through Raphael's loggia in the Vatican; the trompe l'oeil figures, niches and landscapes framed by arches and columns recall Giulio Romano.

The cellar (*opposite, top*) is five feet above ground, allowing ample room for a kitchen and storerooms. The attic was used for the storage of grain.

Murals of Ionic columns upholding a fretwork frieze (*opposite, bottom left*) form bays, some of which have niches with statues and other landscapes.

Delicate arabesques and figures in the ancient Roman manner (*opposite, bottom right*) are set on a white ground in this fresco.

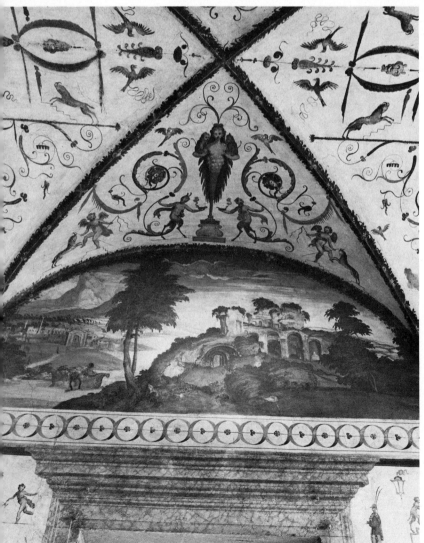

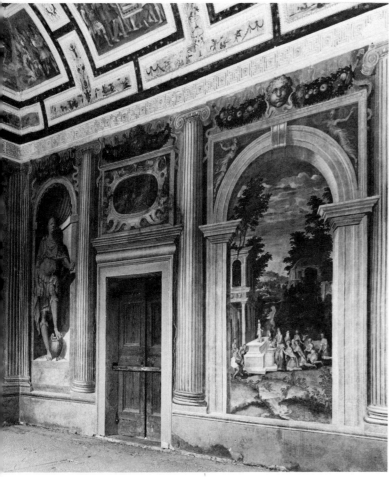

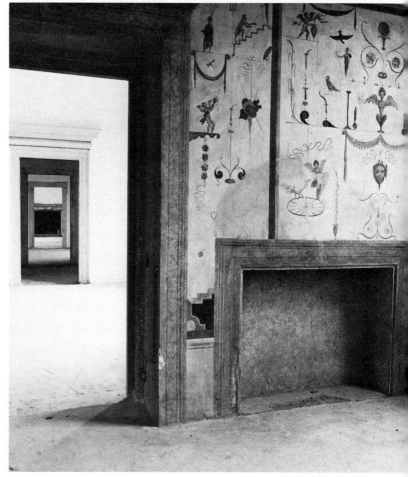

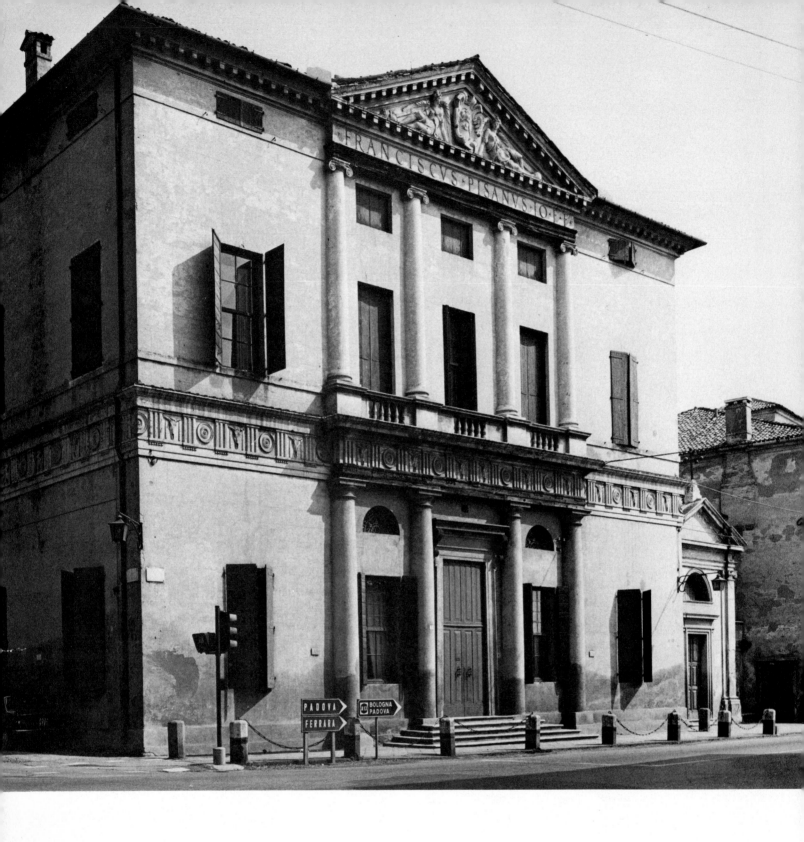

VILLA PISANI (MONTAGNANA)

The Villa Pisani (*above*; 1552) at Montagnana (Padua) could pass for a town house. It stands just outside the walls of a small country town, but what was once a quiet road crossing is now a busy intersection. The superimposed orders, Ionic over Doric, found both in the front and the back in this house, were once one of Palladio's most imitated devices in America. The Doric frieze, as at the Palazzo Chiericati (page 55) has triglyphs with metopes alternately decorated by garlanded bucranes and disks. (Book II, page 49).

The garden front of the villa (*opposite*) has generated imitations. The superimposed orders are part of two porches set in the building. Thomas Jefferson adopted the pattern for the first designs of Monticello. To the right is a late medieval brick tower of the Montagnana town wall.

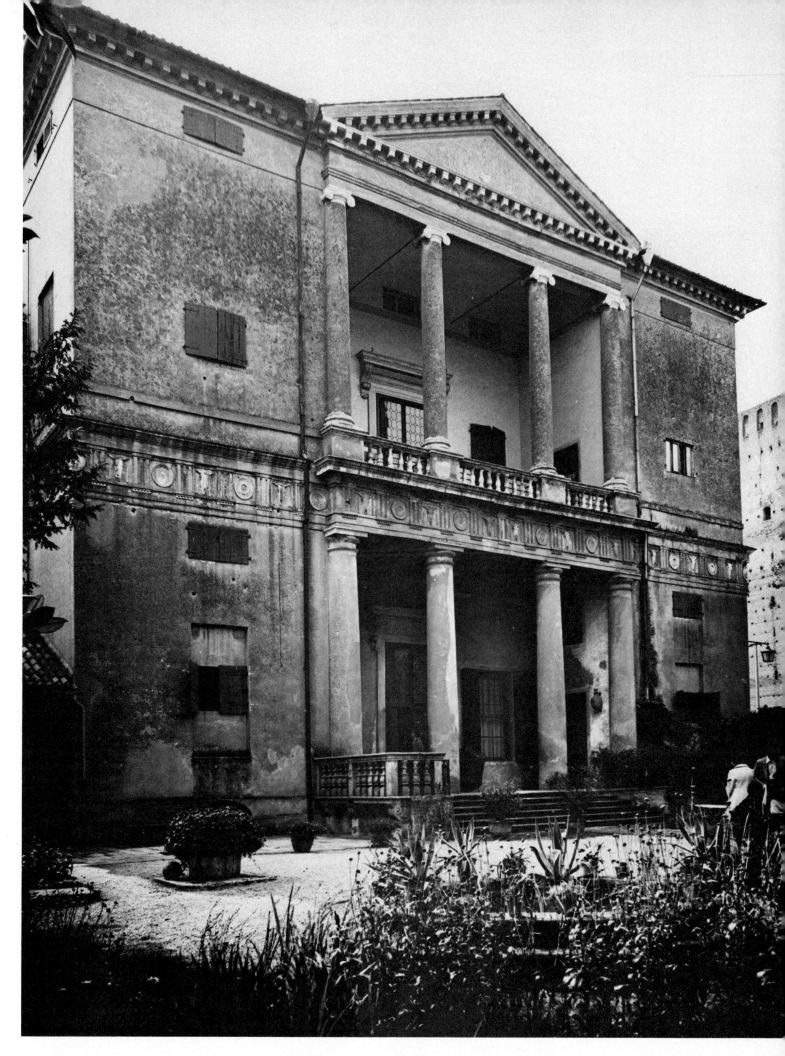

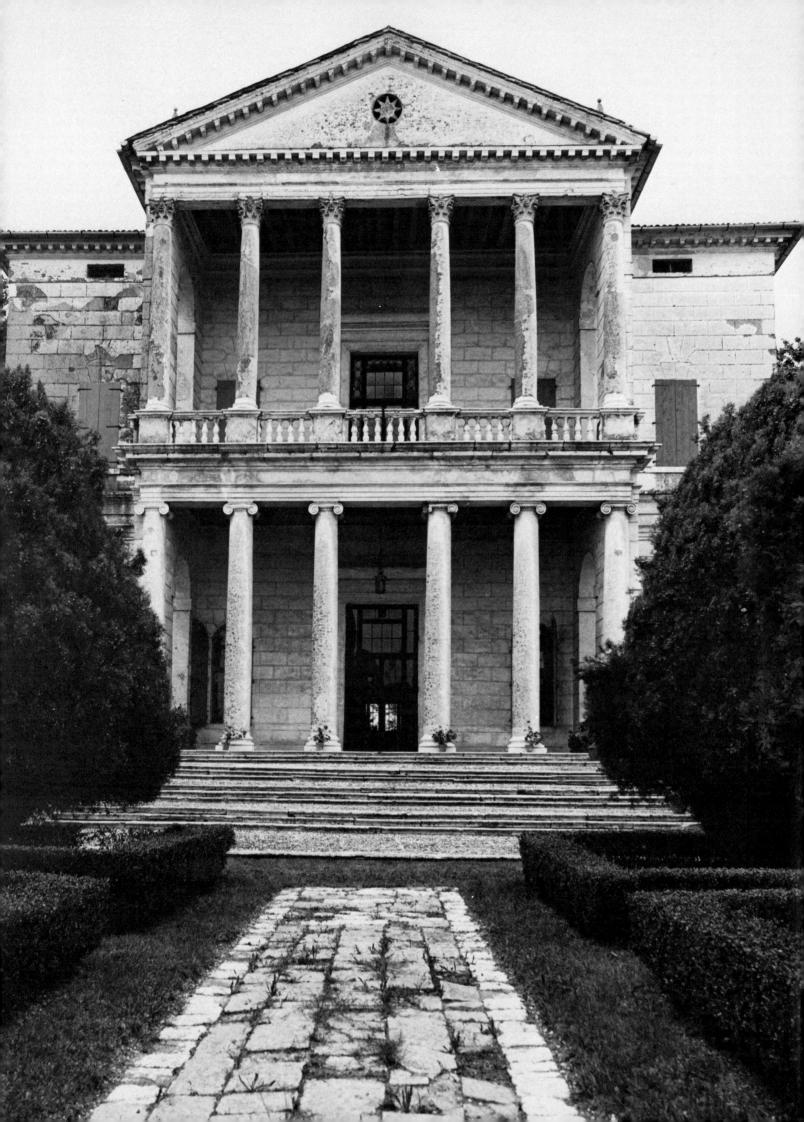

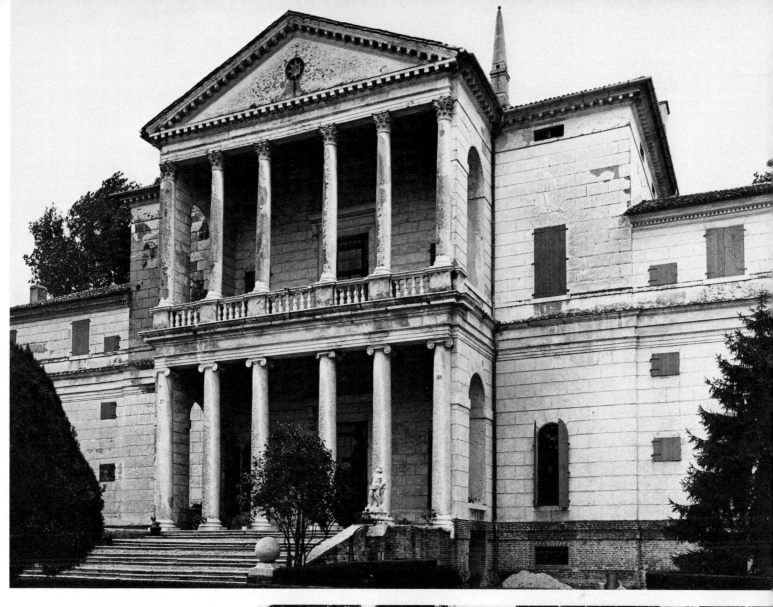

VILLA CORNARO

With this villa, built in 1553 at Piombine
Dese (Treviso), we sense that Palladio is
somewhat bolder in his treatment of the
porch (*opposite*). The porches were almost
flush with the garden facade at the Villa
Pisani at Montagnana; here they extend
from the front. Corinthian columns stand
over Ionic. (Book II, page 50.)

A view of the front of the Villa Cornaro
(*above*), seen from an angle, shows that the
sides of the two porches have arched open-
ings. The obelisk on the roof is one of a
pair, one of the earliest examples of what
became a favorite adornment of Venetian
houses and palaces.

The stairway of the garden side of the
villa (*right*) matches in dignity and pomp
that at the building's front. Steps with low
rises are interrupted by landings to insure
courtly progress.

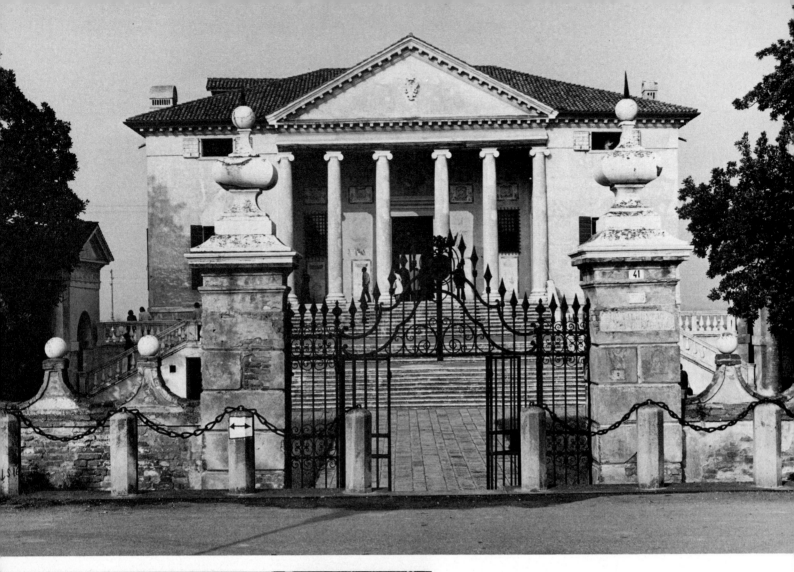

VILLA BADOER

At Fratta Polesine (Rovigo), Villa Badoer (*above*; 1556) is the southernmost of Palladio's villas standing on the flat plain which stretches north from the Po River into the Veneto. It sits on a most unlikely site for a country house, at a level well below the high banks of the nearby Scorico River. The visitor looks down on the villa from the embarkment road. In the sixteenth century the river, a branch of the Adige, was navigable at certain seasons, permitting the owner to arrive by boat. (Book II, page 49.)

A detail of the stairway (*left*) shows the baluster, two feet two inches high, which is of a unique design, as are those in other Palladian buildings. The Doric column and the tile roof of the wing are made all the more pleasing by being part of a curved wing.

Of Palladio's completed villas, the Villa Badoer has one of the more interesting plans. From the house, with its Ionic porches and wide stairway (*opposite, top*) extend two curving colonnades which end in two farm buildings. Pleasure and the utilitarian are nicely joined. A list of dimensions conveys something of the grandeur of the porch which is, after all, only one part of a small house: the columns are twenty-two-feet ten inches high, the pediment eleven feet eight inches. The door, which is not less than thirteen feet eight inches high, adds to the scale. The stairway, with three flights and three landings, is thirteen feet one inch high. By using steps, columns, pediment and door in such a monumental way it is no wonder that Palladio had imitators.

Deep coffering in the porch (*right*), on the ancient Roman model, is only possible in a high ceiling.

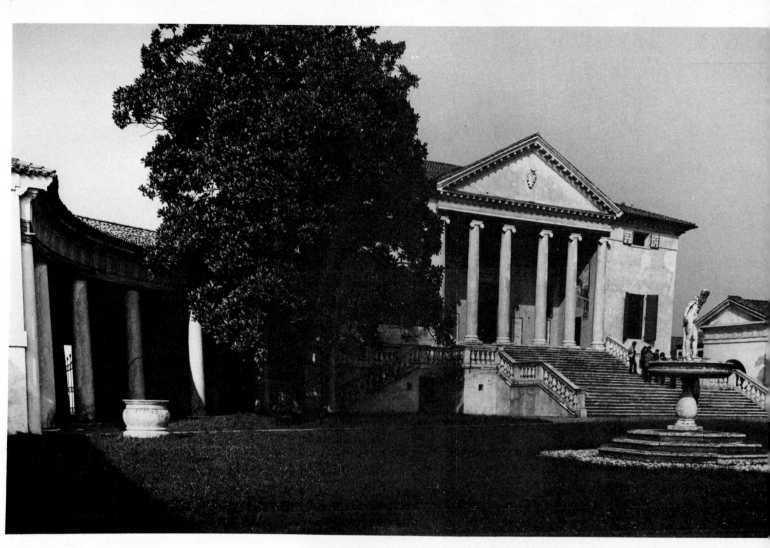

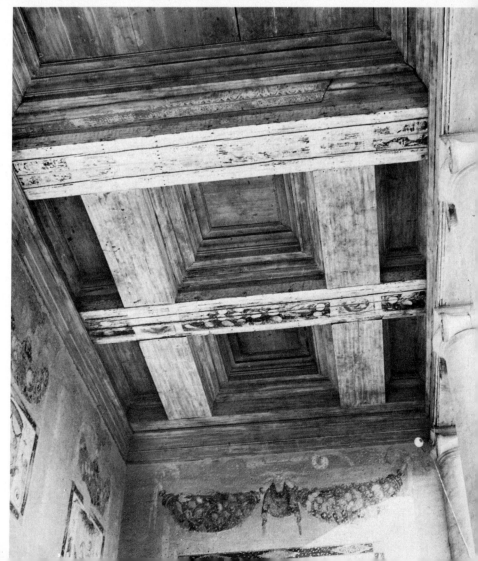

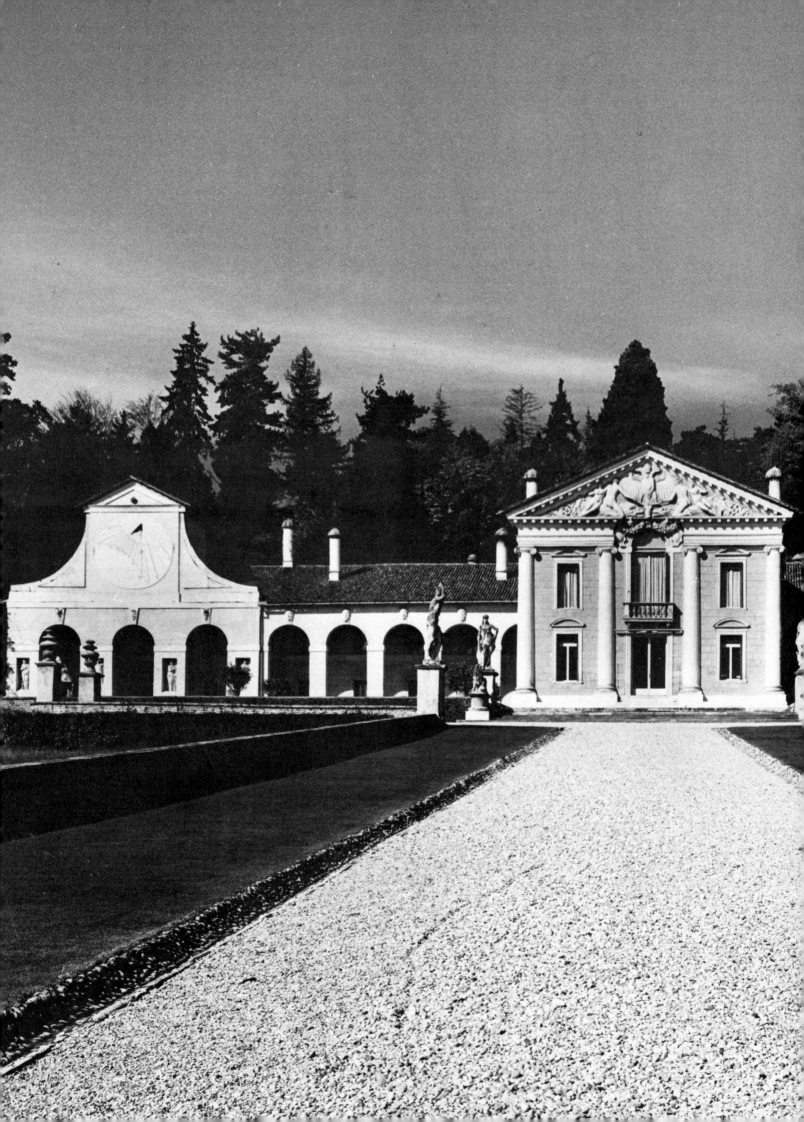

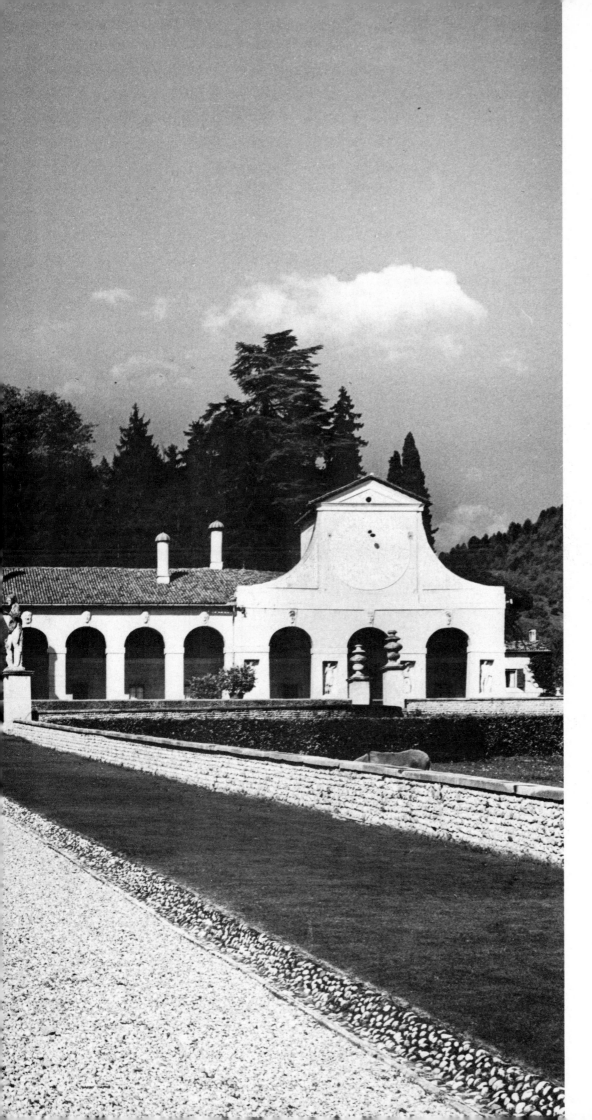

VILLA BARBARO

The Villa Barbaro (1557–58), at Maser (Treviso), is among the best known of the Palladian villas because its frescoes were painted by Paolo Veronese. Set on a low rise against a hill, it faces south to the Venetian plain. The villa (its front having an Ionic order and a sculptured pediment) and the farm buildings form one admirable unit. It seems strange, at least in today's terms, that the farm buildings should be so much part of a country residence. The whole ground floor was for farm use. It must be remembered that people then were much less fussy about smells, especially those of the farm. (Book II, page 49.)

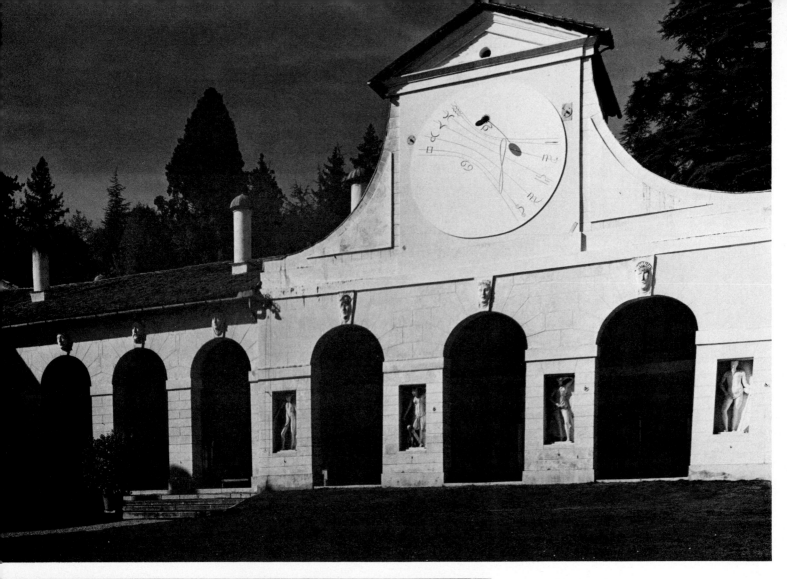

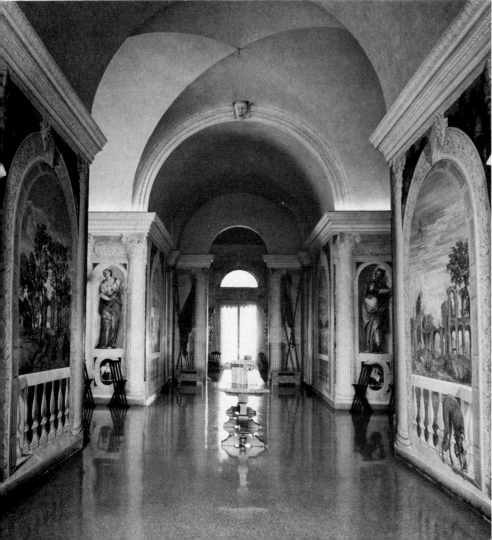

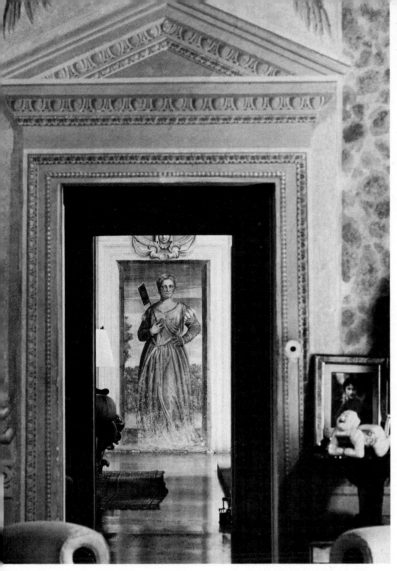

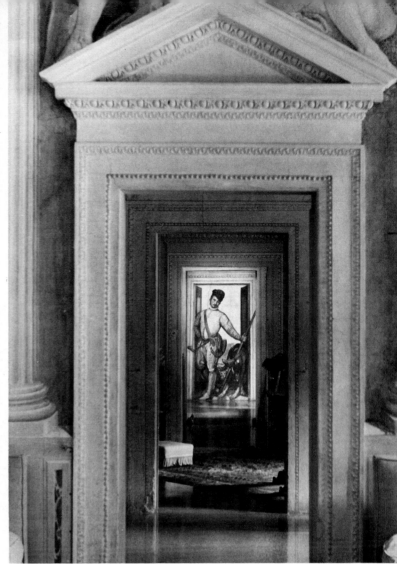

[VILLA BARBARO continued]

A pedimented wing at the Villa Barbaro (opposite, top) contains a large sundial. Statues stand in unornamented rectangular niches. There was once a dovecot in the upper part of the wing. Shallow rustication and masks on keystones are found both in the wing and the arcade.

A view of the south end of the central hall (or Sala a Crociera, after its cross-shaped plan) shows the wonderful murals Veronese executed in fresco. The murals' fine condition is the result of a careful restoration ordered in the 1920s by Count Volpi di Misurata, a public-utility magnate who then owned the house.

Veronese portrayed himself dressed as a hunter in a fresco (top, right) seen from the Hall of Olympus through an enfilade of doors. The pediment and frame of the door are in relief while the columns, bases and other details are part of the fresco.

Another fresco (top, left) depicting Giustiniana Barbaro (the wife of Marcantonio) with a fan, is seen through several doors from the main hall.

One trompe l'oeil mural (right) is painted with a blind doorway. A valet is shown about to enter the room. The trompe l'oeil figures in niches to either side of the door represent musicians with instruments; the one on the left holding a tambourine.

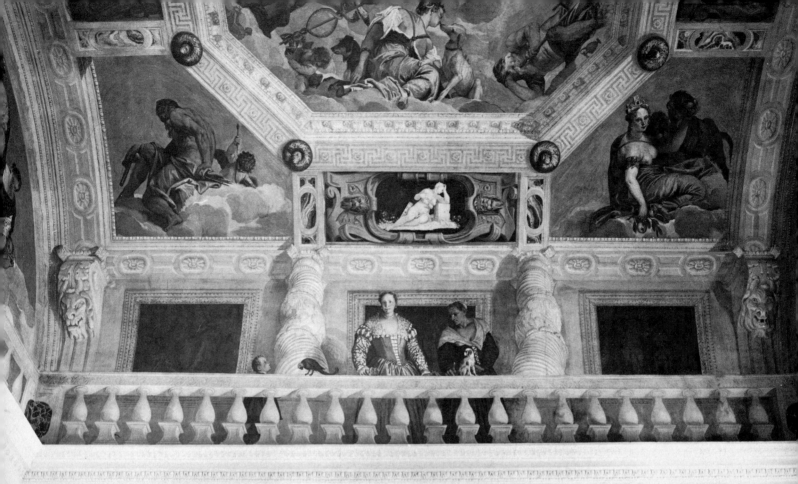

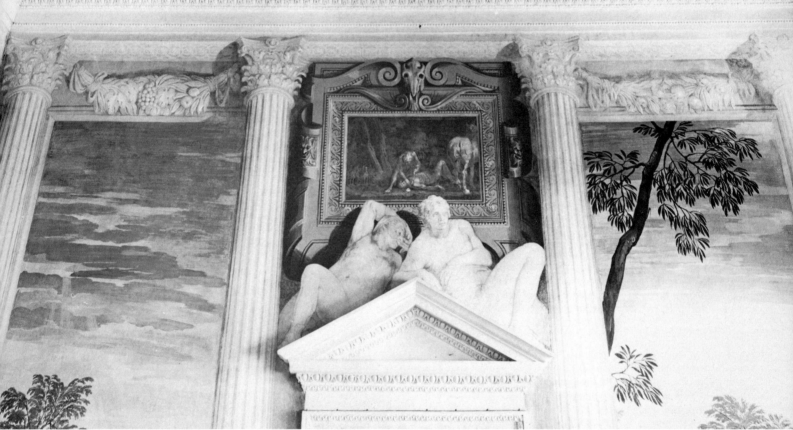

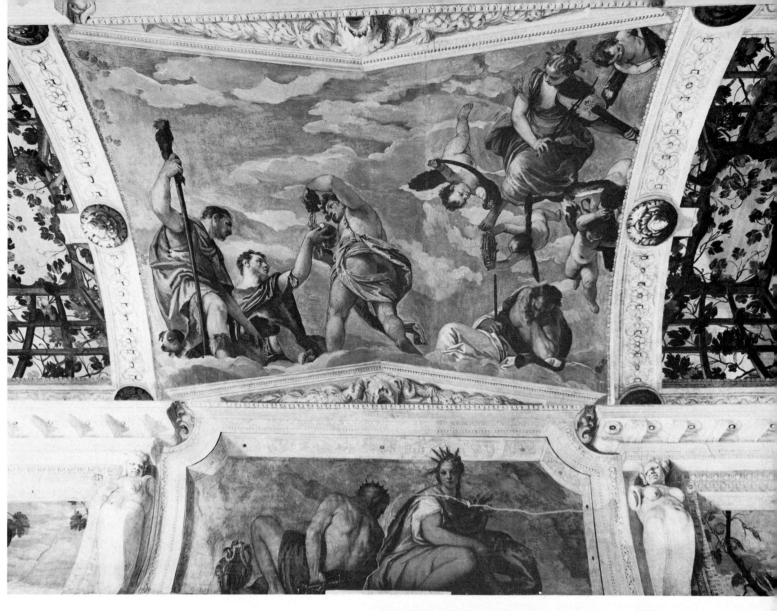

[*VILLA BARBARO continued*]

On the trompe l'oeil ceiling in the Hall of Olympus (*opposite*), Veronese painted Giustiniani Barbaro standing at a balustrade with a nurse, a child and pets. Above her rise murals on the theme of Cosmic Harmony, with Eternal Wisdom featured in the center (not visible in this photograph) and the gods and goddesses of Olympus surrounding her. At the top of the picture, a whippet is nuzzling Diana. At the left corner is an allegorical figure of Fire; at the right, Earth. The iconography is credited to Daniele Barbaro, Patriarch-Elect of Aquileia. When Veronese was at work here in the 1560s, Daniele was attending the Council of Trent in the town of Trento to the north.

In a ceiling mural (*above*) Bacchus reveals the mysteries of wine to man.

Architectural sculpture supplements the murals in the chimney-piece (*right*) by Alessandro Vittoria in the sitting room. The legend, *Ignem gladio ne ferias*, means "Do not poke a fire with a sword."

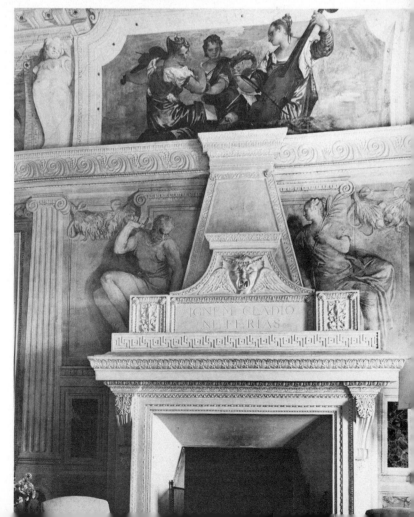

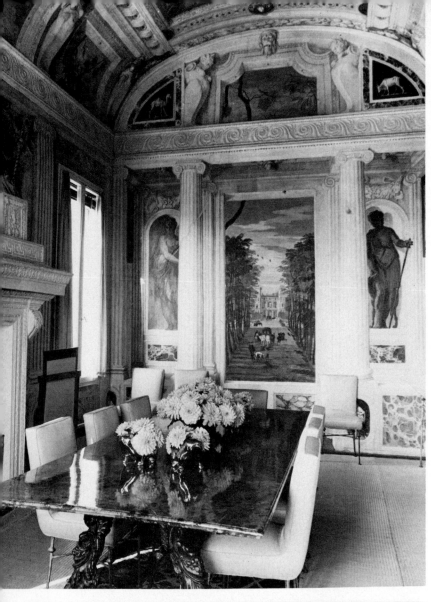

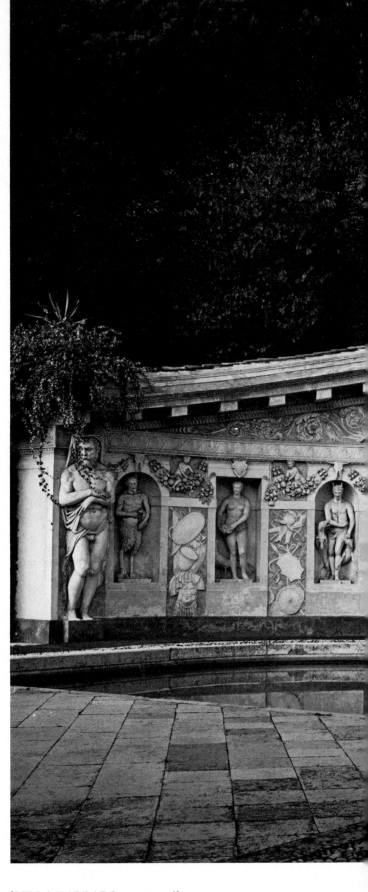

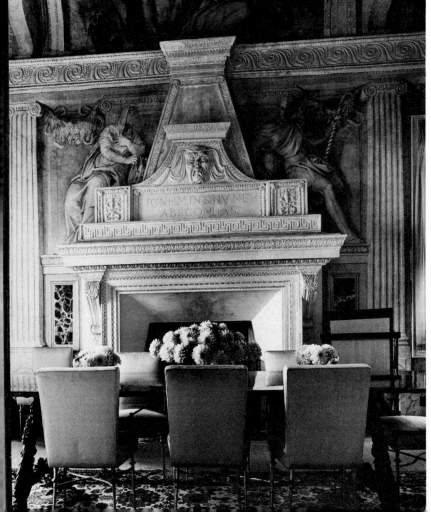

[*VILLA BARBARO continued*]

Veronese divided the walls of the dining room (*left, top*) with columns of an Ionic order which frame a landscape and niches with statues.

The chimneypiece in the dining room (*left, bottom*) also carved by Alessandro Vittoria, bears the motto *Ignem in sinu ne abscondas*, "do not hide a fire in a cranny."

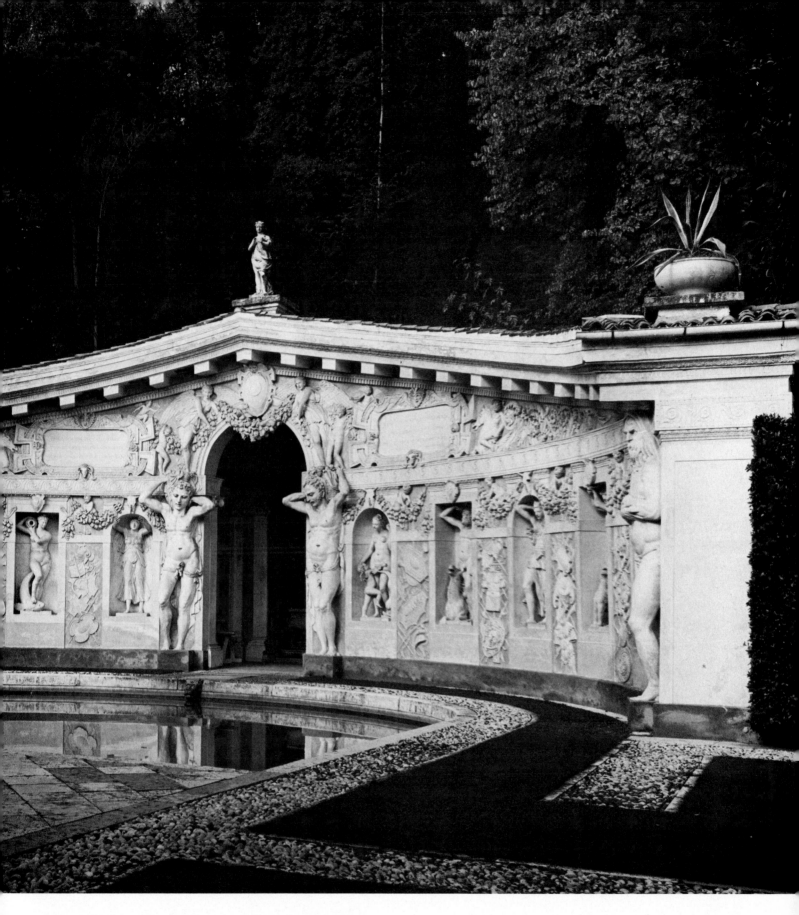

The nymphaeum (*above*) at the back of the villa contains a small pool which originally served as a fish pond. The Olympian gods and wood sprites, set in niches, are by Alessandro Vittoria. But even here Palladio remembered the practical aspects of villa life. "From this place the water runs into the kitchen; and after having watered the gardens that are on the right and left of the road . . . it forms two fish-ponds . . . from whence it waters the kitchen garden. . . . " (Book II, page 49.)

[*VILLA BARBARO continued*]

The ground floor to the left of the arcaded porch at the front of the villa (*above*) once served the farm.

The view to the south (*opposite, bottom*) overlooks the Venetian plain. A formal parterre of turf, gravel and box leaves the wall ex-posed. Statues and flowering shrubs in terra-cotta pots provide orna-ment.

A view southeast from the front of the villa (*opposite, top*) shows the Tempietto Barbaro, the chapel of the Barbaro family.

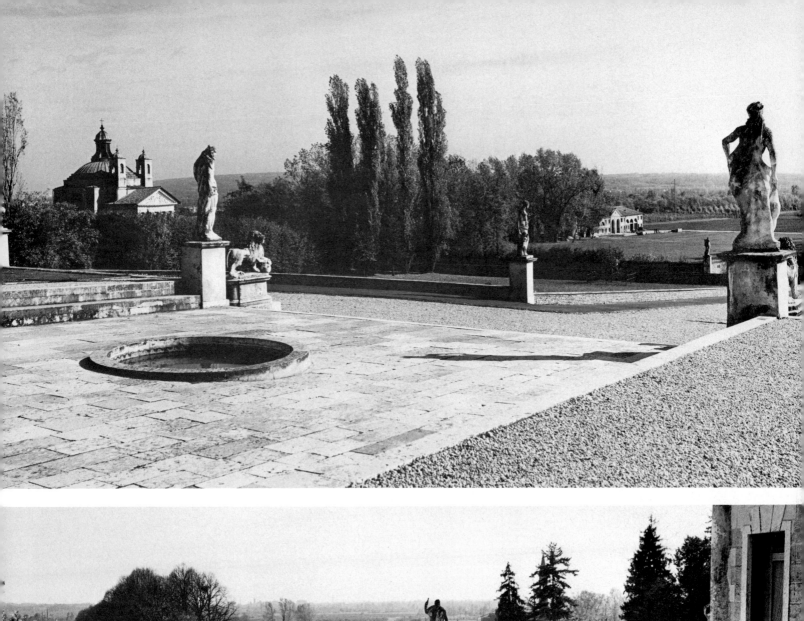

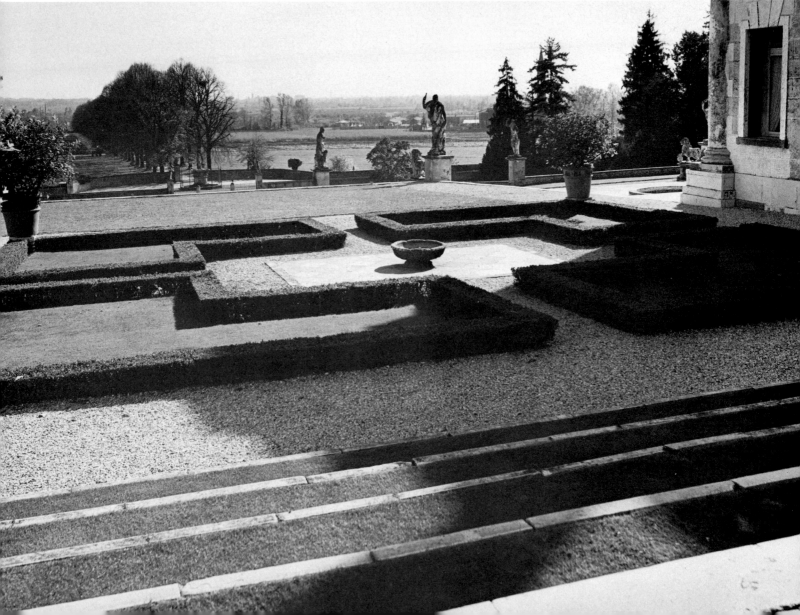

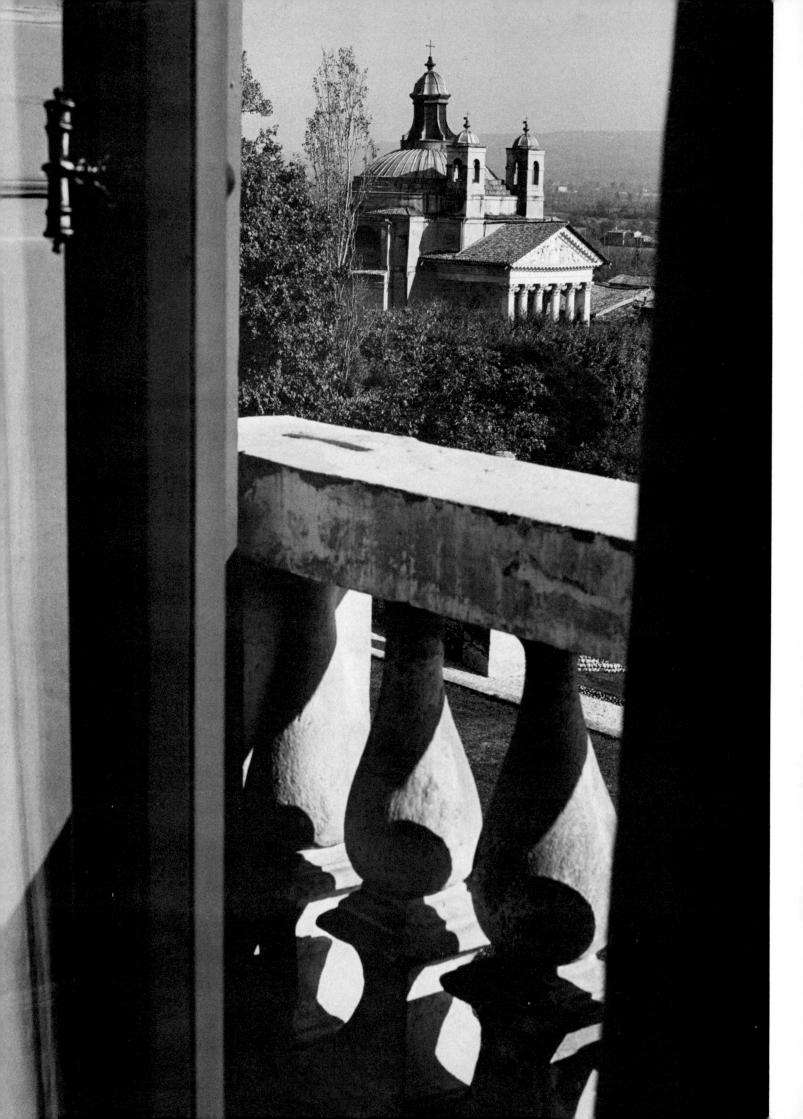

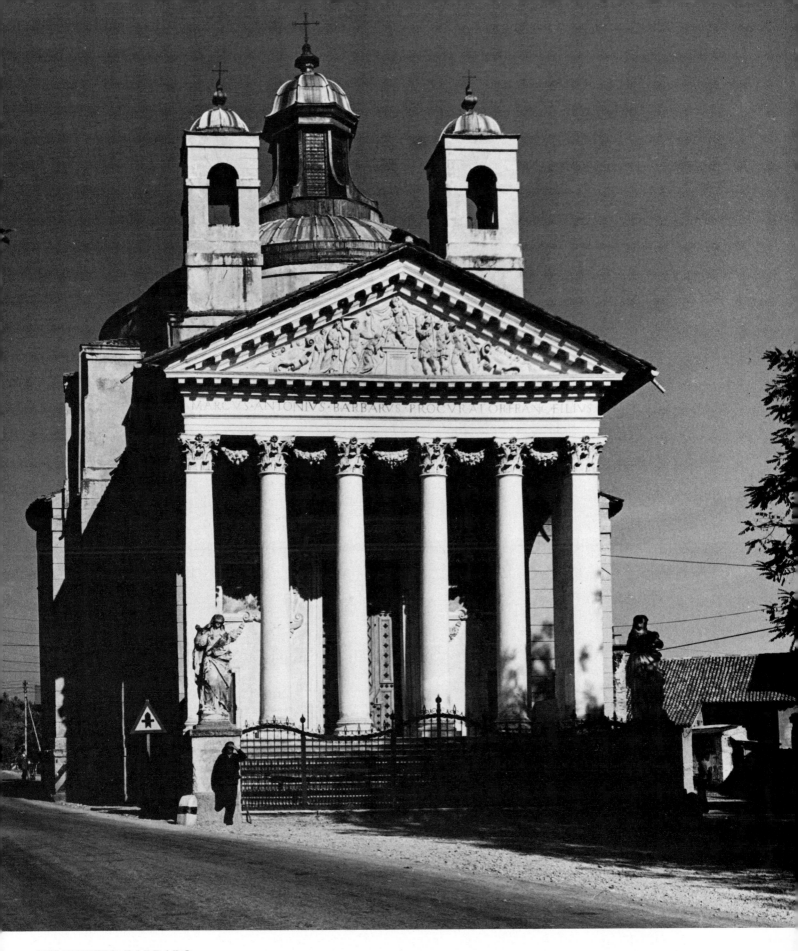

TEMPIETTO BARBARO

The Tempietto Barbaro as seen from the *piano nobile* or main story of the villa is shown opposite.

The Tempietto (*above*) was commissioned by Marcantonio Barbaro and built in 1580. The beautiful church was closely modeled on the Pantheon, the inspiration of so much in classical architecture. The structure consists of a circular interior and a porch much like its Roman model.

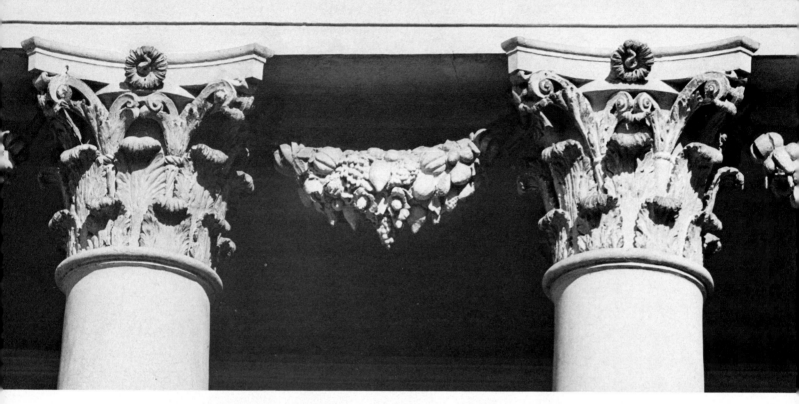

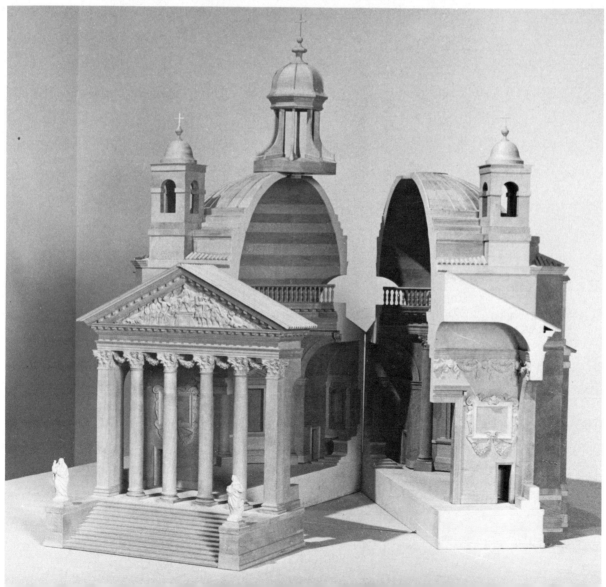

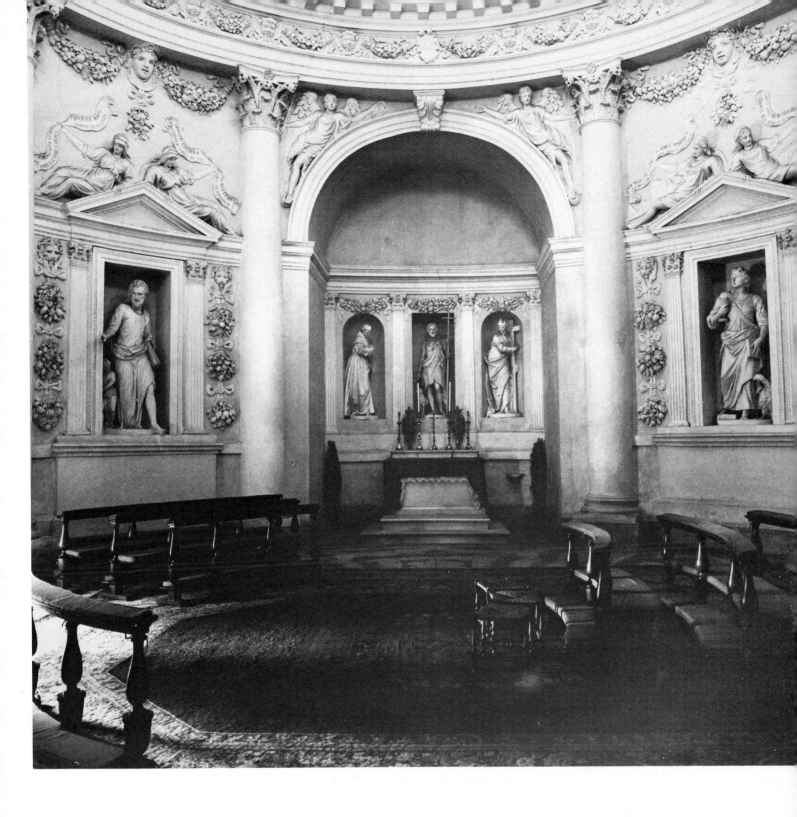

[*TEMPIETTO BARBARO continued*]

The use of fruit swags hanging between Corinthian capitals, incorporated by Palladio into the Tempietto (*opposite, top*), was known in ancient Rome. The porch of the Pantheon was, at one time, believed to have had them. The swags of the Tempietto must be one of the rare instances of their use in this manner in modern times.

The model of the Tempietto (*opposite, bottom*), made for the Centro Andrea Palladio, is opened to show the interior and its relation to the structure.

Engaged Corinthian columns divide the round interior into bays (*above*) which have pedimented niches alternating with three chapels and the entrance. The elaborate decoration is all of white stucco, the limited color scheme having been fixed by Palladio.

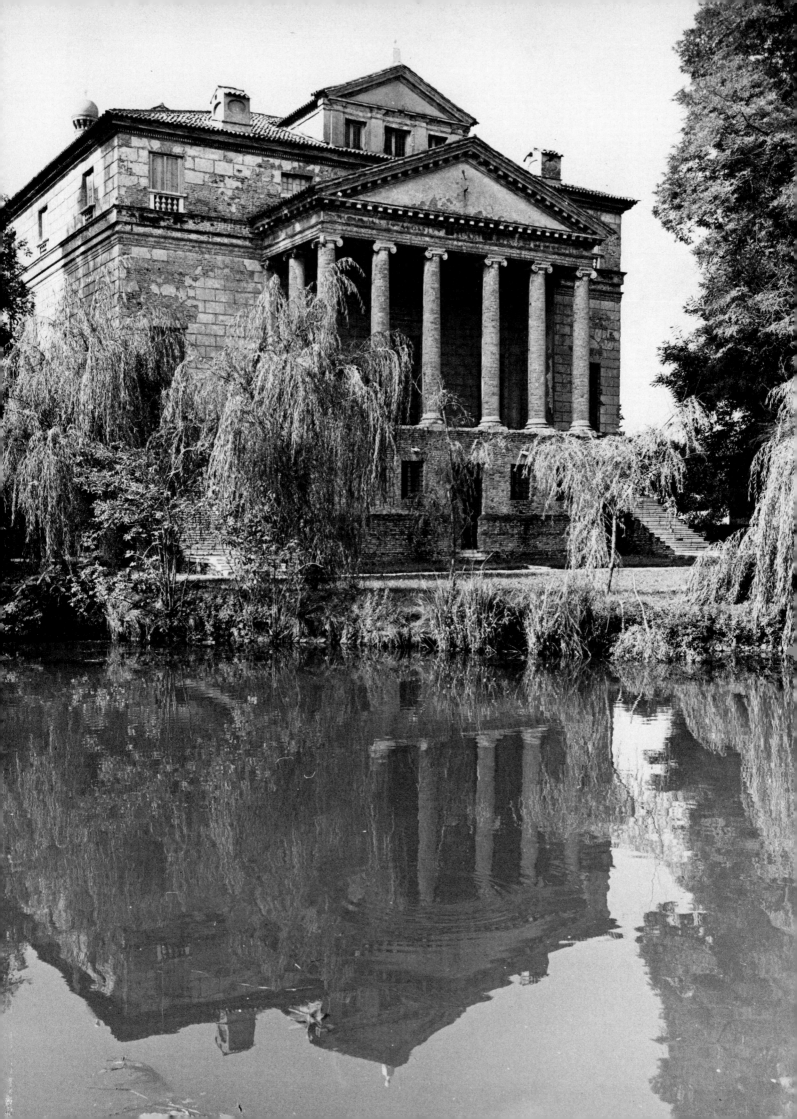

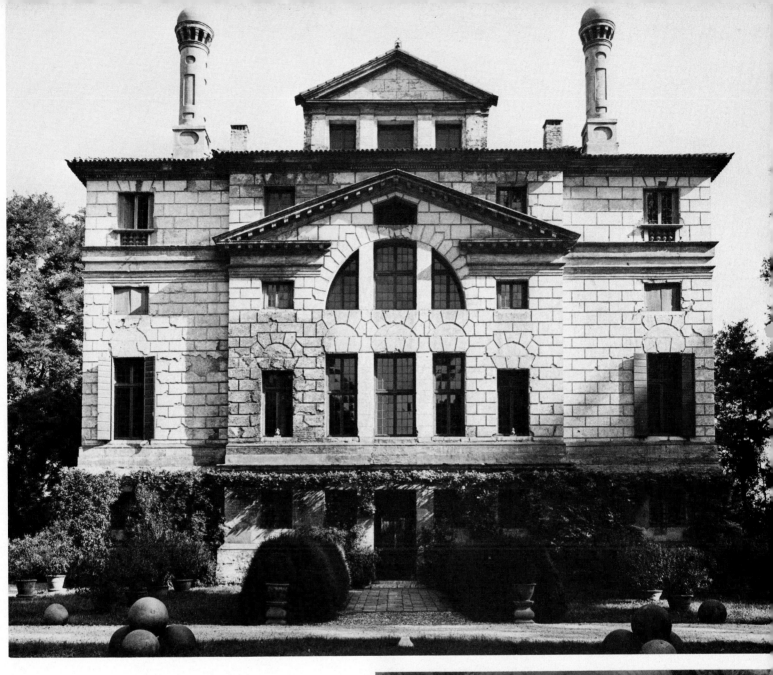

VILLA FOSCARI ("LA MALCONTENTA")

Near Gambarare di Mira (Venice), the villa (*opposite*) is seen across the Brenta River. Another one of Palladio's famous villas, it takes the name "Malcontenta" from a nearby hamlet, and stands on flat land. Built in 1559–60, it is more a rural retreat than part of a working farm. A high Ionic order is found at the front porch facing the river; in the old days people arrived by boat. There are stairways to both sides of the porch instead of one at the center. The whole exterior is rusticated. (Book II, page 49.)

The chief ornamental features at the rear of Malcontenta (*above*) are the rustication, the broken pediment and, set within it, an arched window divided into three parts inspired, no doubt, by the windows of a Roman bath.

An arm of the vaulted central room or *salone*, (*right*) which is cross-shaped in plan, contains murals by Battista Franco and Giallo Fiorentino (the latter having also done murals at Villa Badoer). The window looks out over the back of the villa.

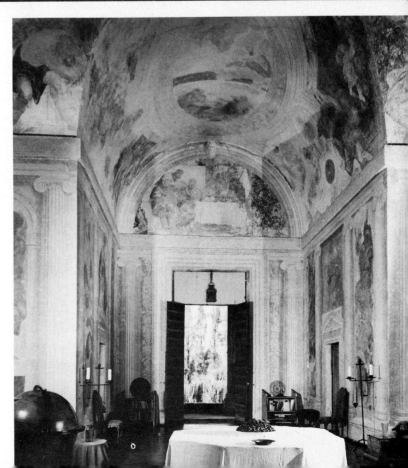

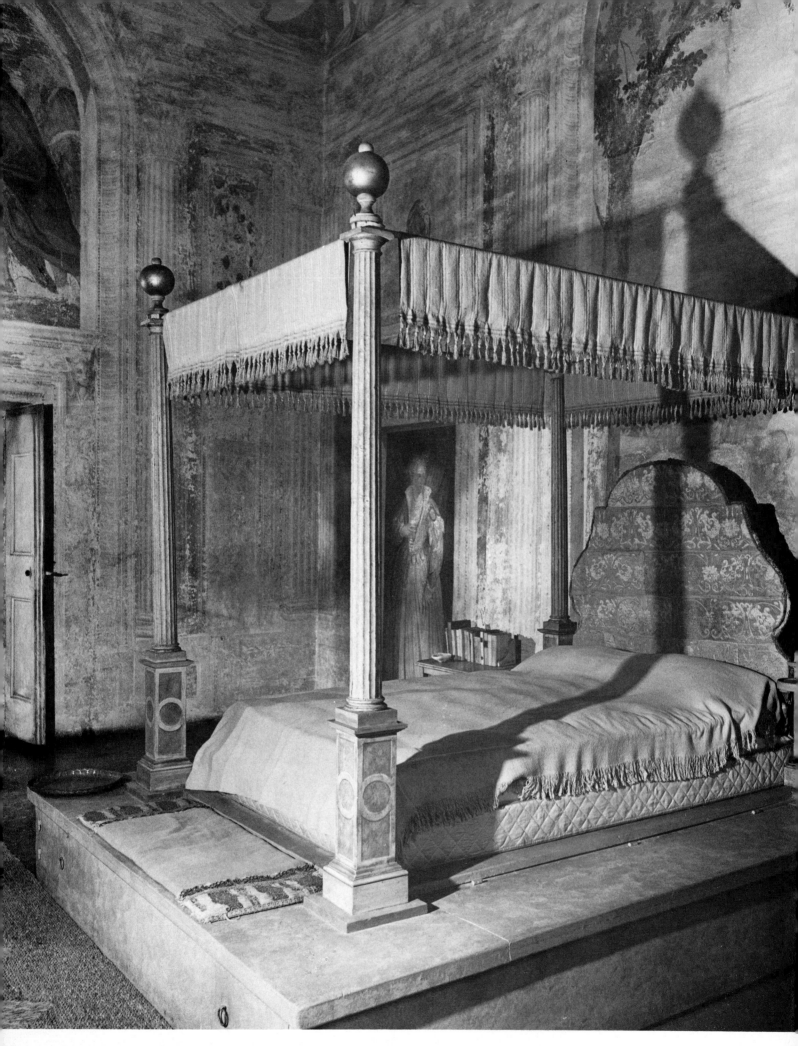

[VILLA FOSCARI continued]

The trompe l'oeil figure standing in a trompe l'oeil doorway in a bedroom (opposite) was typical of mural decoration of the century.

In the servants' entrance (above), the wide segmental vault and the groining over the side doors make for a handsome room.

The servants' dining room (right) is in the basement.

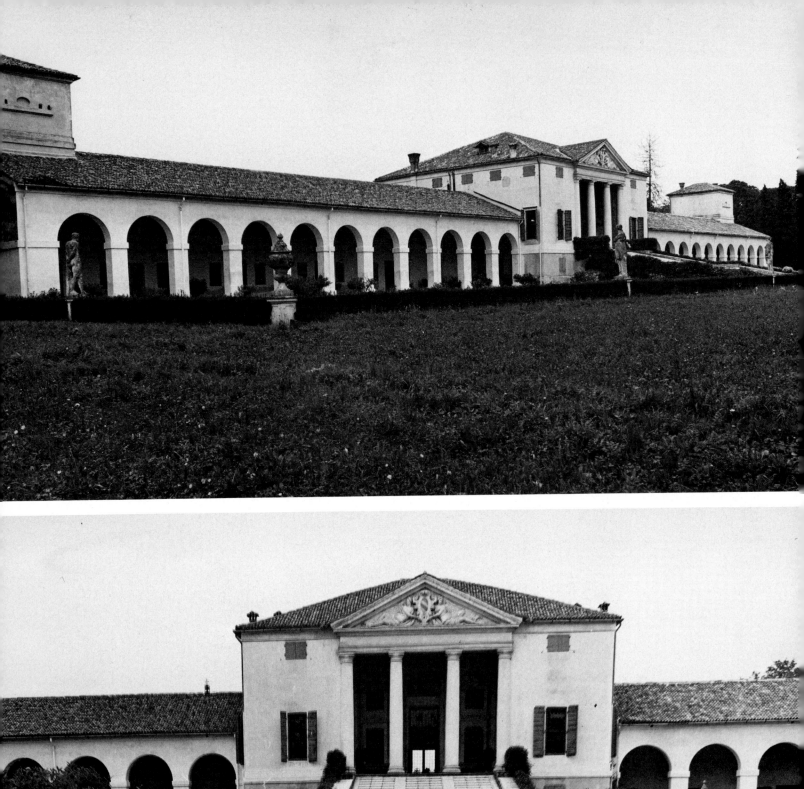
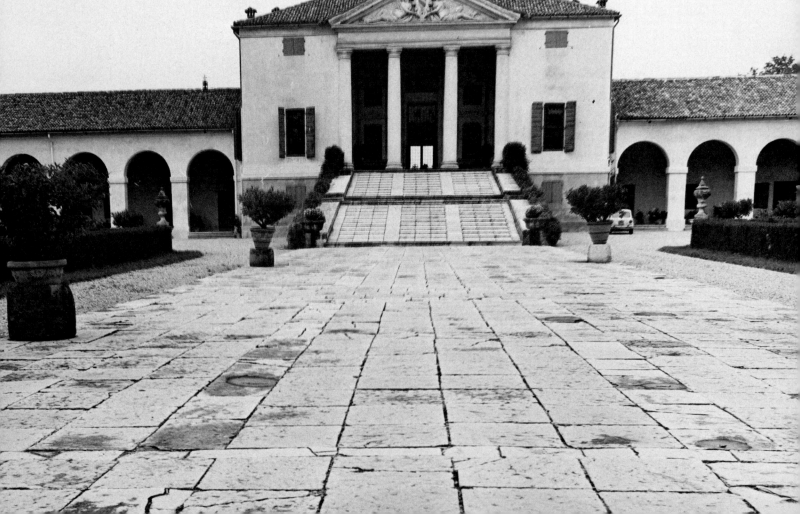

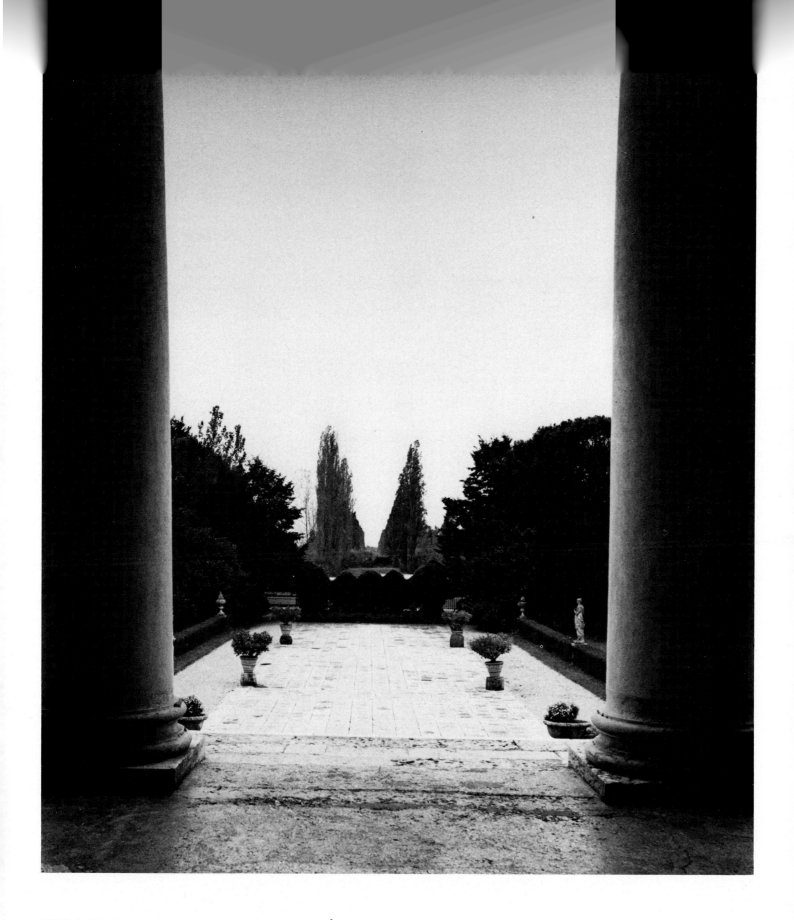

VILLA EMO

The Villa Emo (*opposite, top*), built ca. 1564 at Fanzolo (Treviso), follows the plan of the Villa Barbaro by having a central block with arcaded wings. The stucco is cream yellow with a red tile roof. Built for Leonardo Emo, a patrician of Venice, the villa has remained in the family ever since, a small part of a working estate. (Book II, page 50.)

The central block has a pedimented porch (*opposite, bottom*). The sculpture in the pediment is by Alessandro Vittoria. As at the Villa Barbaro, the interior is frescoed.

The view from the porch to the south (*above*) looks across the Venetian plain. A double row of Lombardy poplars extends the entrance mall into the landscape.

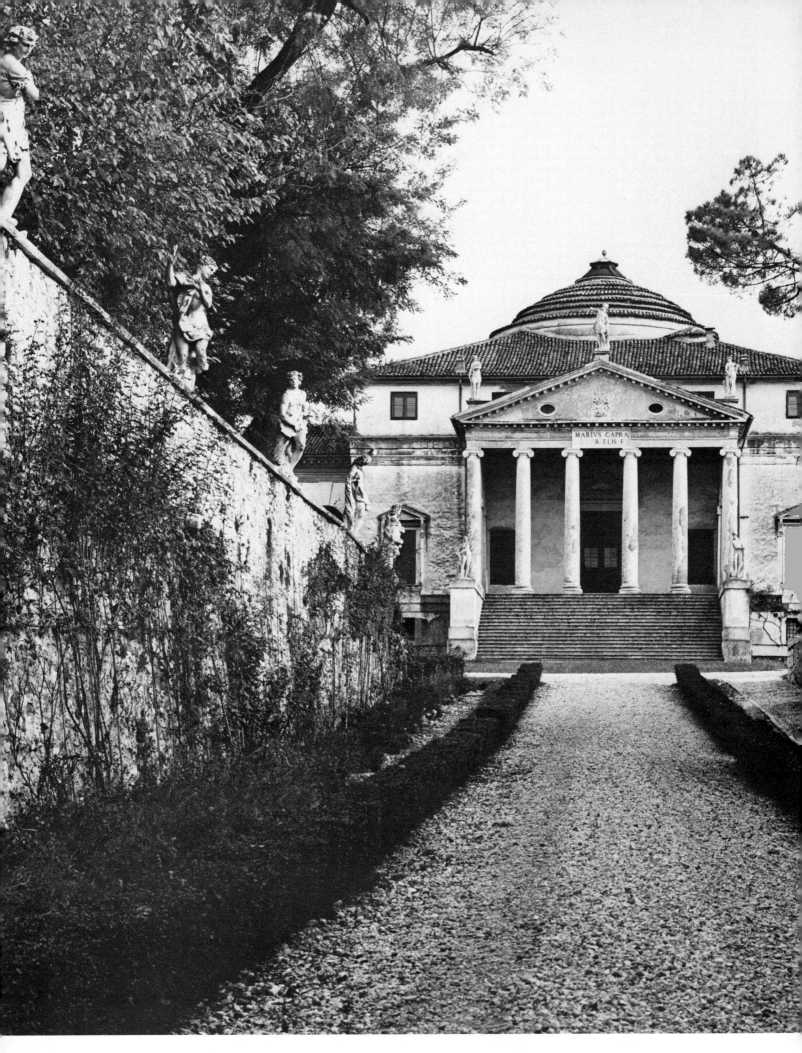

VILLA ROTONDA

The approach to the Villa Rotonda or Villa Almerico (1566–67), on the outskirts of Vicenza. A plain wall is at the left, some farm buildings at the right. The Villa Rotonda stands on a hillock overlooking the Bacchiglione River. Unquestionably the most influential of all the great architect's villas, it was not part of a working farm but a house commissioned by the prelate Paolo Almerico solely for entertaining. (Book II, page 41.)

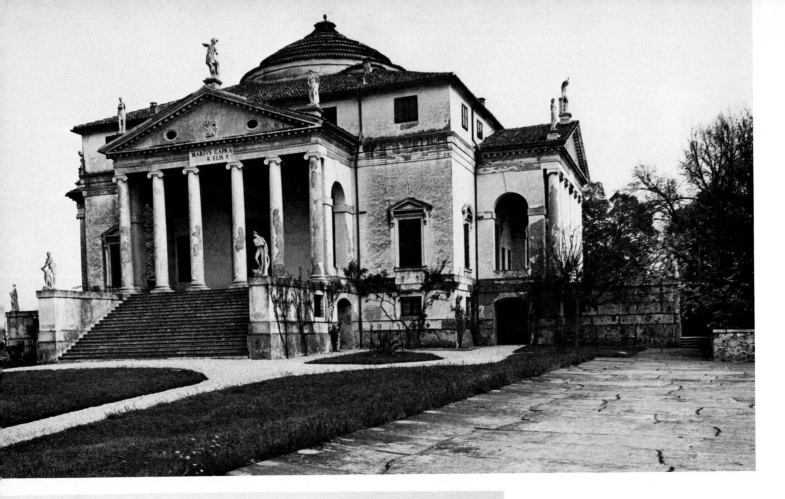

[*VILLA ROTONDA continued*]

Palladio took advantage of the site to give the building four similar sides in the form of Ionic porches and flights of steps (*above*), a rarity in architecture in such cases, where two sides—front and back—are customarily different and the two other sides the same. This porch faces northwest.

A close view of the northeast porch (*left*). Some measurements give an idea of the proportions and the size of the Villa Rotonda: An Ionic column is two feet four inches in diameter at the base and twenty-one feet two inches in height, a ratio of one to ten; the doorway is thirteen feet five inches high; the flight of steps is eleven feet five inches and the pediment is nine feet in height; the top of the dome is seventy-five feet five inches above the terrace. The proportions are big in relation to size; the average New York brownstone is no more than fifty to fifty-five feet high. Sculpture, as Palladio well knew, is of supreme importance in adding interest to the silhouette. The pediment statues, six feet two inches tall, are the work of Giovanni Battista Albanese and were installed in 1600, two decades after the architect's death. No less important are the statues on the stairs. The work of Lorenzo Robini, they are said to have been in place by 1569.

The northeast porch (*opposite*) looks out over the Venetian plain. If Monsignore Almerico built the Rotonda for his pleasure, he did not let the land about it lie fallow any more than does the present owner; this is very much in the Vicentine tradition.

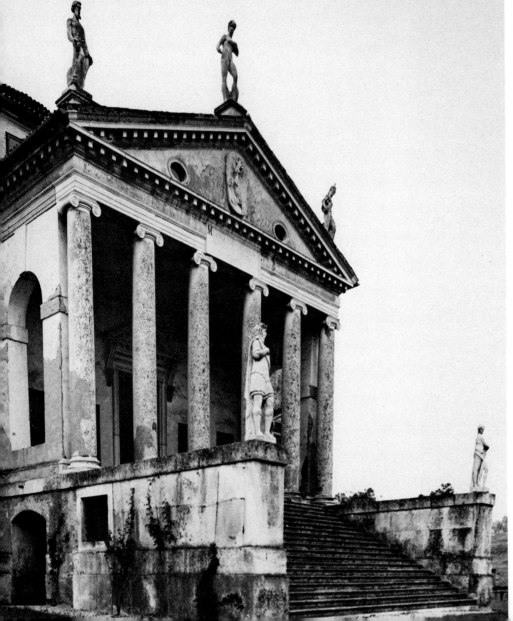

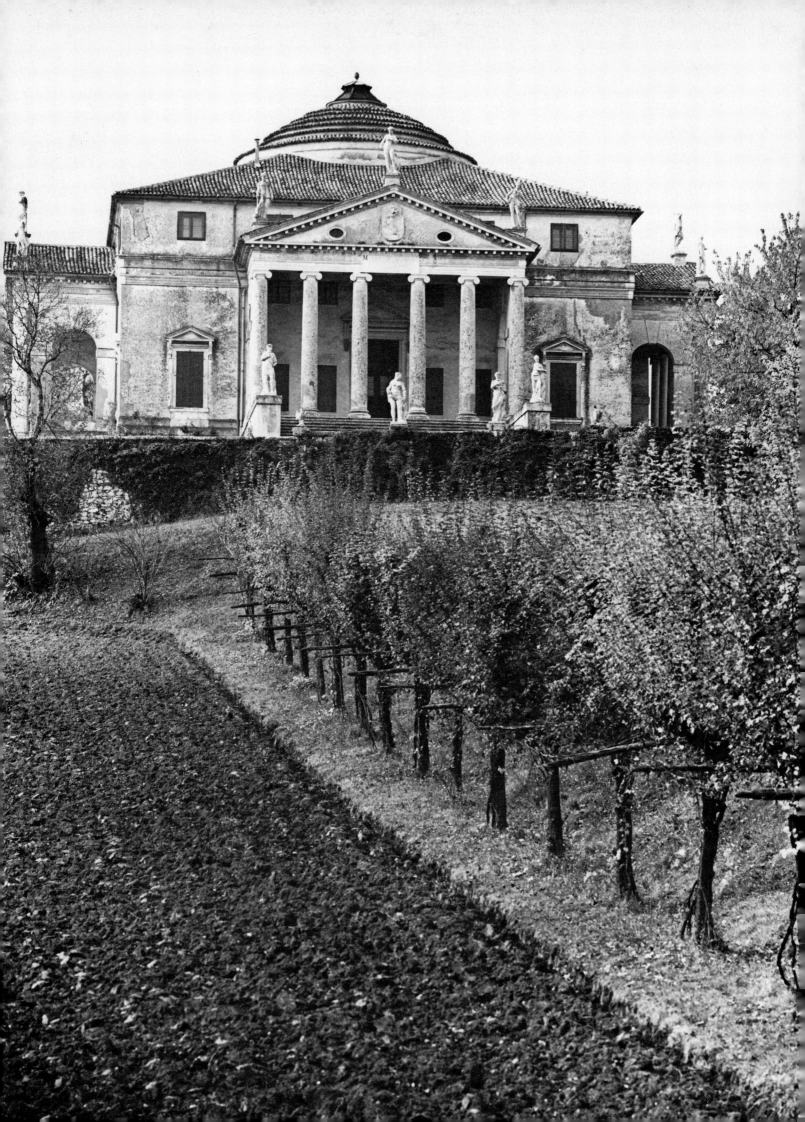

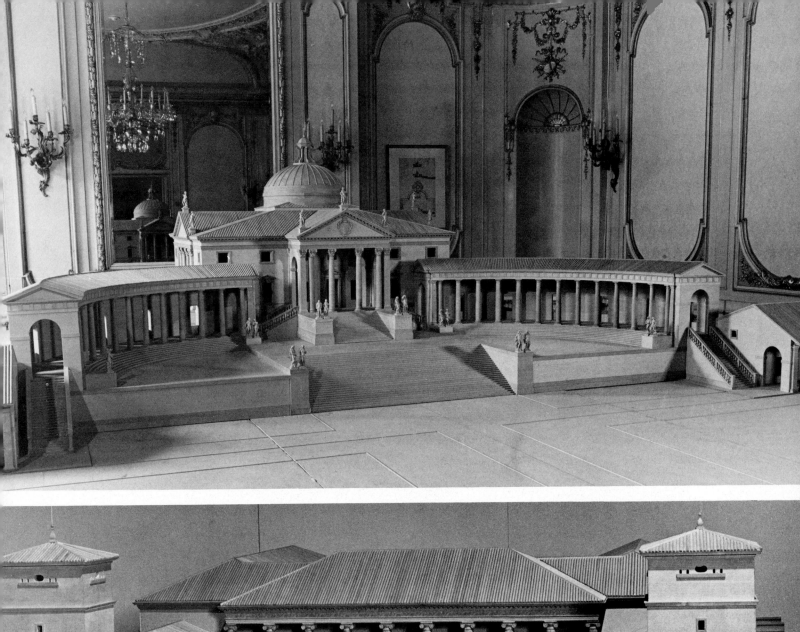

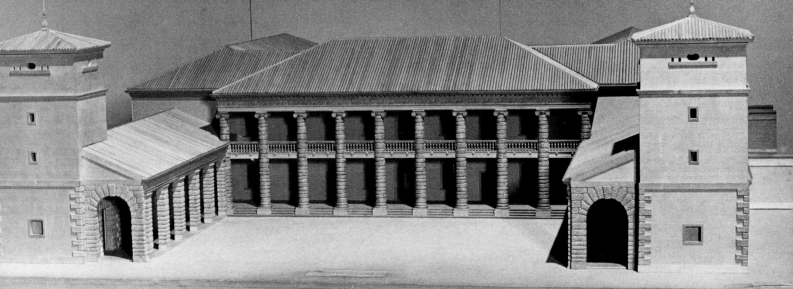

VILLA TRISSINO

The model of the Villa Trissino (*top*), shown here in the salon of the Andrew Carnegie mansion (now the Cooper-Hewitt Museum), is based on Plate 43, Book II of *The Four Books*. The magnificent design never got further than a small portion of one of the wings, built in 1567. (This orphan can be found at Meledo di Sarego in the Province of Vicenza.) The villa is truly Roman in magnificence. Unquestionably, it influenced Thomas Jefferson when he designed the Rotunda and quadrangle of the University of Virginia in Charlottesville (page 119).

VILLA SAREGO

The view of the model (*bottom*) shows a U-shaped, colonnaded forecourt with two wings to either side, reserved for stables. We know of this forecourt only from Book II, Plate 49, of *The Four Books*. The portion that was actually built (ca. 1569) in Santa Sofia di Pedemonte, Verona, consisting of half of the main court, lay beyond. Not only are the drums of the Ionic columns underscored by the pronounced rustication, but the drum surface is pitted to resemble vermiculation, or worm tracks. The Villa Sarego is generally accepted as the last of the villas which Palladio designed.

Palaces

At first Italian palaces were little more than fortresses built on city streets. There was good reason for this: street battles, arising out of political conflicts and family differences, were common. (Vicenza, where nearly all Palladio's palaces are to be found, is in "Shakespeare Country." It is said that Romeo came from Vicenza; Shakespeare transplanted him to Verona.) By the sixteenth century the plague of city warfare had largely disappeared, but the palaces remained. If they were no longer fortresses, they were still headquarters for large families enjoying semifeudal rights. In Vicenza the pre-Renaissance palaces were Venetian Gothic in style, seemingly modest structures because of the minor scale of Gothic ornament. The classical style of the Renaissance offered a monumental alternative, one which allowed a flourish to impress the world.

With the villa we have seen how Palladio made use of several elements, such as the templed front, to achieve grandeur. With the palace he did the same, relying chiefly on bold rustication for the ground floor and pilasters or engaged columns for the floors above. Occasionally he would arrange column over column, or pilasters above columns, or a single very high order rising to an attic. The aim was always to impress the beholder.

The equivalent can easily be found in American cities. The New York Stock Exchange, a low building, is made imposing by having very high Corinthian columns on a high base. Nearby on Wall Street the former United States Assay Office, now the Seamen's Bank for Savings, has pilasters rising from a rusticated base. In Chicago, on La Salle Street, the Northern Trust Company has an Ionic order over a massive rusticated base. In Philadelphia the Girard Bank just makes use of columns and a pediment. This is not to say that these buildings are Palladian; American architects simply adopted classical devices as Palladio did in Vicenza.

Of Palladio's several palaces, truly public buildings in the contemporary sense, the finest is that called the Palazzo della Ragione or the Basilica, the city building which made him famous. To sheathe an older structure with superimposed arcades and give it an outward splendor, he turned to what is called the Palladian motif, the arched opening set between two flat-topped openings. Although he had been anticipated in its use by Bramante and Serlio—it is also known as the Serlian motif in Italy—Palladio gave it prominence by his use of it at the Basilica. Such was the fame of the building that his name, at least in the English-speaking world, has ever since been associated with the device.

"This fabrick may be compared with the antient edifices, and ranked among the most noble, and most beautiful fabricks, that have been made since the antient times . . . " was Palladio's own opinion of the Basilica—he set a high value on his own work. Let us concede the great architect this boast, although we might actually prefer several of the other *palazzi*.

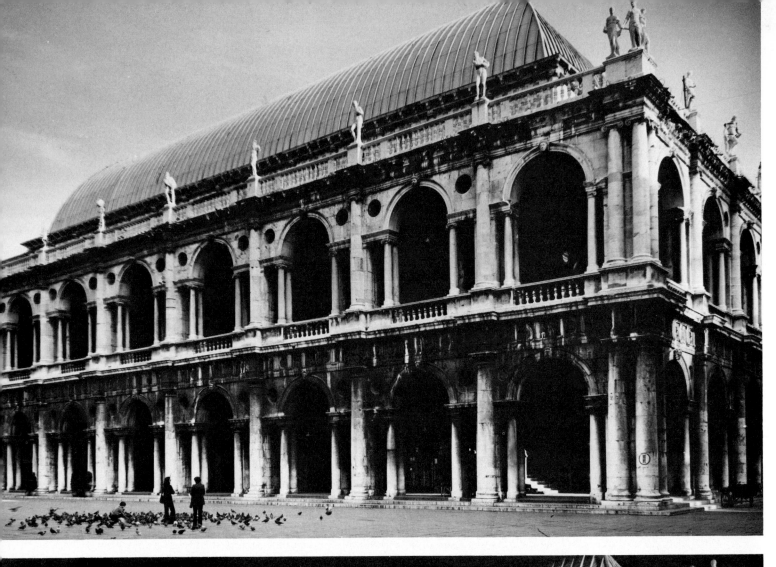

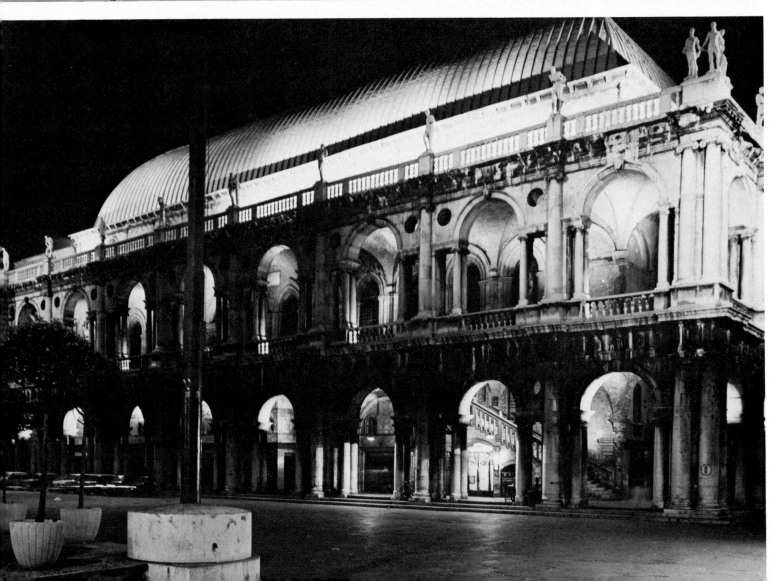

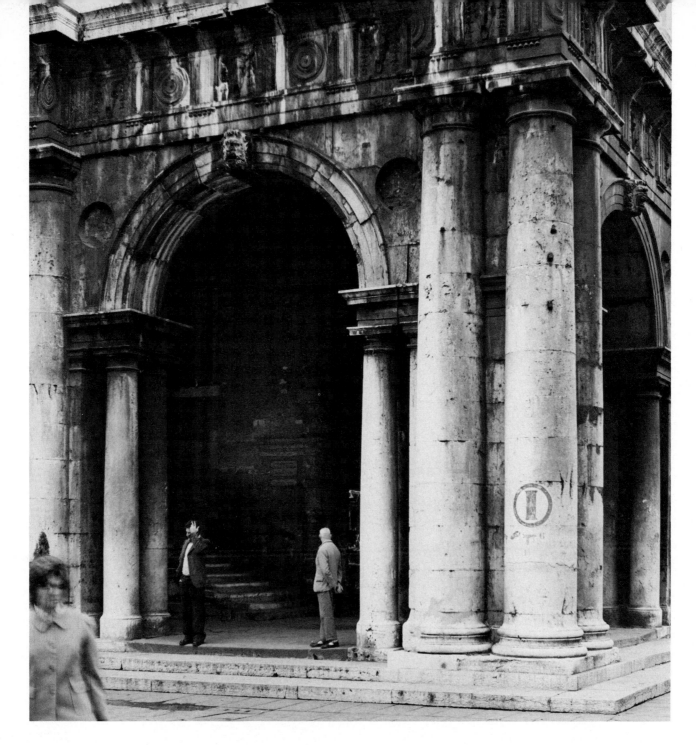

THE BASILICA

The north and principal front of the Basilica (1546/1549–1616) faces the Piazza dei Signori in Vicenza (*opposite, top*). It is two hundred and twenty-nine feet four inches long and is divided into bays whose width varies from twenty feet four inches to twenty six feet one inch, a fact which escapes the eye of even the most alert observer. The arch and small paired columns supporting it within each bay are all of the same dimensions, the center of columns being thirteen feet two inches apart . This gives the bays visual unity . The Basilica is constructed of Pietra di Vicenza (scientifically, Calcareniti di Castelgomberto) taken from three quarries in the Colli Berici. (Book II, page 76.)

The north facade of the Basilica is seen at night (*opposite, bottom*). It was a challenge for Palladio to divide vertically a facade which could have been overwhelmingly horizontal. This he did by providing accents at each bay: engaged columns, broken entablatures above each column over which stand statues on a balustrade. As Inigo Jones pointed out, the statues are one third the height of the Doric column of the ground story, seven feet nine inches compared

to twenty-two feet five inches. The balustrade, here so clearly silhouetted, is four feet four inches. It is used not so much to screen the roof as to give the facade scale.

The narrow bay (*above*) at the west end of the north front is twenty feet ten inches wide. The small columns supporting the arch are thirteen feet six inches in height, contrasting in scale to the bay columns which are twenty-two feet five inches. The small space of this bay explains why the oculi, or circles, of the spandrels are closed while the others were left open. Although the added column on the corner is there by structural necessity, it is also visual in function, moving the eye of the viewer around the corner. The Basilica possesses the most famous example of the Palladian motif, the arched opening between two-flat-headed openings.

A view inside the ground-story porch of the north flank looking east (*over*), shows the windows and doors of the older, inner structure which dictated the irregular bay widths of Palladio's porch.

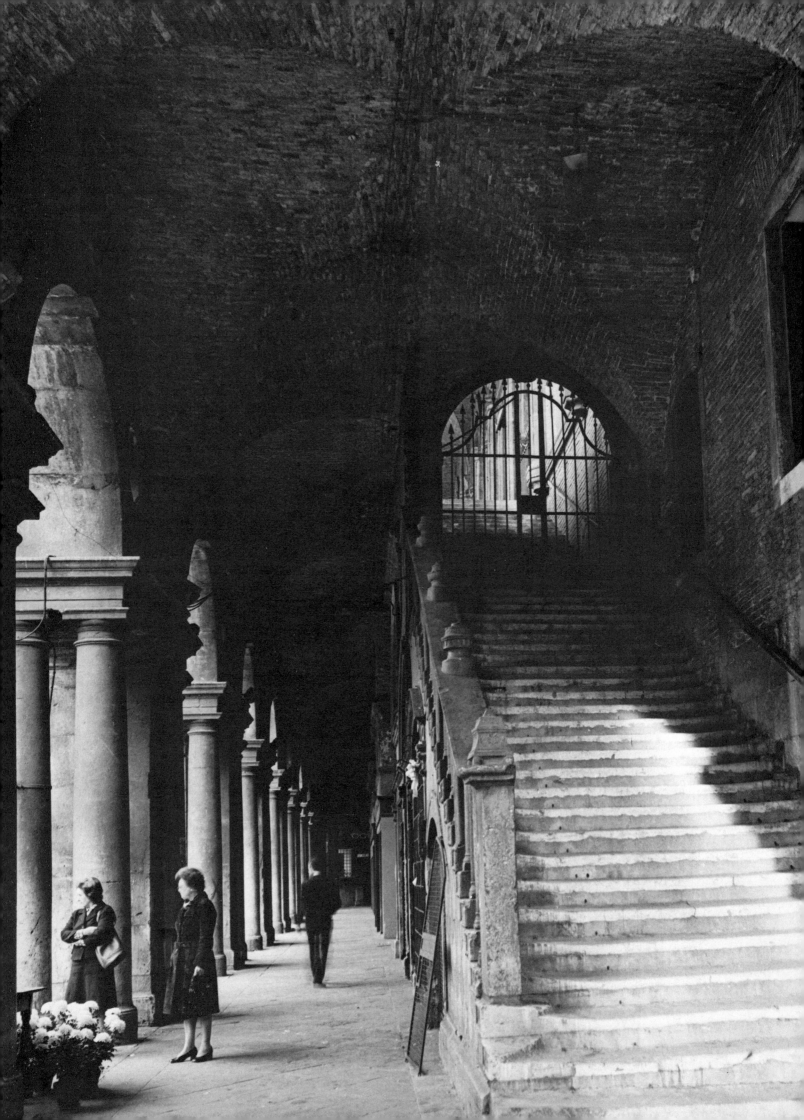

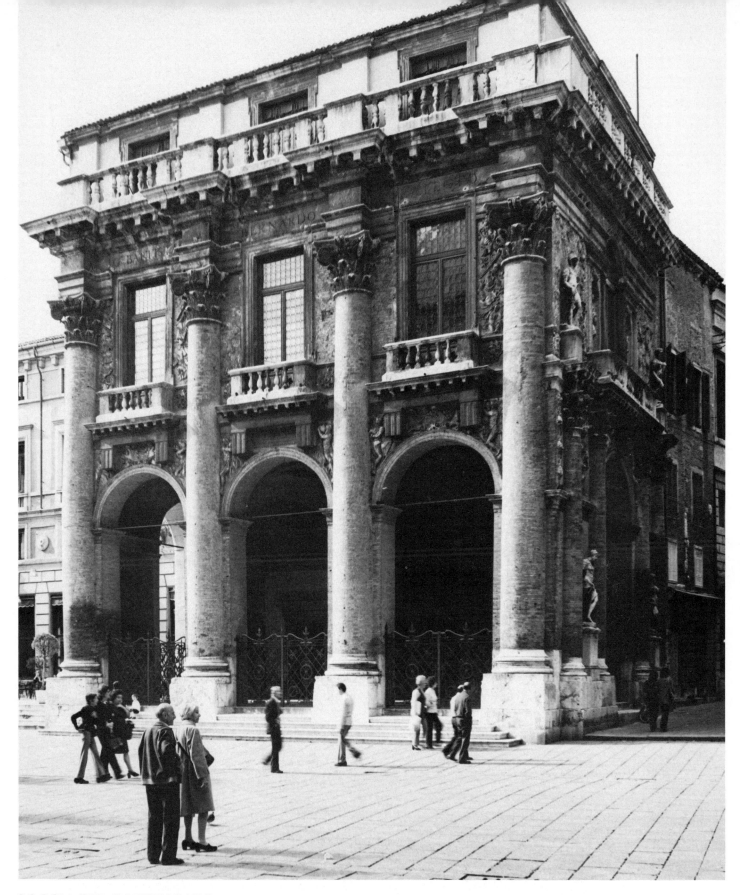

LOGGIA DEL CAPITANIATO

North of the Basilica, across the Piazza dei Signori, stands the Loggia del Capitaniato (1565–71). This unfinished building, designed to combine a proper setting for ceremonial occasions and an apartment for a city official, presents a monumental facade to the piazza. The columns are Composite, an order often found in Italy and but rarely in the United States. Where the Doric column of the Basilica is twenty-two feet five inches high, the ones here are thirty-nine feet one inch, part of a sixty-one foot facade. (In the United States a monumental order is apt to be higher because it is part of a much larger building. The Corinthian columns at the foot of New York's Municipal Building, by William Mitchell Kendall of McKim, Mead and White, are fifty-one feet, nine and three-quarter inches high.) Palladio used the balconies to underscore the column height. The column shafts, of a pleasing rose-red brick, were intended to remain bare, in contrast to the panels and spandrels with stuccoed relief.

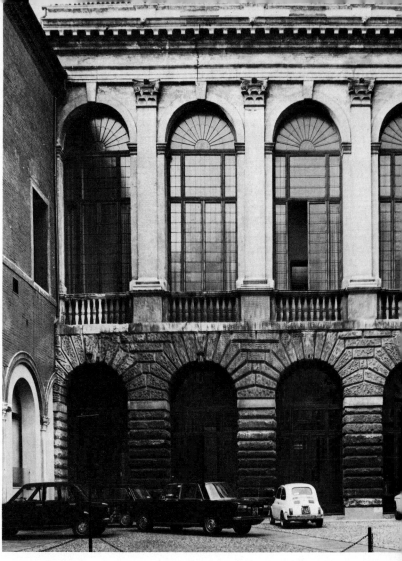

PALAZZO THIENE

Built in 1542–46, Palazzo Thiene (*opposite*) was Palladio's second Vicentine palace. In all of them, except the first, the monumental triumphs, and no more so than here. Palladio offers a lesson in the use of rustication, emphatic in the ground floor and lightly touched in the second. In this way a base, massive to the eye, upholds a lighter second story which is punctuated by Composite pilasters and pedimented windows framed by Ionic columns whose engaged shafts are divided by blocks (adding to the sense of visual power). Palladio, of course, did not work in a vacuum. In the Basilica he was influenced by Serlio. Giulio Romano's Palazza del Te in Mantua inspired

the rustication of the Palazzo Thiene. Now the headquarters of the Banca Popolare di Vicenza, the building is beautifully maintained. (Book II, page 40.)

A detail of the ground-story rustication (*above, left*) shows the deeply recessed joints and pitted surface. The brick has lost the stucco which once covered it in imitation of stone.

The elevation of the court (*above, right*) is a variation on the theme of the facade with wide, tall openings between the pilasters. Originally the second-story arcade was open.

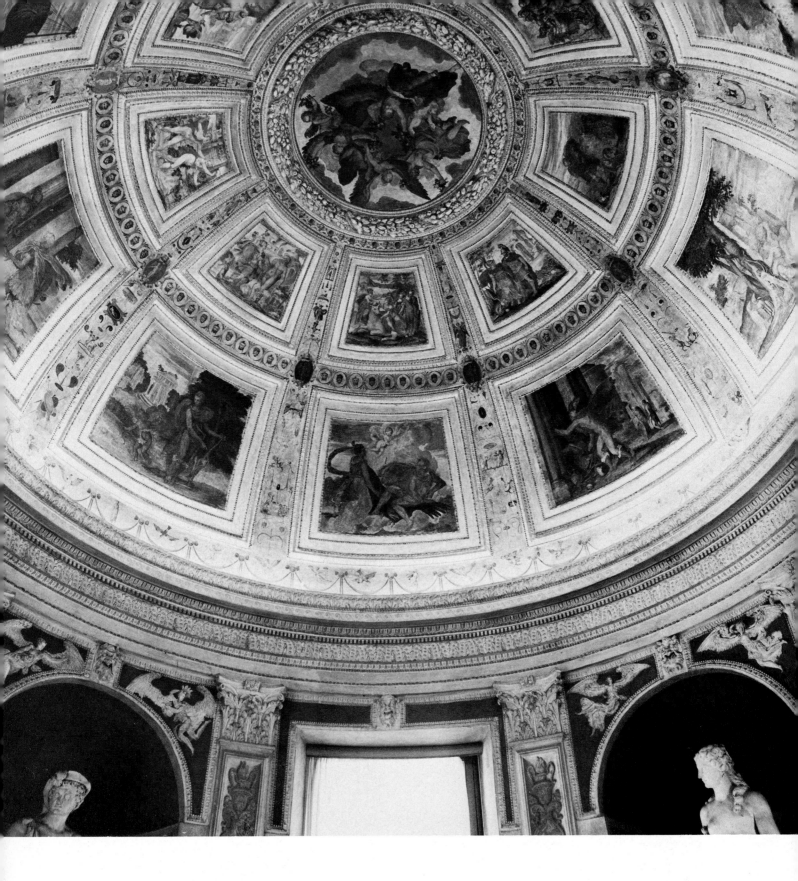

[*PALAZZO THIENE continued*]

Palazzo Thiene is the most lavishly decorated of the Vicentine palaces. The stunning ceiling in the Rotonda, or the Hall of the Metamorphoses (*above*), is the work of Bernardino India, an artist who decorated several of Palladio's buildings.

One of the grotesque fireplaces in the Palazzo Thiene by Bar-tolomeo Ridolfi (*opposite, left*). Such grotesques were more apt to be found in keystones and in garden statuary.

Another fireplace (*opposite, right*) images the one-eyed Polyphemus of Homer's *Odyssey*.

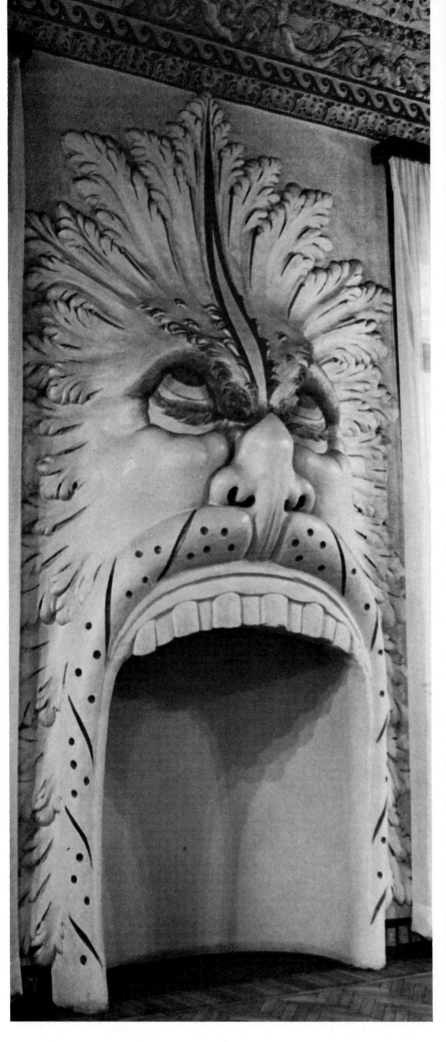

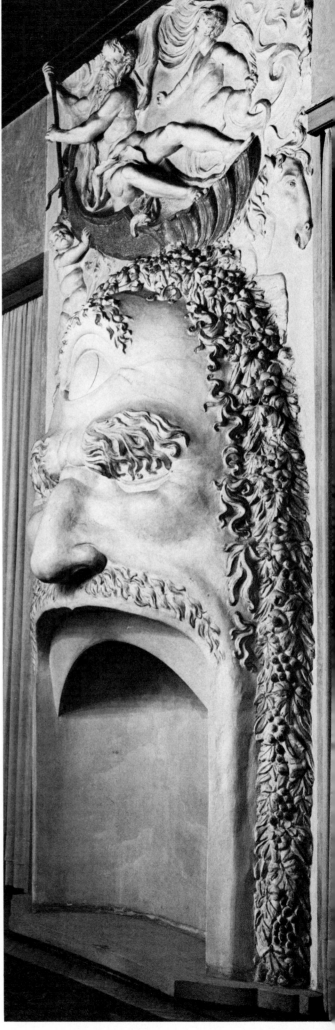

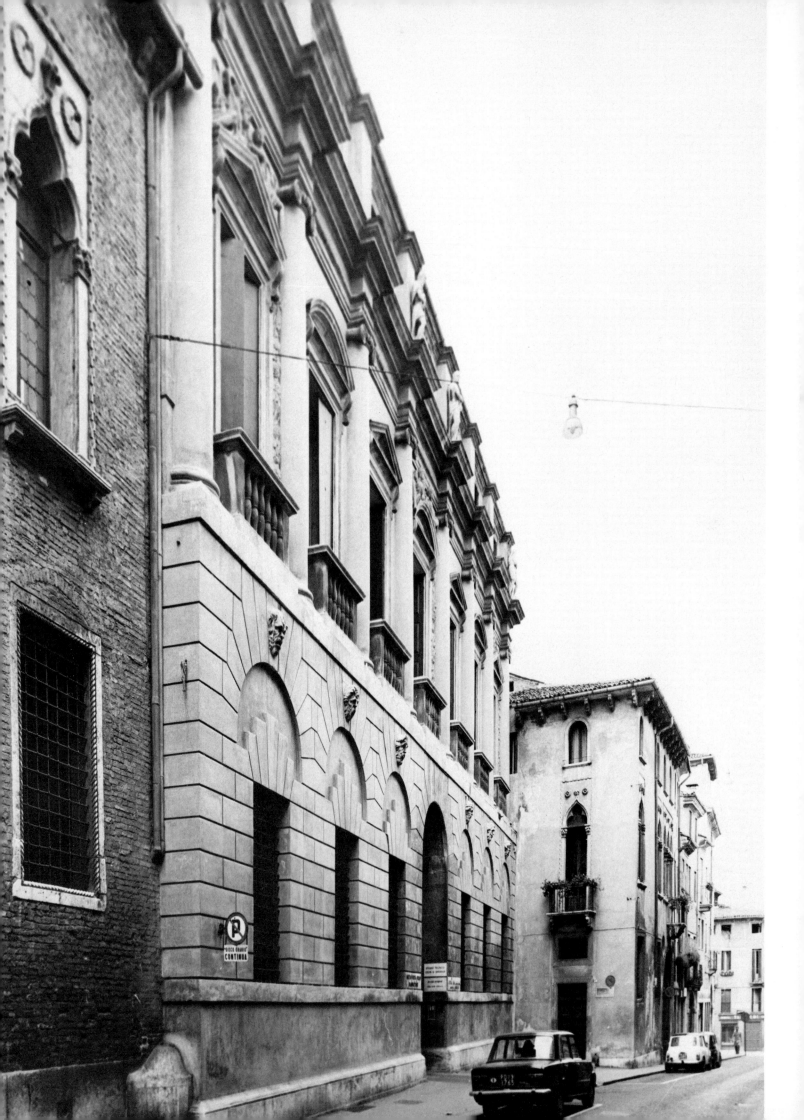

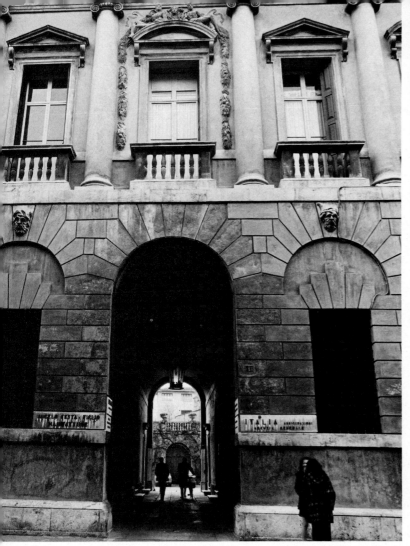

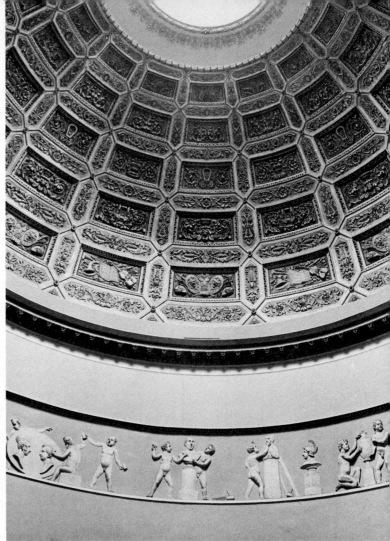

PALAZZO DA PORTO FESTA

Palazzo da Porto Festa (*opposite*; ca. 1549), is a variation on the theme of the Palazzo Thiene: a rusticated first story carrying an Ionic order of engaged columns. The boldness of the first story is confined to filling the upper part of the round-arched bays within a squared arch consisting of a stepped keystone and voussoirs. The keystones have admirable masks which are found on Vicentine and Venetian palaces, and at one time on many New York buildings. A part of an older palace is seen to the left. Low ceilings and Gothic detail make for much smaller scale compared to the Palladian facade, demonstrating what an enormous change was made by the revival of the classical tradition in the Renaissance.

Over the round pediment of the second-story window of the entrance bay (*above, left*) are paired figures from which hang festoons of fruit.

Part of the interior of the Palazzo da Porto Festa is dominated by a dome with small panels set in the coffering (*above, right*). Beneath it is a frieze in relief, a capriccio of cherub-artists. It probably dates from the early part of the nineteenth century and shows that Palladio left plenty of suitable domes, vaults, ceilings and walls for decoration by succeeding generations of artists.

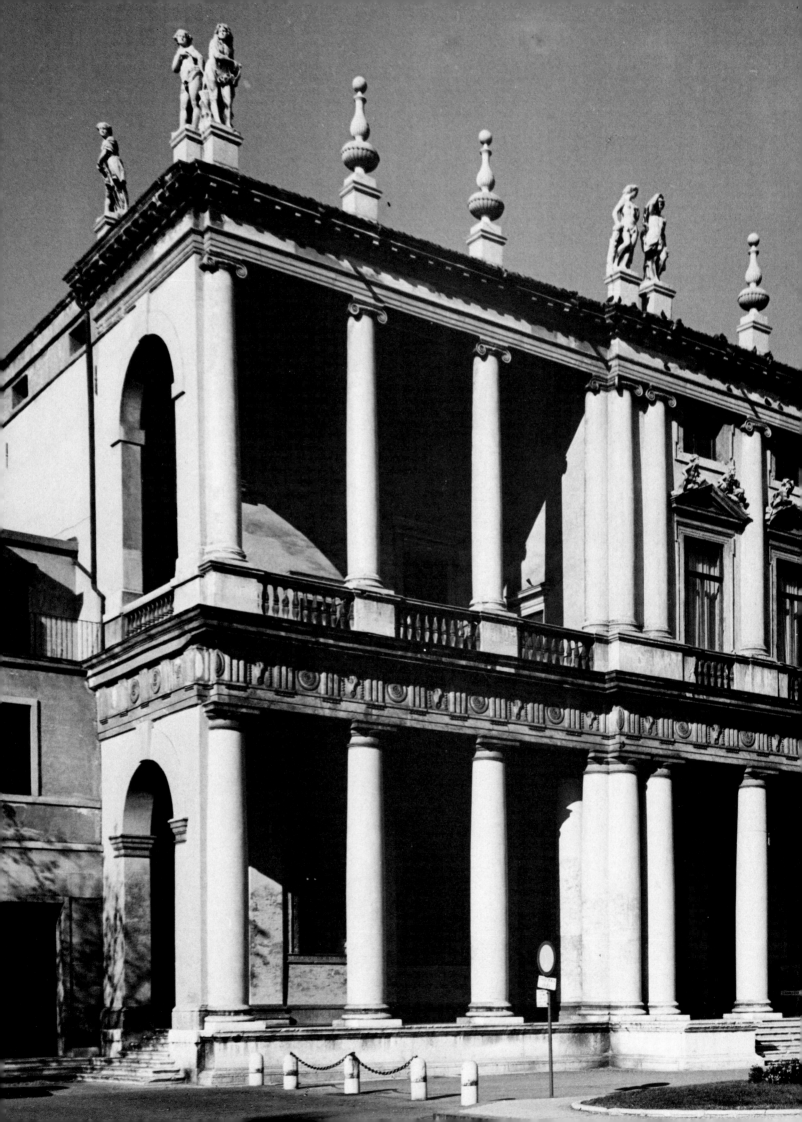

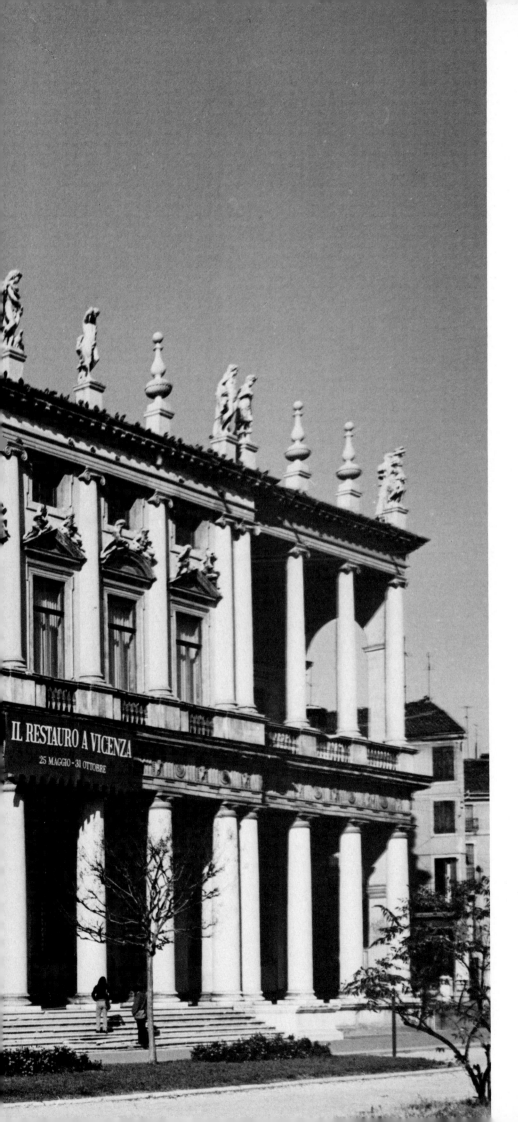

PALAZZO CHIERICATI

The most spectacular of Palladio's palaces is Vicenza's Palazzo Chiericati (1550), which even inspired a movie theater, the Howard, once standing in Atlanta, Georgia. An open colonnade is on the ground story and two porches are on the second, an unusual feature. In exchange for allowing the extension of the building over a piece of public land, the owner had had to provide a portico for the public. The building was completed a century after it was begun, at which time the statues and urns were placed on the attic. Although not in his design, they are certainly of the ancient Roman model which had such an influence on him, and they greatly add to the silhouette. (Book II, page 39.)

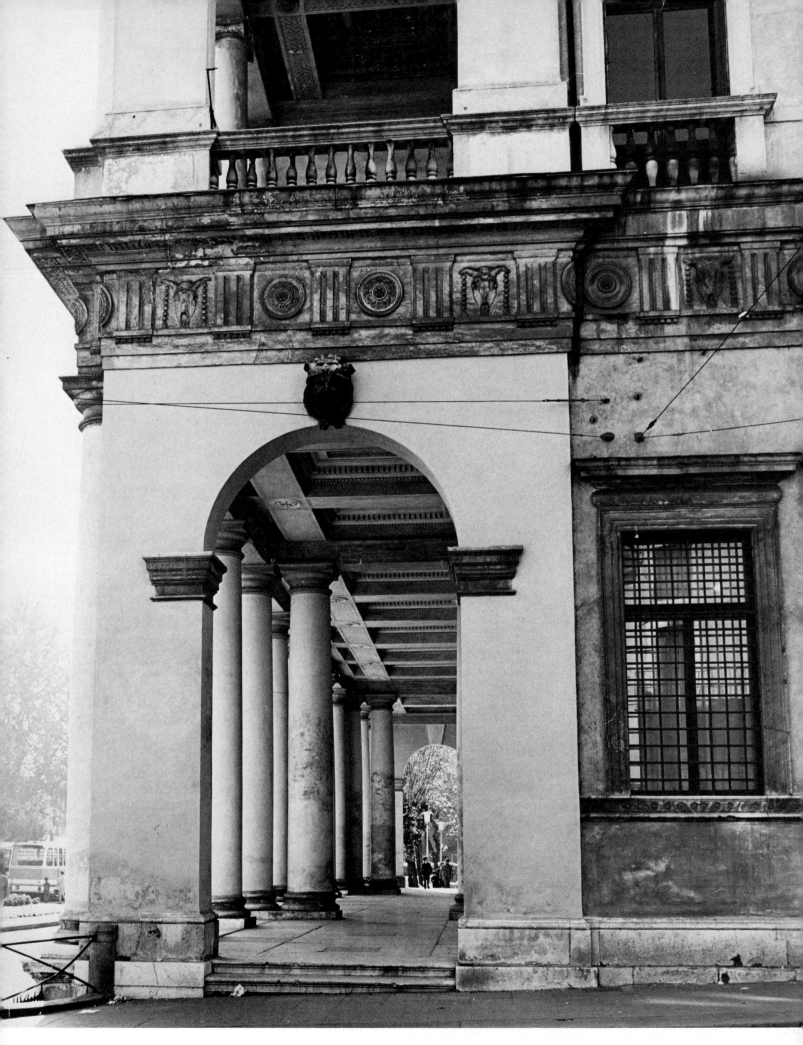

[*PALAZZO CHIERICATI continued*]

The imposts of the portico arch (*opposite*) appear pasted at the springing as if an afterthought. They do, however, make a difference in the design.

The deep coffering of the porch (*right, top*) found in many of Palladio's porches, is decorated with bead, dentil, bead-and-reel, and leaf-and-dart moldings with a central patera. All the paterae are of different design; in American buildings they are always the same.

The triglyphs of the Doric frieze of the portico (*right, bottom*) are separated by metopes which alternate garlanded bucranes and disks, as at the Basilica.

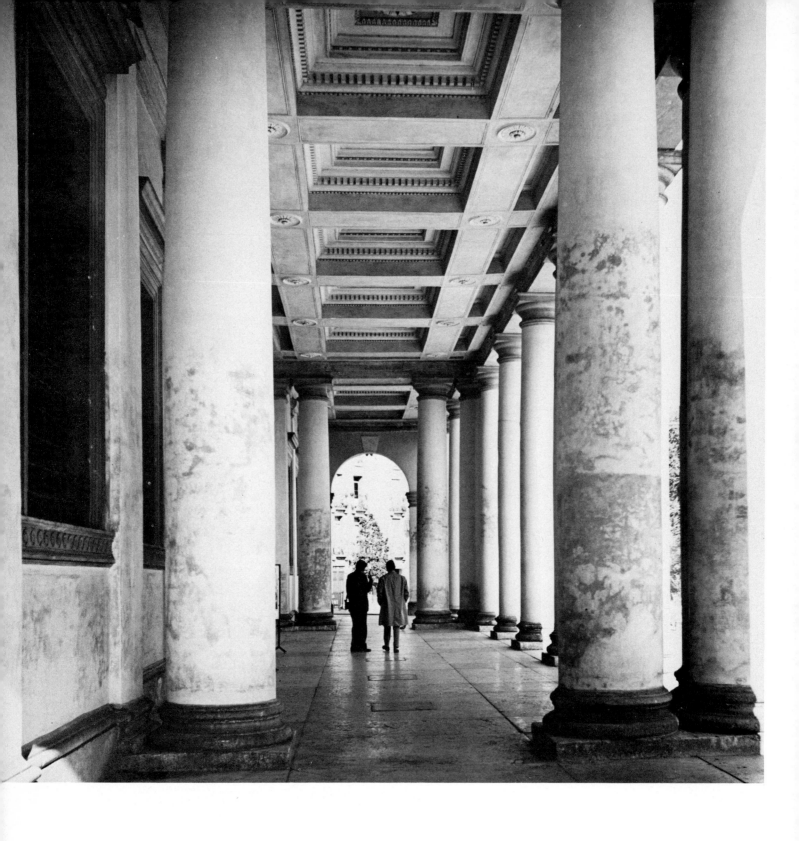

[*PALAZZO CHIERICATI continued*]

Quadrupling the columns at either end of the five central bays of the portico (*above*) was no doubt structurally necessary, but is also an admirable way of dividing a porch to achieve a visual break.

A view of the sculpture on the straight-sided pediment of a second-story window (*opposite*) includes a detail of the Roman Ionic capital. The admirable statues and urn, added above the cornice in the seventeenth century, are a bit enlarged because of the angle at which the photograph was taken.

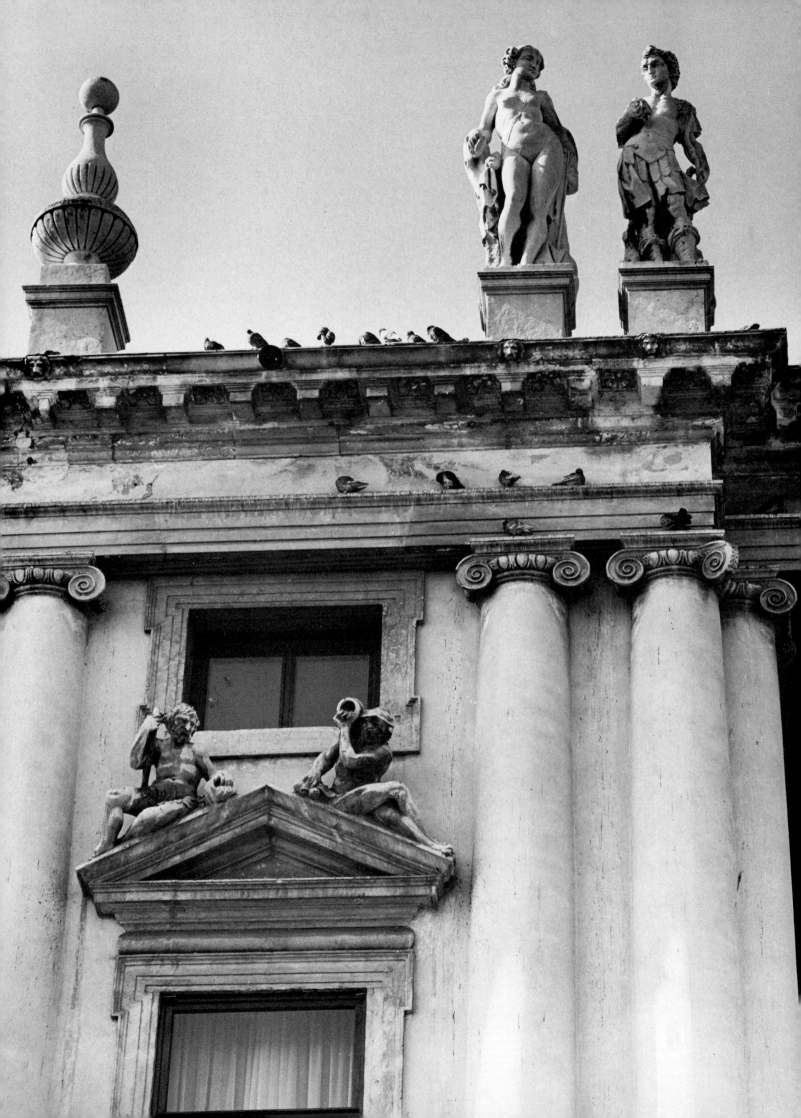

PALAZZO VALMARANA

With the Palazzo Valmarana (1565–66), Palladio adopted a Composite order of giant pilasters and put them on a high base (*opposite*), a combination found in the United States' classical skyscrapers, with the Corinthian substituted for the Composite. To furnish a contrast in scale, Palladio set smaller Composite pilasters against the larger ones and, at either end of the facade, substituted a smaller for the larger. As the smaller pilasters are confined to the first story, he had the space above filled with figures in relief. (Book II, page 41.)

A splendid example of a Composite capital (*left*) is almost the same as that found on the column illustrated in Plate XXVIII, Book I of *The Four Books*.

The frieze of the Ionic colonnade in the courtyard (*below, left*) has unusual blocks above the columns, topped by broken cornices.

An interior doorway (*below, right*) demonstrates one way of framing an opening.

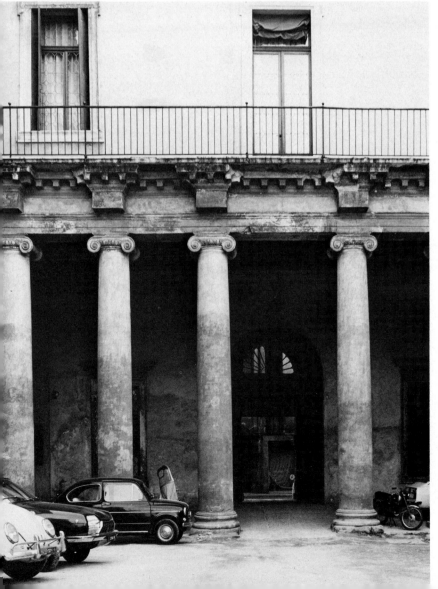

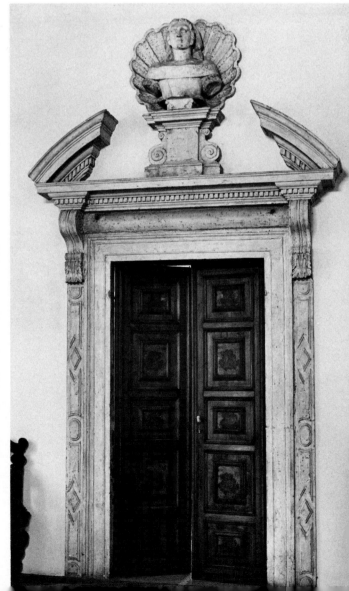

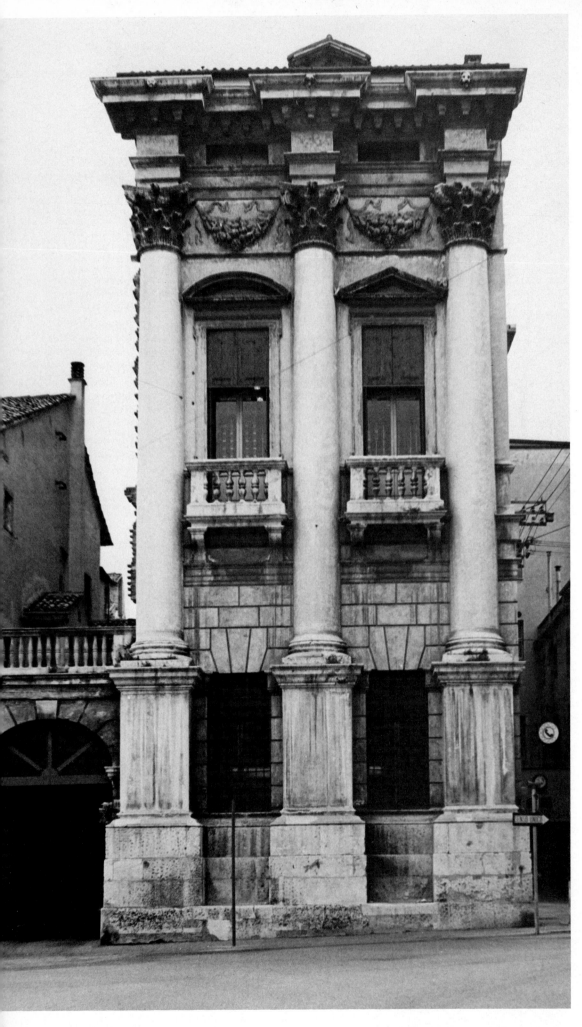

PALAZZO DA PORTO BREGANZE

The facade (*left*) of the incomplete Palazzo da Porta Breganze (after 1571) is in the high monumental vein, once again conveyed by a giant Composite order resting on high bases. A contrasting minor scale is provided by the balconies with balustrades, just as at the Loggia del Capitaniato. The fruit garlands and fluttering ribbons in relief between the capitals are a Roman device.

PALAZZO BARBARANO

Vicenza's Palazzo Barbarano (*opposite*; 1569–70), along with Palazzo Chiericati, is one of the rare palaces built with an open colonnade over the sidewalk. An Ionic order at the first story carries a high Composite order which rises two stories to the principal entablature.

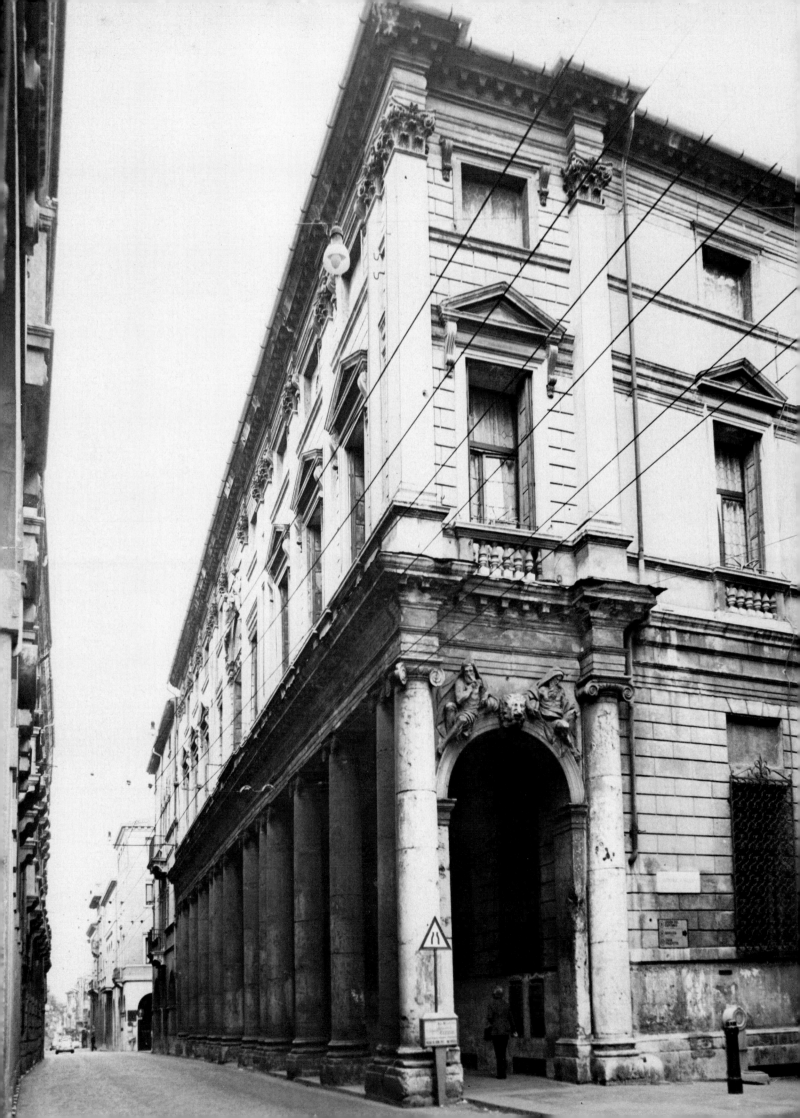

A Convent & Three Churches

The convent, called the Carità, is now part of the Accademia di Belle Arti, whose picture galleries are known to every visitor to Venice. Commissioned by the canons of the Church of St. John Lateran in Rome, the convent, erected in 1560–61, was Palladio's first building in Venice. From the description and plate in *The Four Books* (Book II, page 43) it will be seen that only a small part, one side of the cloister, is left today—a triple arcade with three orders, Doric, Ionic and Corinthian, superimposed. Nothing could be simpler and yet nothing is more successful. Palladio has triumphed by obeying the academic rules, his skill being to fix the proportions.

Palladio's second Venetian building was the Church of San Giorgio Maggiore, which stands on the Isola San Giorgio, the island on the Bacino di San Marco, opposite the Doge's Palace. Begun in 1565, it was not finished until 1610. The plan is that of the Latin cross, Palladio consciously adopting the symbol. As for the front, it is best to cite Palladio's own explanation for the design:

> Temples ought to have ample portico's, and with larger columns than other fabricks require; and it is proper that they should be great and magnificent (but yet not greater than the bigness of the city requires) and built with large and beautiful proportions. Whereas, for divine worship, in which all magnificence and grandeur is required, they ought to be made with the most beautiful orders of columns, and to each order ought to be given its proper and suitable ornaments. [Book IV, page 82.]

For San Giorgio Maggiore, Palladio designed a facade with two templed fronts, one with high columns and pediment imposed on a second with low pilasters and split pediment. His use of pediments was to be imitated especially in churches in the Veneto.

Inside the church, high and low Corinthian engaged columns and pilasters are set against each other to achieve scale. Such devices as broken entablatures, barrel vaults with side groining, pendentives, a drum and a cupola join in visual harmony.

What is most astonishing—as can be seen from the photographs—is the absence of abundant decoration, be it the mural decorations, pictures or polychromed ornaments typical of Italian churches. Instead, decoration is confined to architecture with the colors limited to gray and white. Here again the best explanation comes from the architect:

> Of all the colours, none is more proper for churches than white; since the purity of colour, as of life, is particularly grateful to God. But if they are painted, those pictures will not be proper, which by their signification alienate the mind from the contemplation of divine things, because we ought not in temples to depart from gravity, or those things, that being looked on render our minds more enflamed for divine service, and for good works. [Book IV, page 82.]

In 1562 Palladio did the facade only of San Francisco della Vigna, a commission he obtained through Daniele Barbaro, Procuratore di San Marco. It has the same "templed" front as the Church of San Giorgio Maggiore.

A third church is Il Redentore, the Church of the Redeemer, built from 1576 to 1592. Set on the water, like San Giorgio, it has a splendid site. Once again pediments and columns are joined to form an imposing front. The interior is the same as that of San Giorgio even to having a choir behind the presbytery or a retrochoir. It is equally severe in the absence of abundant decoration and polychromy.

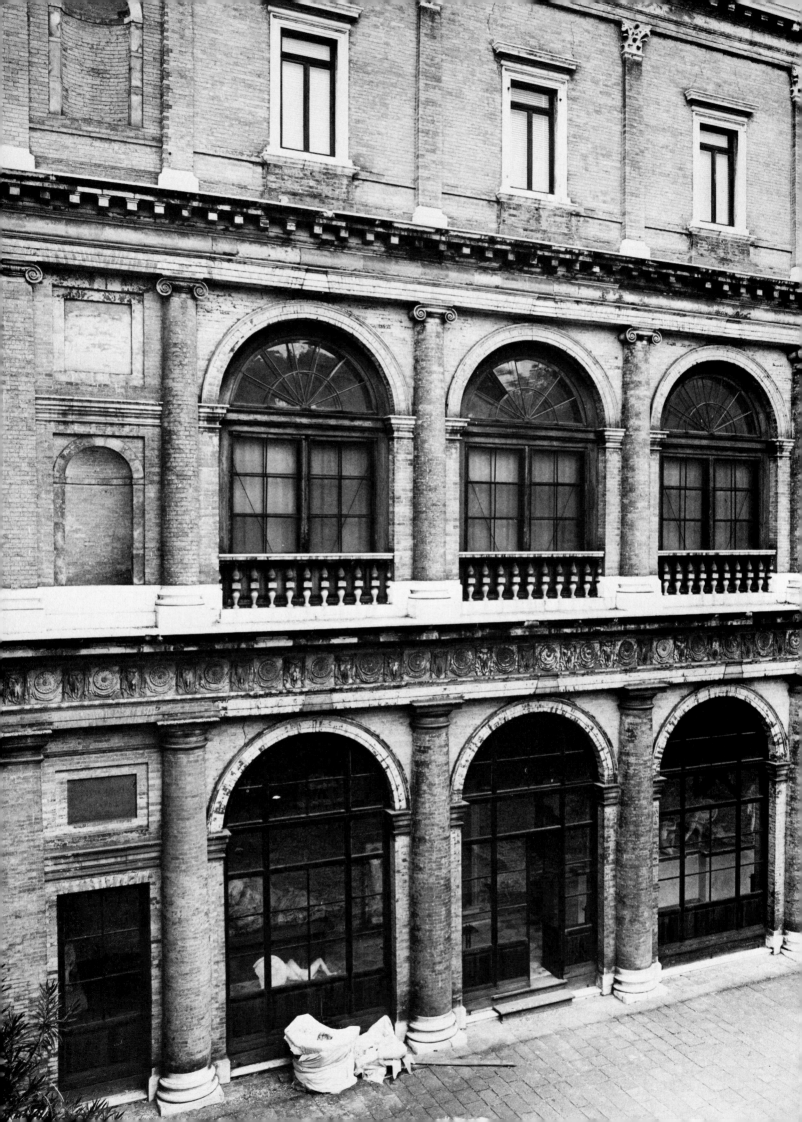

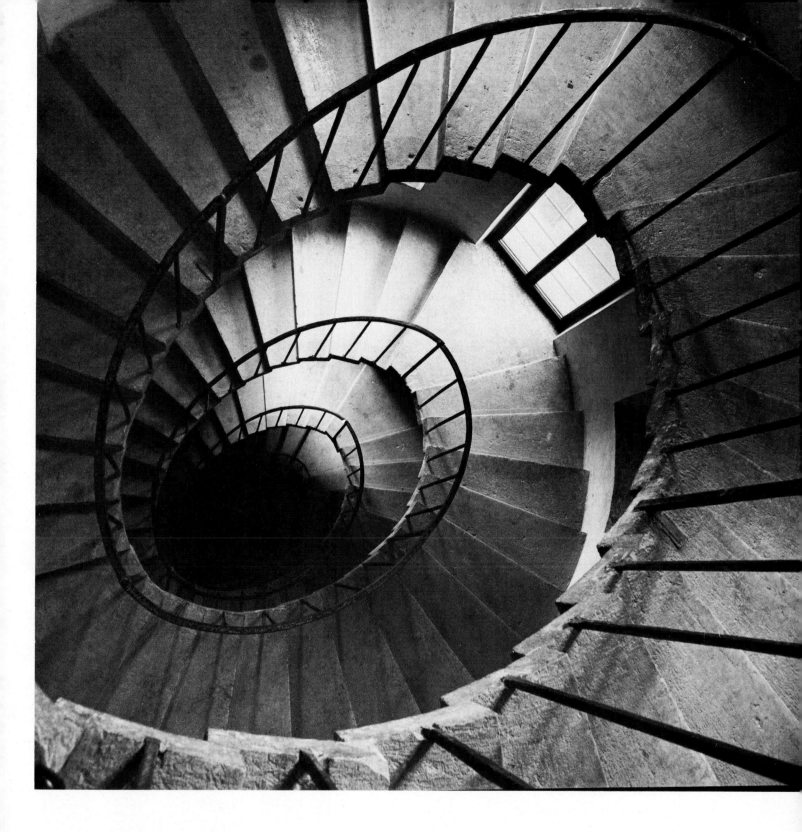

SANTA MARIA DELLA CARITÀ

The only surviving wing (*opposite*) of Venice's Convent of Santa Maria della Carità (1560–61), popularly known simply as the Carità, is constructed of rose red brick, a color contrasting with the white stone (the Istrian marble found everywhere in Venice) which is used in the capitals and bases of the engaged columns and in the balustrades. As a conservative architect, Palladio followed the formula of sumperimposing the three orders—Ionic on Doric and Corinthian on Ionic. What creates the effect, of course, is the distribution of such elements as columns, pilasters, arches and balustrades. An interesting comparison can be made with the dimensions of the Basilica facade and those of the Carità. The Doric column is nineteen feet seven inches high, its diameter two feet five inches, the arch height eighteen feet four inches, the width of the opening ten feet five inches, and the imposts inside the piers which sustain the arch thirteen feet one inch above ground. Most important visually is the relation of the supporting pilasters to the columns. The balustrade on the second floor is only three feet six inches tall, in contrast to an Ionic column's seventeen feet seven inches. (Book II, page 43.)

The oval staircase of the Carità (*above*) took Goethe's fancy on his Italian journey in 1786, as did the convent wing. "The most beautiful staircase in the world," wrote the German poet. "This has a broad open newel and the stone steps are built into the wall and so tiered that each supports the one above it." It is over fifty feet high.

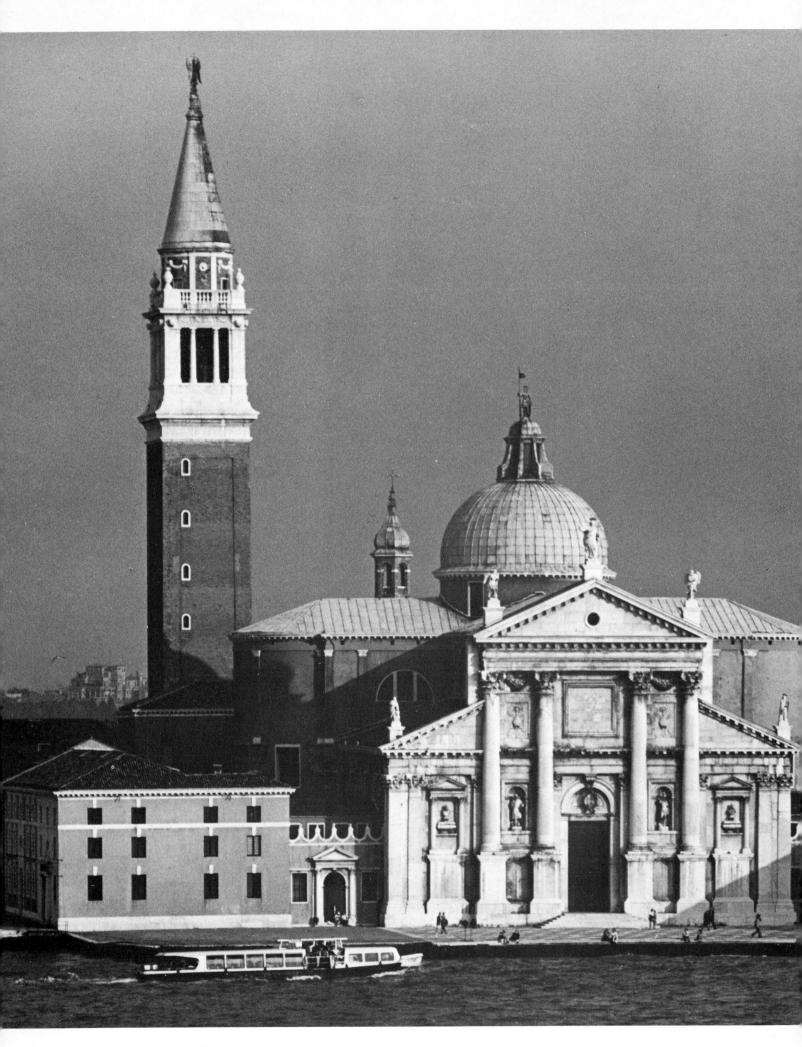

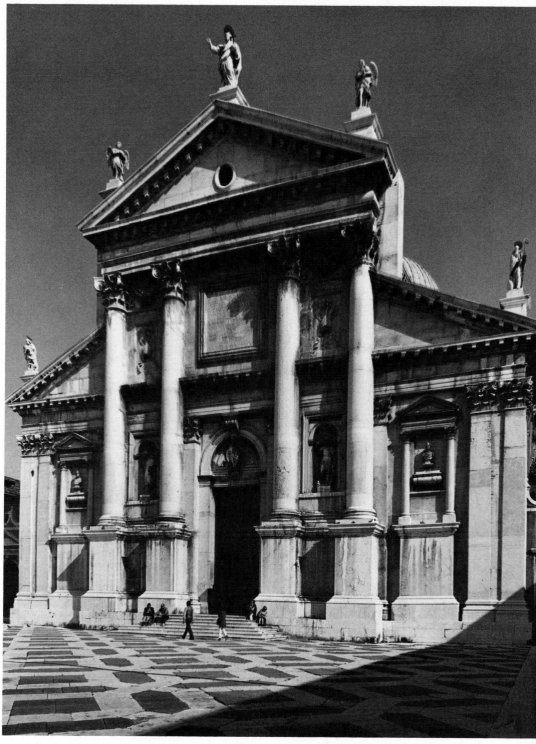

SAN GIORGIO MAGGIORE

The Church of San Giorgio Maggiore (*opposite*) is here seen from the Doge's Palace across the Bacino di San Marco. The church, built in 1565–1610, is part of what was once a Benedictine monastery which is now divided up among several institutions. The best known is the Giorgio Cini Foundation, established by Count Vittorio Cini, a colleague of Count Volpi who restored the Villa Barbaro. Starting in 1951 the Cini Foundation restored the church and monastery. An interesting footnote to the monastery's importance is that Veronese's great painting, *The Marriage at Cana*, now in the Louvre, was painted for the monks who once lived here.

The Istrian marble of the facade of San Giorgio (*above*) has weathered to a pure white, making it conspicuous. Paired Corinthian pilasters frame the front and support a divided entablature and pediment. Set against the center of the frame are four engaged Composite columns, an entablature and a pediment. The design contrasts the high round columns on high bases with the small flat pilasters on low bases. The paving of the piazza extending between church and water is also decorative.

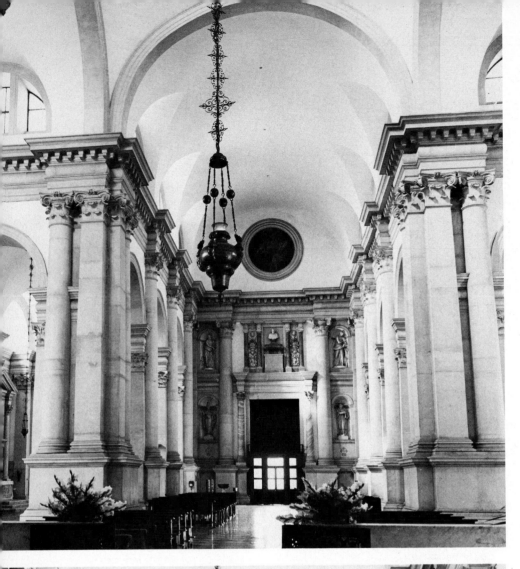

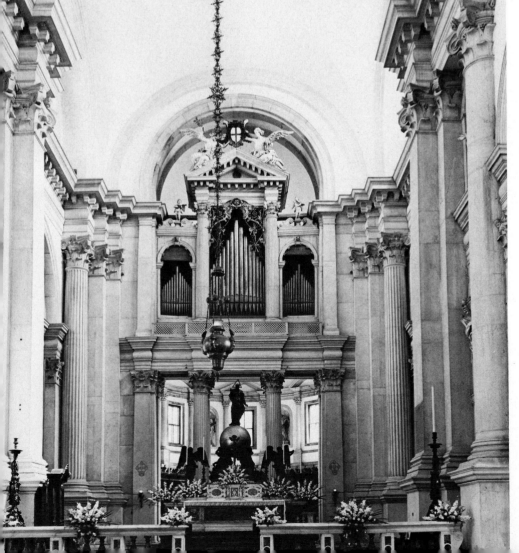

[SAN GIORGIO MAGGIORE continued]

In the nave, seen here looking toward the entrance (*left, top*), the Composite order was adopted for the high pilasters and engaged columns at the piers. They support an entablature with a pulvinated frieze, a common Palladian device.

A close-up of the sanctuary (*left, bottom*) shows the organ over the high altar. Palladio adopted fluting in a pair of his columns, probably the only example of it in one of his buildings. He worked his way around corners behind the columns by using pilasters in repetition.

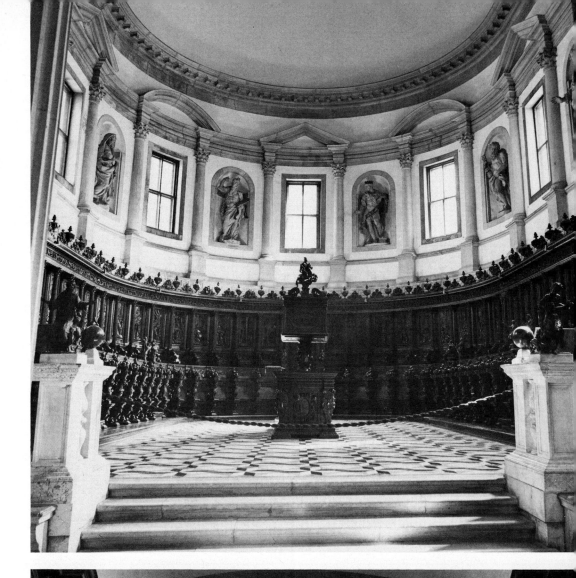

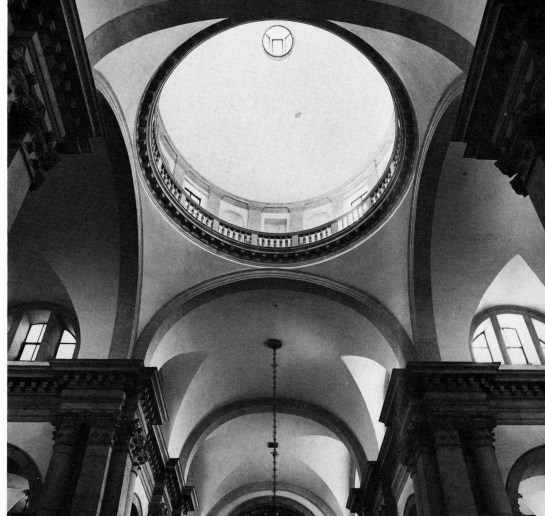

The monks' stalls line the retrochoir behind the high altar (*right, top*). Windows with round and straight pediments are divided by niches filled with the statues of saints. A common cornice links the window pediments and the niche bays.

The opening and dome over the crossing (*right, bottom*), with the pendentives and adjoining barrel vaults, make a spectacular abstract composition. The dome opening is approximately forty feet wide.

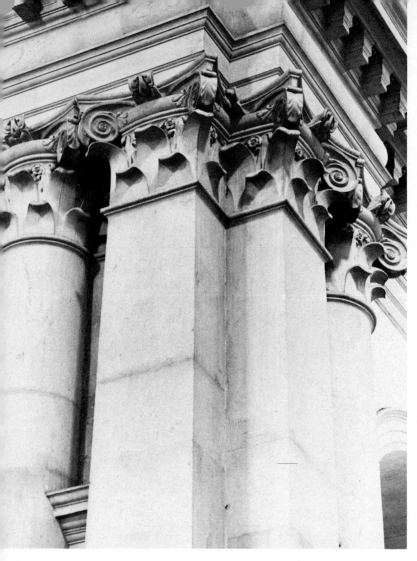

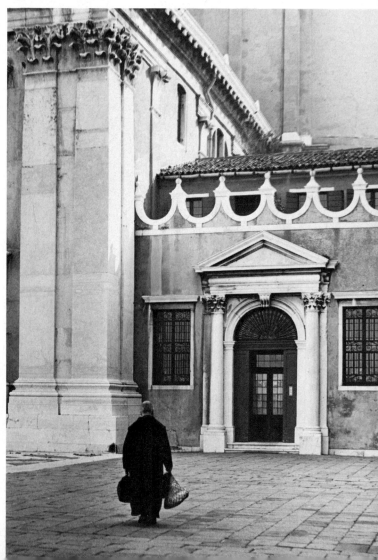

[*SAN GIORGIO MAGGIORE continued*]

The Composite capitals and entablature of the transept (*above, left*) are contrasted with the engaged Corinthian columns and pilasters found inside the bay arches (*above, right*). They form another counterpoint to magnify the scale of the high shafts of the Composite columns.

A priest approaches the parish house next to the church (*right*). The top of the parapet wall of the parish house resembles that of the wall in front of Villa Badoer.

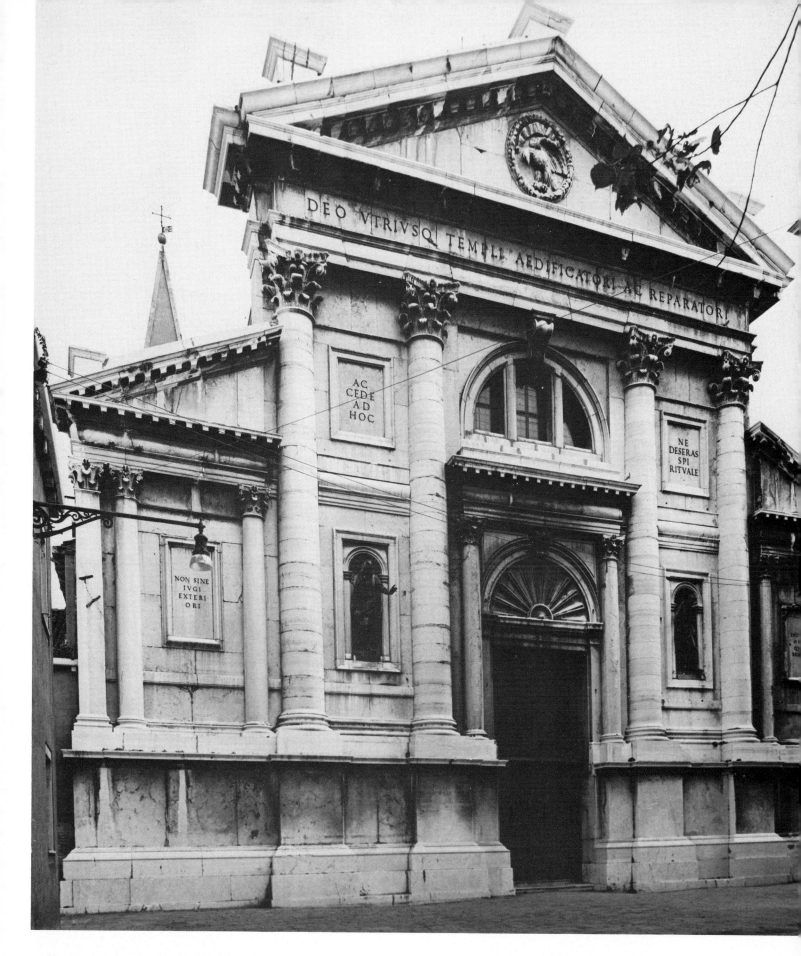

SAN FRANCESCO DELLA VIGNA

The facade of the Church of San Francesco della Vigna (1562) in Venice was Palladio's only contribution to the structure. Palladio follows his treatment of the villas by placing the facade on a high base. The monumentality of the tall Corinthian columns is under-scored by contrast with the smaller ones. The high doorway cut into the base also gives a grand scale. Inside, Marcantonio Barbaro is buried in the family chapel.

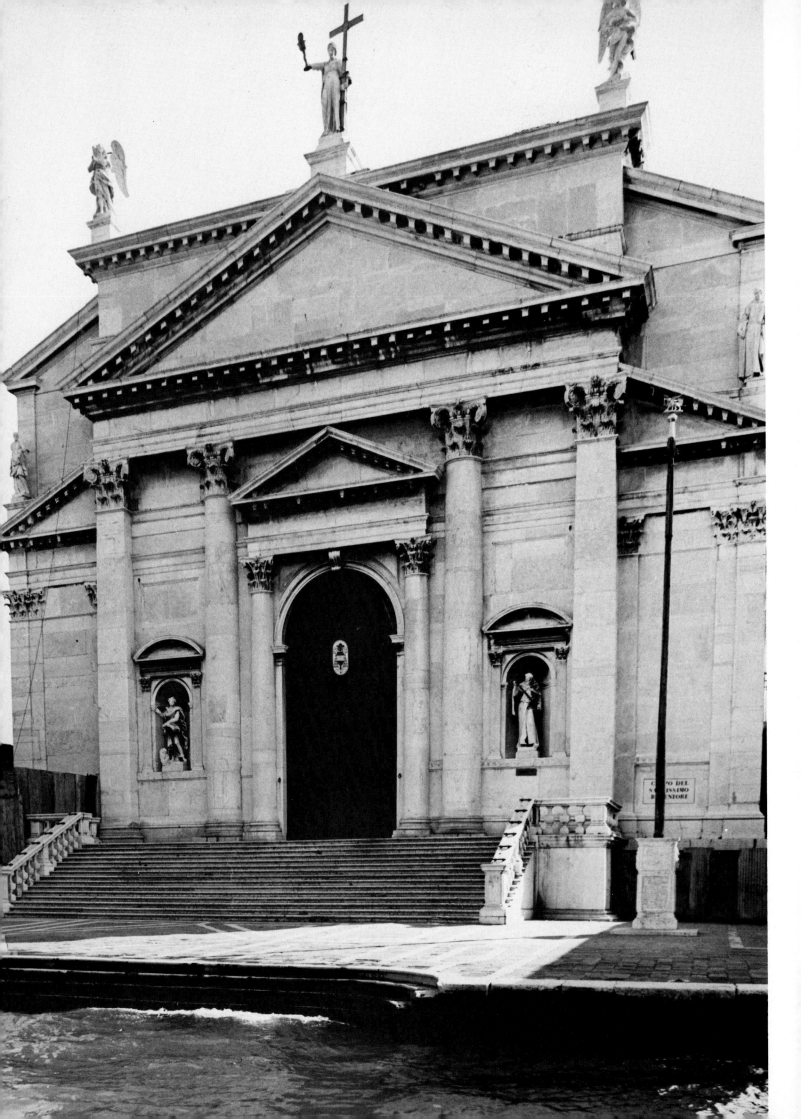

IL REDENTORE

Il Redentore (*opposite*; 1576–92) on the Giudecca in Venice. Palladio again juxtaposes the Composite and the Corinthian. The main pediment is less prominent than that of San Giorgio because it is backed by the attic. The monumental effect is achieved by a high platform for the whole building and a wide, high flight of steps. The platform is eight feet two inches high, the column forty-seven feet six inches, the door twenty-nine feet five inches, the main pediment fifteen feet six inches and the central statue with base sixteen feet four inches.

A detail of the facade (*right*) reveals how the Composite and Corinthian capitals are contrasted. Great attention is given to the moldings which are about forty-five feet above ground level.

Il Redentore is a favorite church for married couples renewing their vows on anniversaries (*below*).

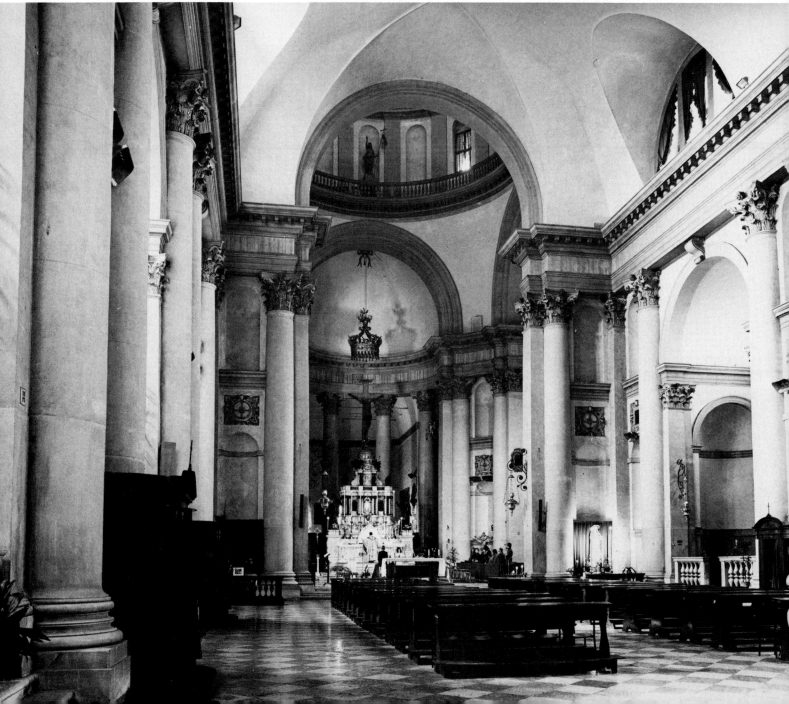

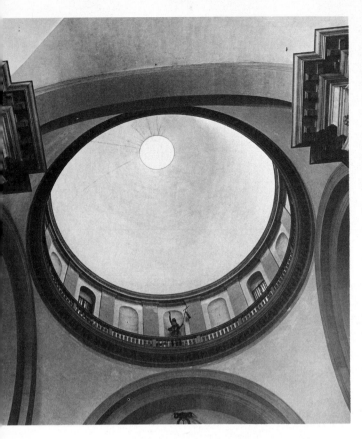

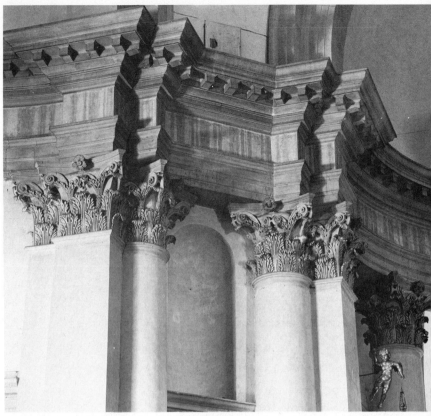

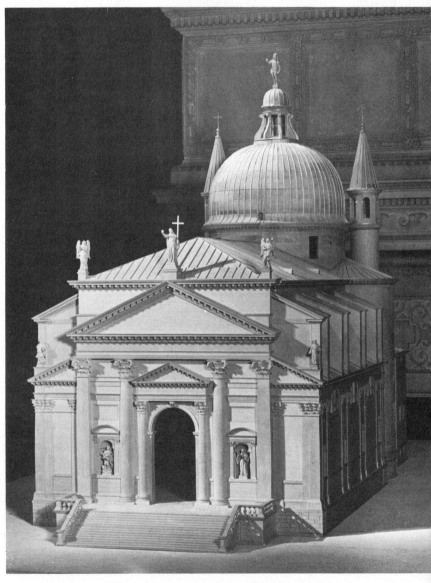

[*IL REDENTORE continued*]

The dome and pendentives above the sanctuary (*above, left*). The dome of Il Redentore is fifty feet in diameter; San Giorgio's is forty.

A detail of the Corinthian capitals and entablature below the dome (*above, right*). The freestanding column is part of the exedra separating the sanctuary from the retrochoir. The combined use of pilaster and engaged columns was one of Palladio's devices for getting around corners.

The model of Il Redentore (*right*) belonging to the Centro Andrea Palladio shows how the dome rises above the sanctuary at the end of the church. The length from the entrance to the rear wall of the retrochoir is two hundred and twenty-seven feet—twenty-seven feet more than the distance between the north and south sides of a standard block in the Manhattan grid.

Teatro Olimpico

From the beginning of the Renaissance in the fifteenth century architects have attempted to reconstruct ancient classical buildings. (Today, regrettably, the pursuit has been taken over by the archeologist.) With some it has even been an overwhelming passion, occupying a lifetime. Palladio was no different from others in this interest. Book IV of *The Four Books* is devoted to reconstruction. That he was not always accurate in the light of what we know today makes no difference; it was a useful exercise in design.

Palladio had supplied the illustrations to Daniele Barbaro's translation of Vitruvius. Many of them consisted of inventions, as he had nothing to go by but the text. Then the opportunity presented itself to execute a reconstruction. In 1555 the Accademia Olimpica had been founded in Vicenza in imitation of the first academies organized in ancient Athens. Palladio, along with a number of his clients, was a founding member. Among its undertakings were theatrical productions; for the first one Palladio built a temporary theater inside the Basilica. In 1580 he was asked to build a permanent theater based largely on an illustration he made for Barbaro's edition of Vitruvius.

Palladio lived to see only part of it rise because he died in 1580. Vincenzo Scamozzi completed it five years later. The theater opened with a production of Sophocles' *Oedipus Rex*.

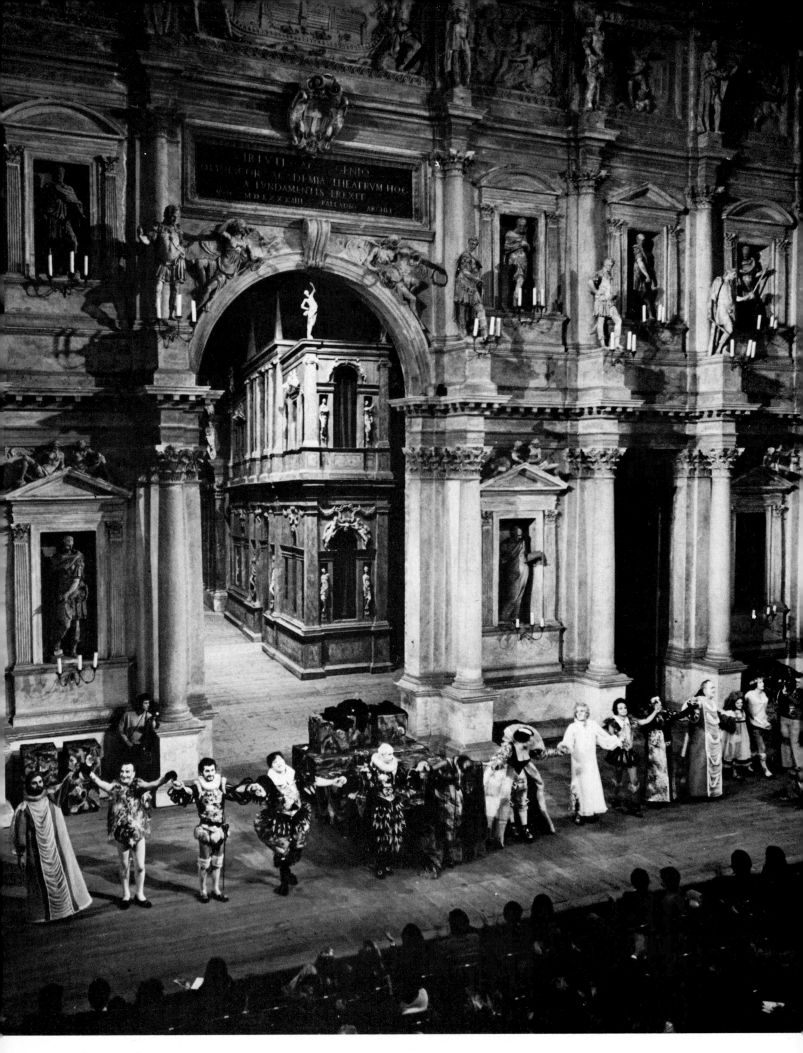

78　Teatro Olimpico

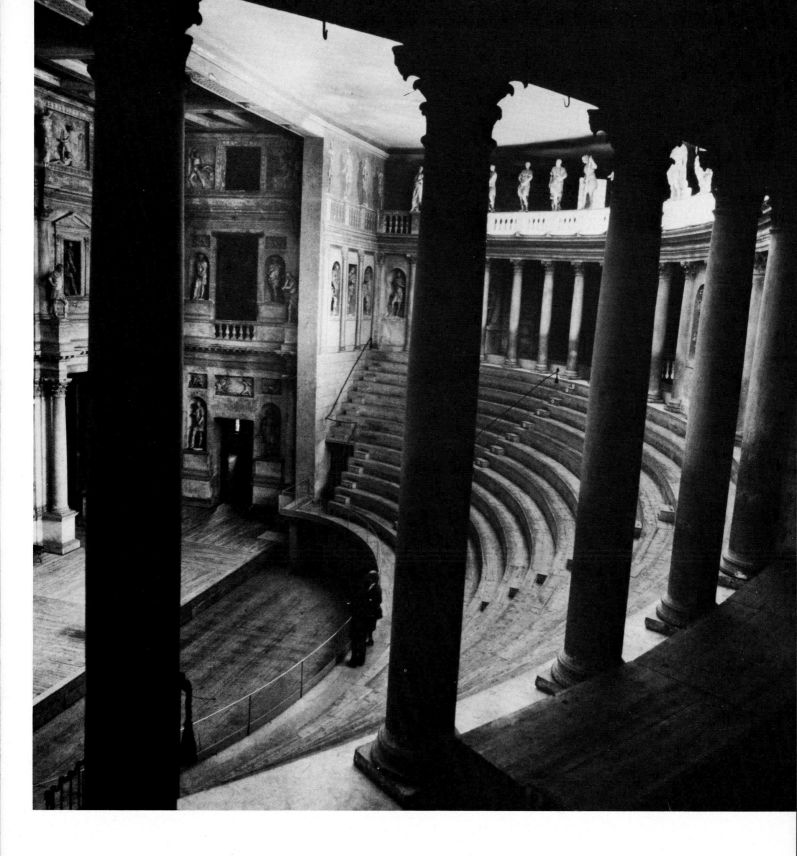

TEATRO OLIMPICO

Palladio and many of his contemporaries were fascinated by ancient theaters and amphitheaters. Palladio knew those of Verona and Pola first hand. His Teatro Olimpico, or Olympic (Olympian) Theater (1580), is nothing more than a brick box on the exterior. A surprise awaits the visitor on entering, even if he has seen a picture of the interior, for standing on the stage is a permanent set of wood and plaster, covered with architectural detail and statues. The perspectives seen through the doors of the set are credited to Scamozzi. They consist of foreshortened streets, depicting a city at dawn or dusk. It remains an active theater. In the view opposite the cast of a production of Ben Jonson's *Volpone* bows to the applause.

The wood-covered benches of the auditorium (*above*) are monastic, but the rest of the interior has befitting ornament in the shape of a Corinthian colonnade and a balustrade. The abundance of statues, both above the colonnade and on the permanent set, shows what sculpture can do in a very modest building. We are reminded of the role of sculpture in the architectural ornamentation in the American movie palaces of the 1920s and 1930s.

Palladio's Influence in England & Scotland

The Four Books of Architecture carried Palladio's name well beyond the Veneto. Along with the books of Alberti, Serlio, Vignola and others, the work made a deep impression on Europe. In England, however, Palladio's name would be virtually unknown had his influence depended on the book. What turned the tide in his favor was the admiration of two men—Inigo Jones (1573–1652) and Richard Boyle, Third Earl of Burlington and Fourth Earl of Cork (1695–1753).

Jones, a Londoner, became a successful set and costume designer when masques were the fashion at court. So elaborate were these presentations that Ben Jonson complained that the playwright had been overwhelmed by the designer of "spectacles." Jones was in Italy, we know, some time before 1603. A second visit followed in 1613 in the retinue of Lord Arundel when he went as far south as Naples. It was on this journey that he annotated his copy of *The Four Books*. Not long after his return, Jones was named Surveyor of the King's Works, a powerful position which he held until 1642.

He transformed English architecture, until then largely Gothic, by raising it to the high classical style of the Renaissance. Palladio offered his inspiration. Few of Jones's buildings survive, the most important being the Queen's House at Greenwich and the Banqueting House in Whitehall in London.

Lord Burlington, who inherited his titles at the age of nine, had a passion for architecture. A brief trip to Italy in 1714 was followed by a second in 1719 largely devoted to seeing the works in and around Vicenza. It was said that "Lord Burlington was so much for Palladio that he used to run down Michael Angelo . . ." Burlington House, on Piccadilly, now the seat of the Royal Academy, was rebuilt by him, his architect being Colin Campbell, who later designed Mereworth. After Campbell, Lord Burlington aided and worked with William Kent. He paid for Kent's *Designs of Inigo Jones* and he published Palladio's studies of Roman baths.

With the changes often dictated by fashion, Palladianism went into a decline in England after 1750. One reason was its rejection by Robert and James Adam. But Robert Adam was not above accepting the Palladian influence when it suited him, as we can see by looking at the picture of the Pulteney Bridge in Bath.

By 1800 Palladianism had so filtered into English architecture that something of the great architect's influence was pervasive in many buildings constructed in the classical tradition. By that time Palladianism had been exported beyond England, to have its strongest devotees in the United States.

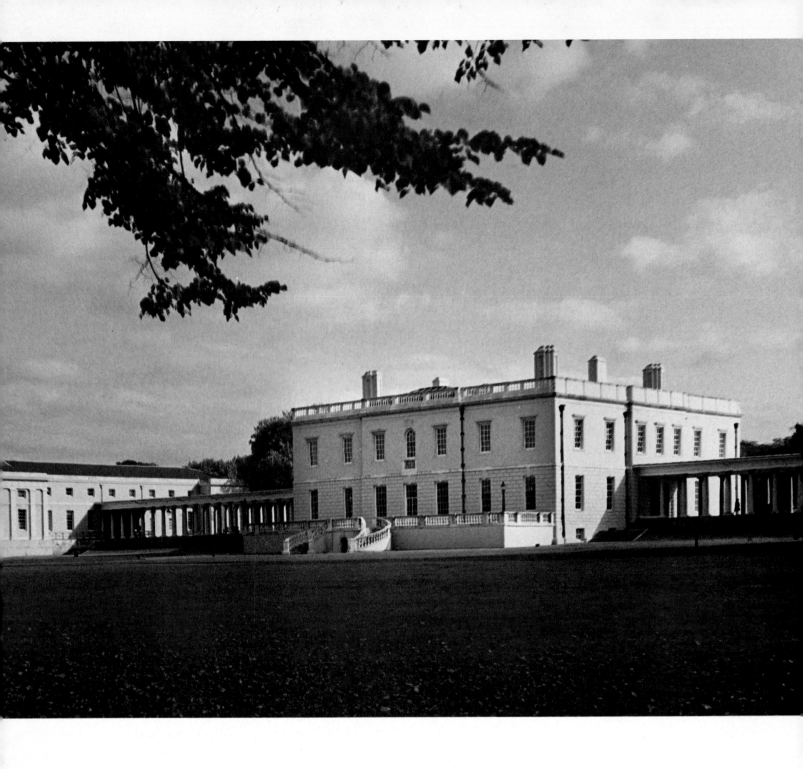

THE QUEEN'S HOUSE

In Greenwich near central London, the Queen's House (*above*) was built in 1618–35. Inigo Jones disposed the main block between two colonnaded porches which joined it to wings, in imitation of Palladio. The rusticated first story is also Palladian.

The spiral staircase (*opposite*) is derived from Palladio's at the Carità in Venice.

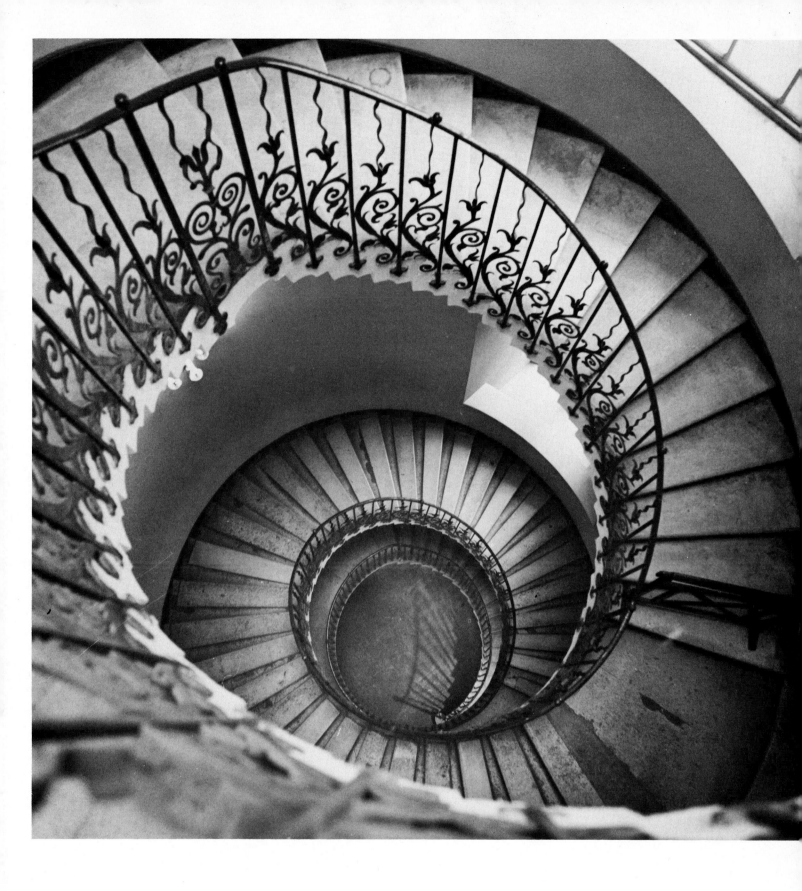

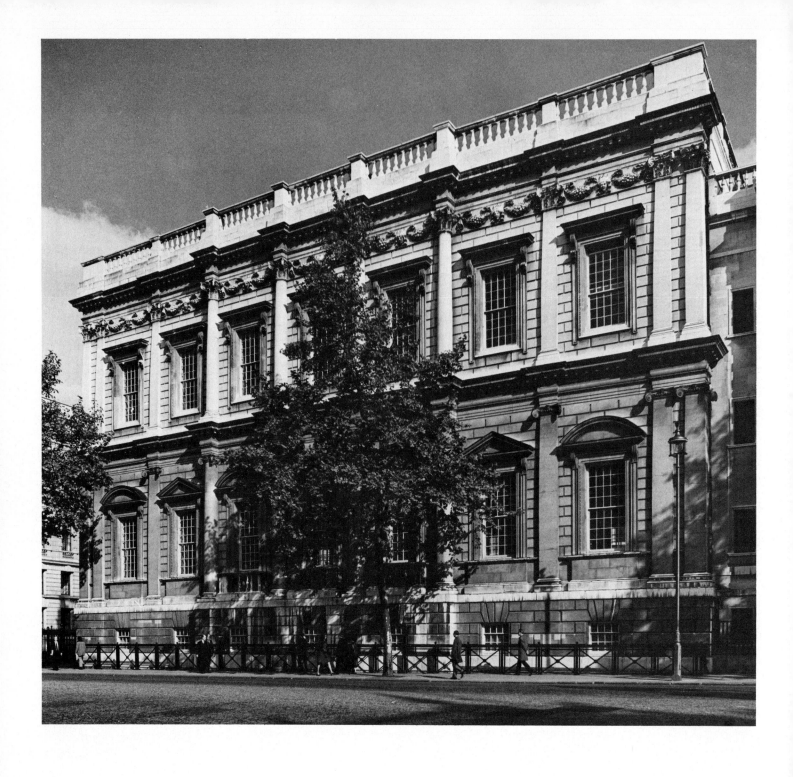

THE BANQUETING HOUSE

Inigo Jones had so absorbed Palladio's vocabulary that he produced the Banqueting House (*above*) in Whitehall, London. The edifice introduced the high classical to England.

A detail shows how a second-story bay (*opposite*) is framed by a Composite order, linked at the top by fruit swags, a mask and folded cloth. On the rusticated wall is a window with bracketed cornice. The Ionic order below supports Palladio's favored pulvinated frieze.

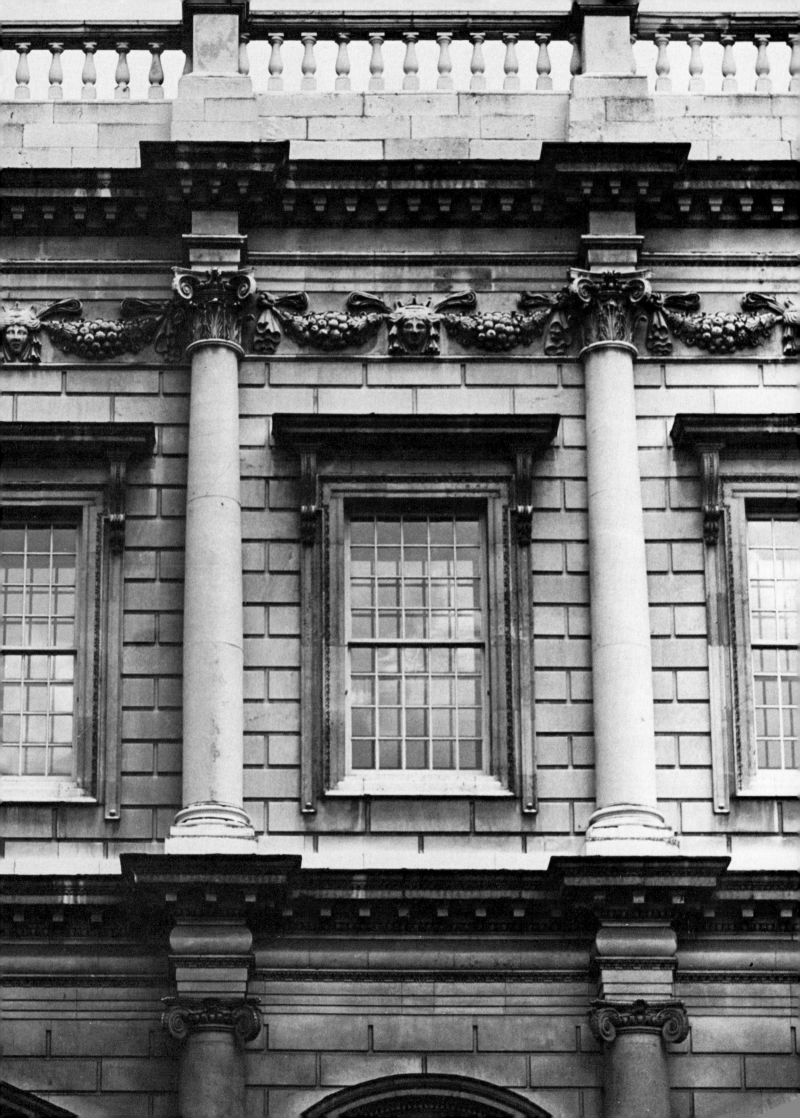

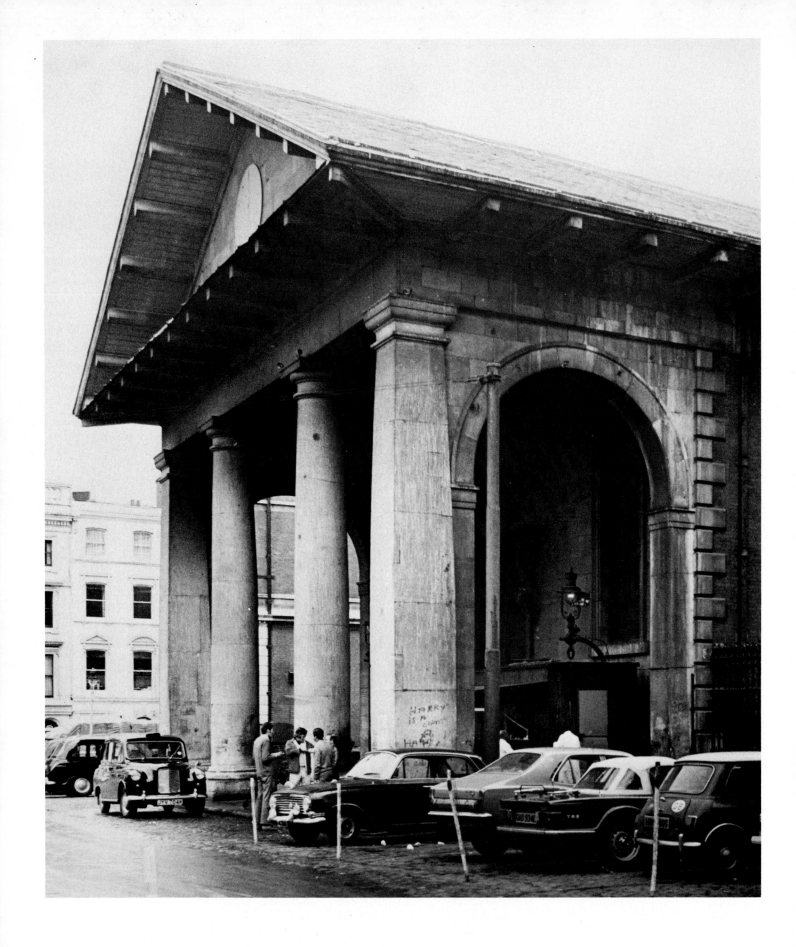

ST. PAUL'S CHURCH

Inigo Jones's St. Paul's Church in Covent Garden, London (1633) was the first building in England with a classical portico. Jones simply took the porch which Palladio created for his villas and placed it on a church. To the comment that the church was a barn, Jones answered that it was "the handsomest barn in Europe."

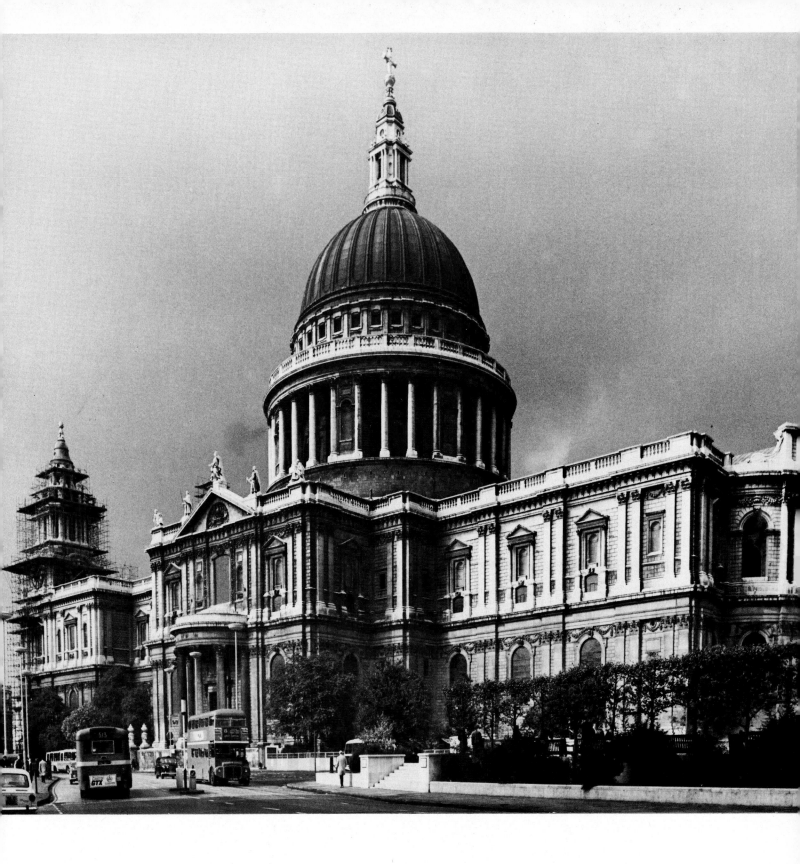

ST. PAUL'S CATHEDRAL

St. Paul's Cathedral (1675–1709) is the masterpiece of Sir Christopher Wren. The high base and the use of pilasters in pairs with a frieze linking the capitals are traceable to the Palladian influence of Inigo Jones's Banqueting House.

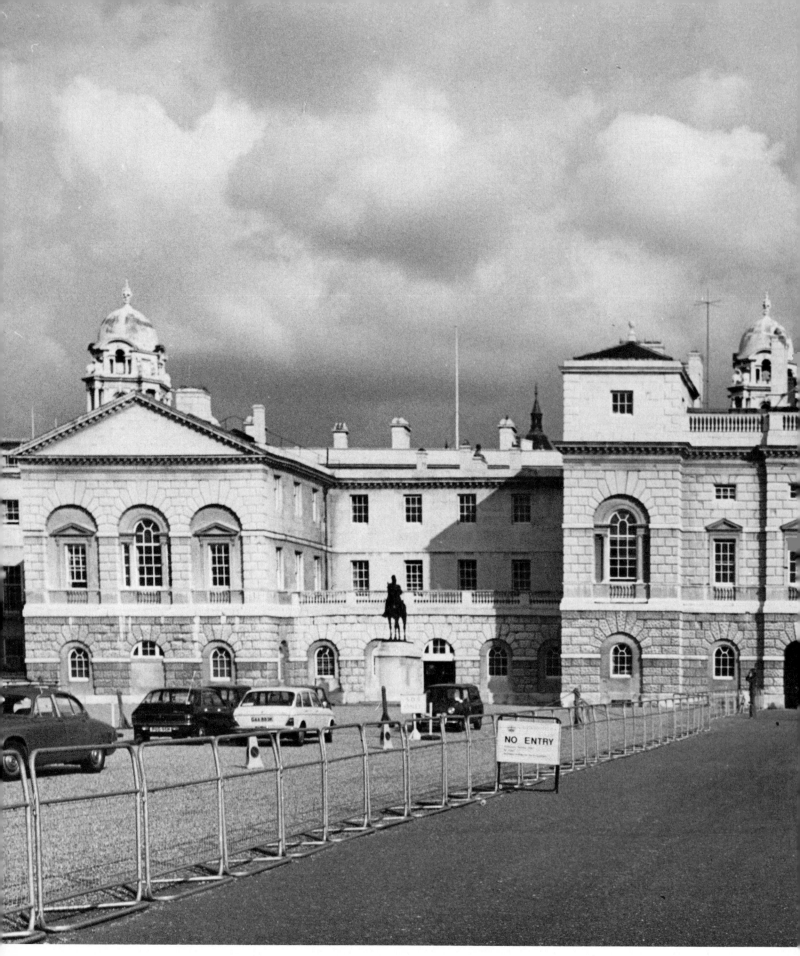

THE HORSE GUARDS

The Horse Guards (1742), London, by William Kent, as seen from St. James's Park. Two different kinds of rustication, much as in the Vicentine palaces of Palladio, mark the front. On the ground story rustication is bold and coarse, on the upper two stories it is refined. Palladian windows accent the second story.

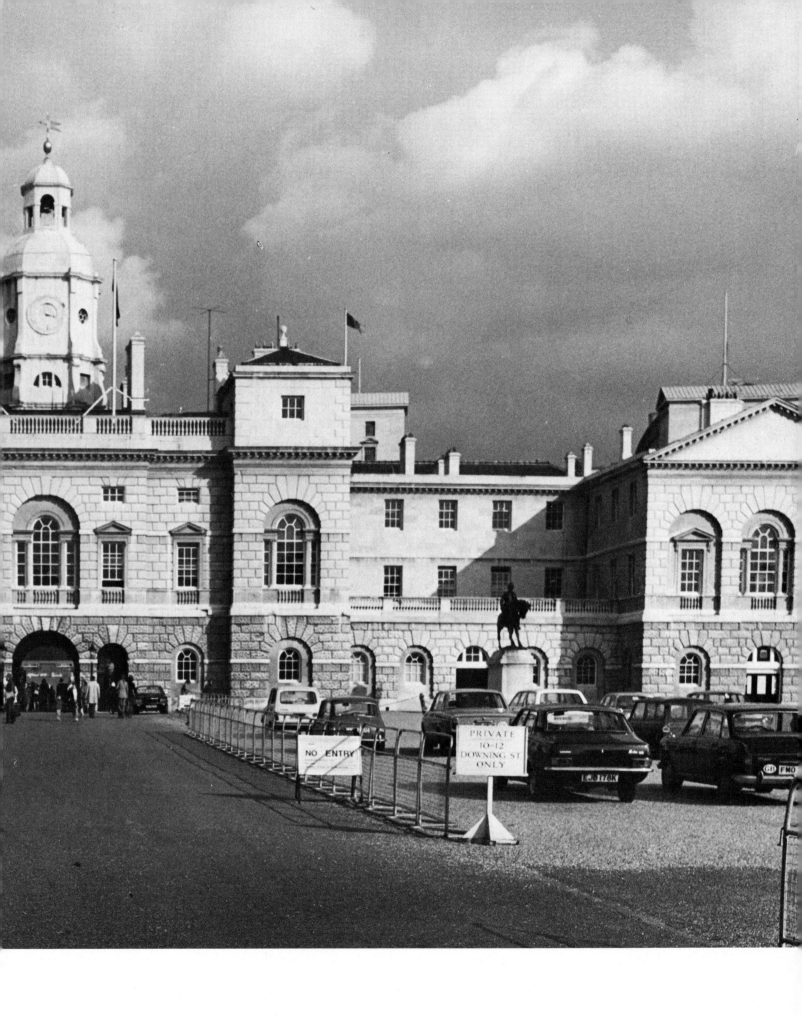

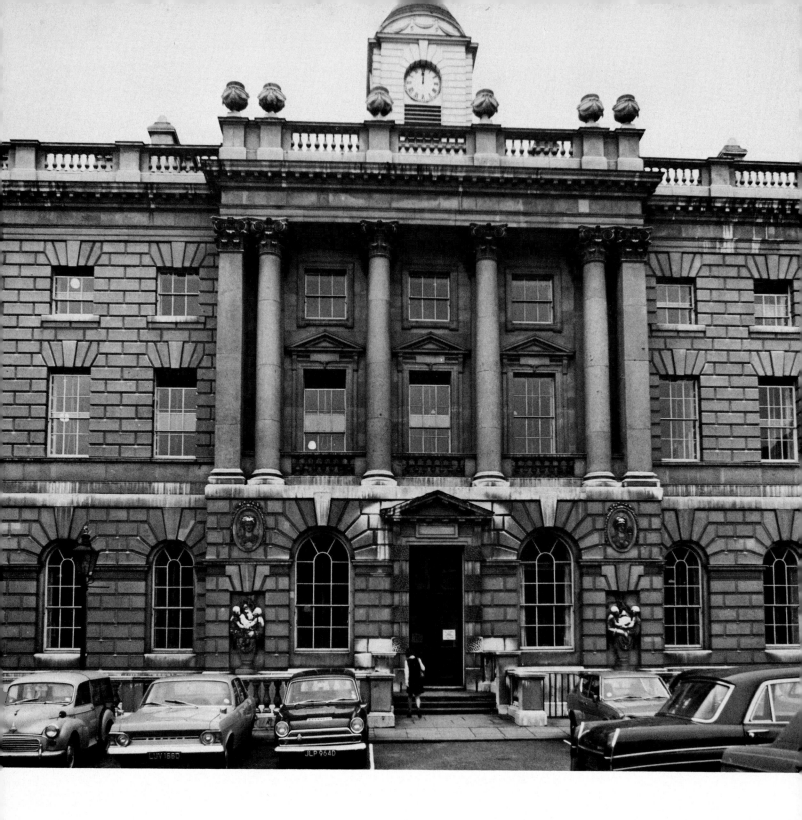

SOMERSET HOUSE

The courtyard of Somerset House (*above*; 1776–86), London. Sir
William Chambers adopted the Palladian mixture of columns, here
Corinthian, set on a rusticated base. One of London's monumental
buildings, it evoked an early imperial note.

THE ROYAL OPERA HOUSE

By the nineteenth century Palladian features had become common-
place in English architecture. The Royal Opera House, Covent
Garden (*opposite*; 1858) was designed by E. M. Barry. The porch
consists of high Corinthian columns and a pediment.

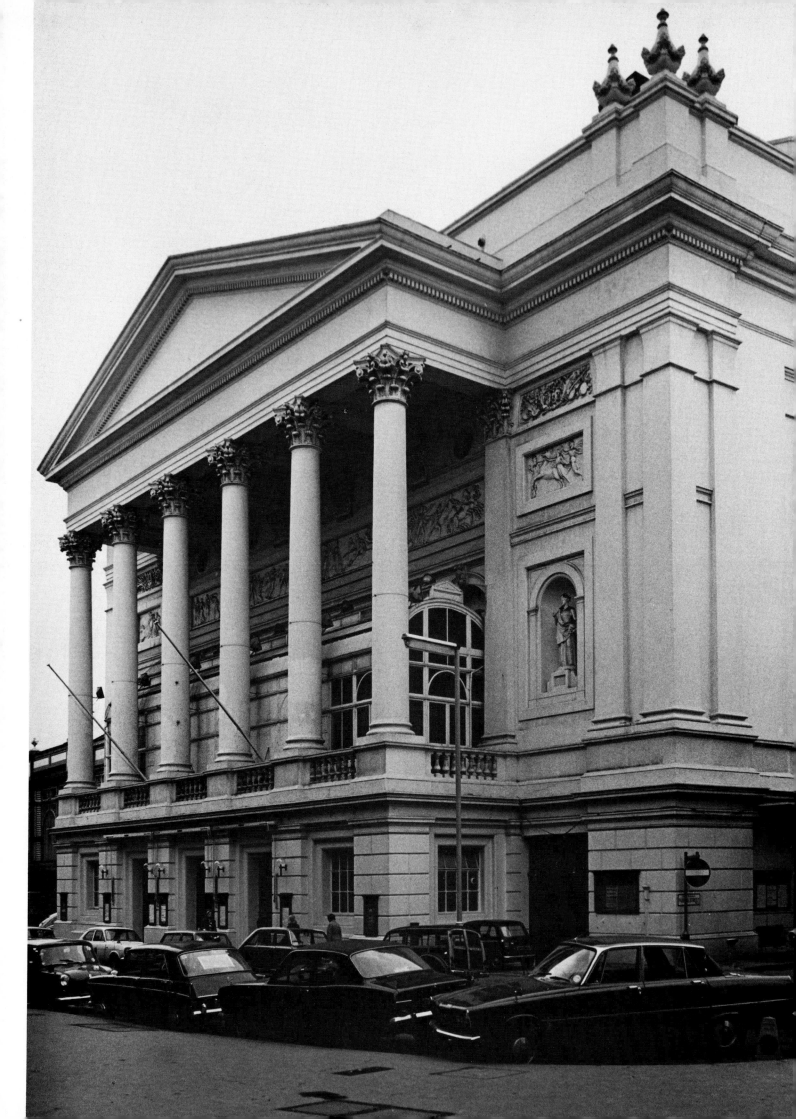

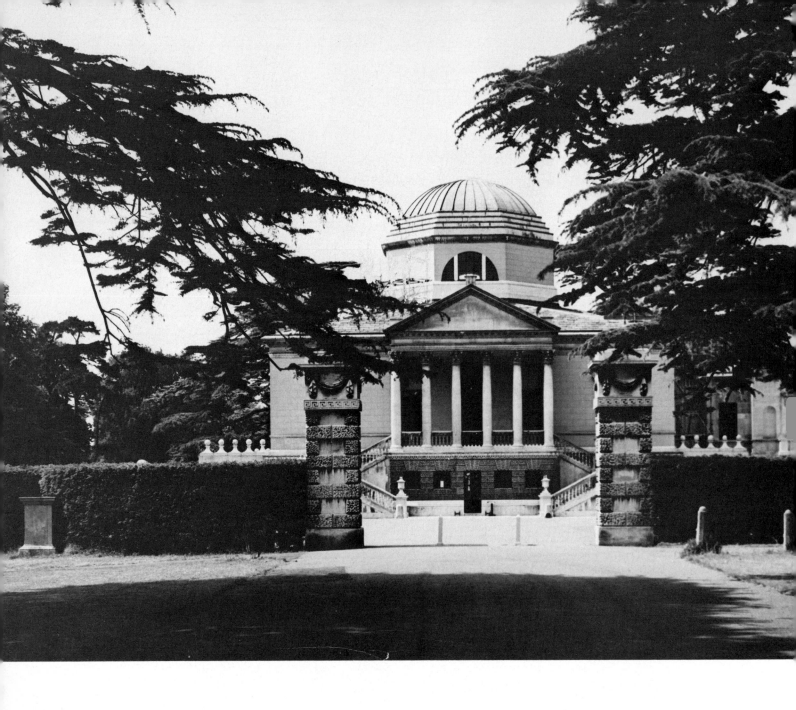

CHISWICK HOUSE

Chiswick House (*above*; 1729) was designed by William Kent and Lord Burlington. Known as the Palladian Villa, it was modeled on the Villa Rotonda. There are differences, such as the dome being octagonal and higher than in its model, but Plate XIII in Book II of *The Four Books* reveals that Palladio intended the Rotonda to have a high dome.

THE JONES GATE

Inigo Jones offers a lesson in design in the Palladian manner in the Jones Gate, (*opposite*) now at Chiswick. Rustication, engaged Doric columns and a pediment frame an entrance. For the top of the wall Inigo Jones took his cue from the Villa Badoer. The gate was built in 1621 at a house in Chelsea, London, but was moved here in 1740, as Alexander Pope explains

> O Gate, how cam'st thou here?
> I was brought from Chelsea last year
> Battered with wind and weather.
> Inigo Jones put me together,
> Sir Hans Sloane
> Let me alone:
> Burlington brought me hither.

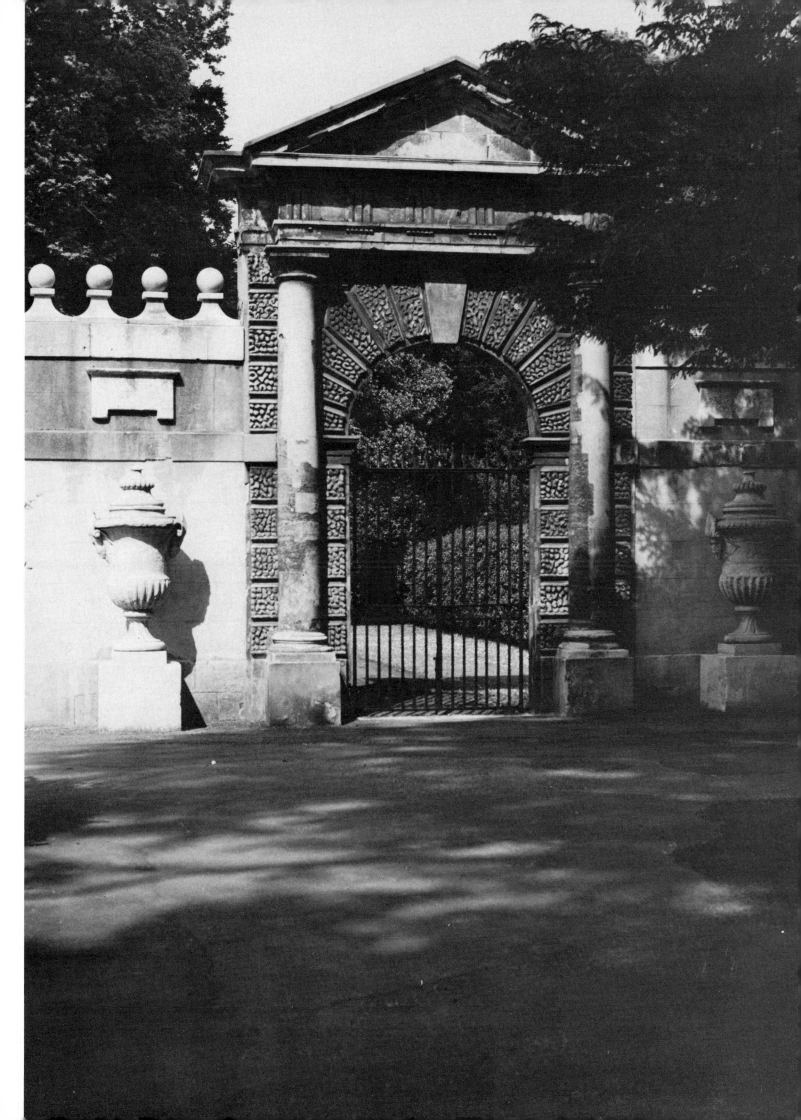

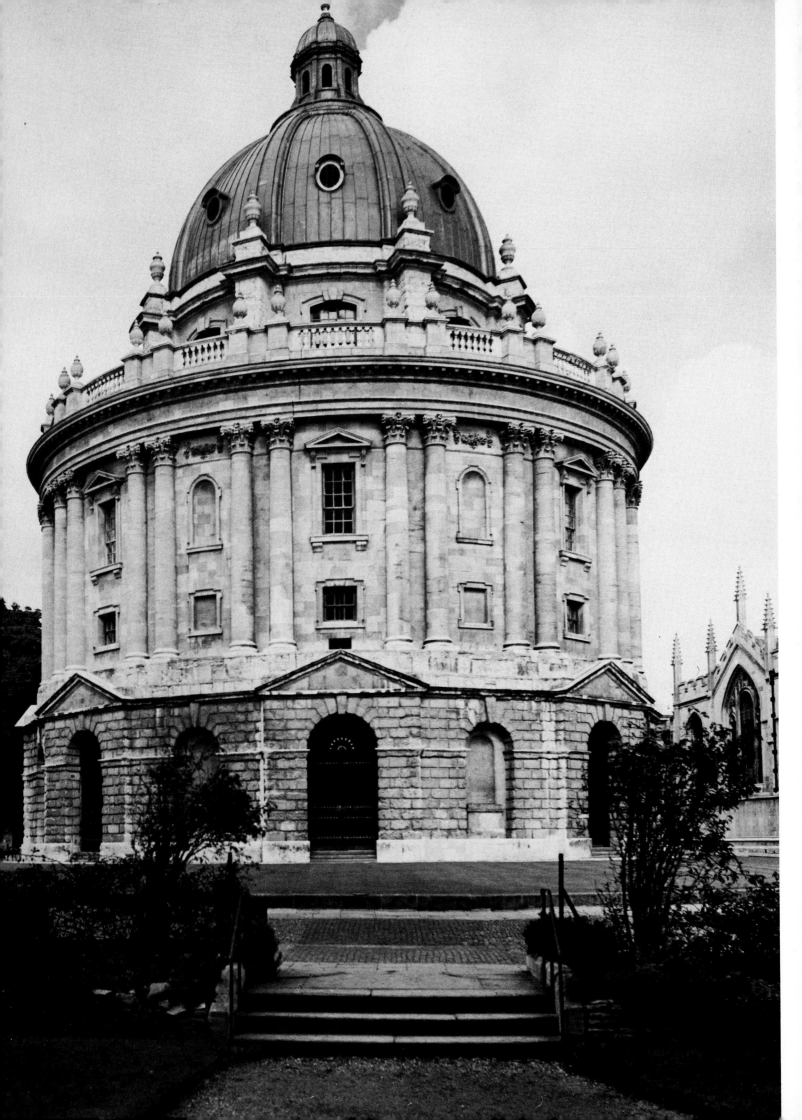

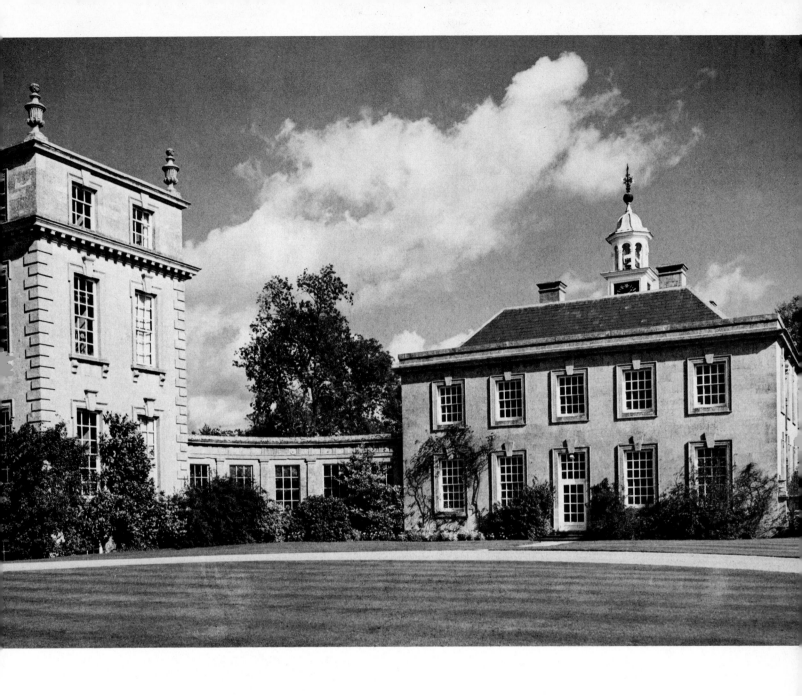

RADCLIFFE CAMERA

The library (*opposite*), designed by James Gibbs, was built in 1739–49. The high rusticated base and the swags linking the paired columns stem from Palladio.

DITCHLEY

Also designed by James Gibbs, Ditchley (*above*) was built in 1720–22. It is a variation on a Palladian theme: a main house linked to two wings.

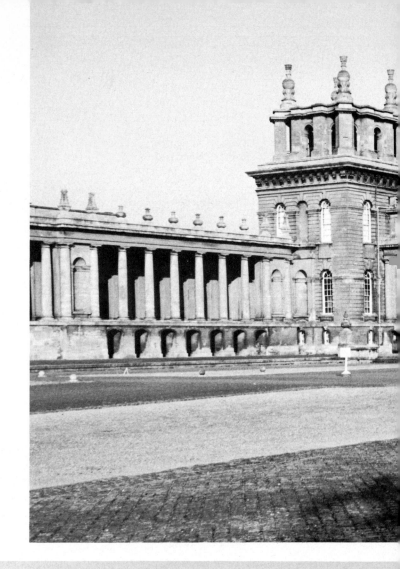

BLENHEIM PALACE

Designed by Sir John Vanbrugh for the First Duke of Marlborough and built in 1705, Blenheim (*right*) is the most monumental country house in England and the only one, other than several royal residences, entitled to be called "palace." The central porch is derived from Palladio.

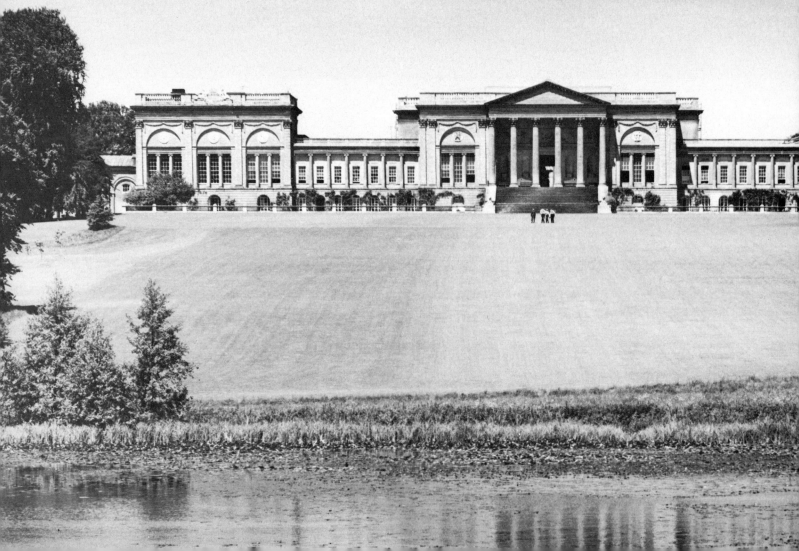

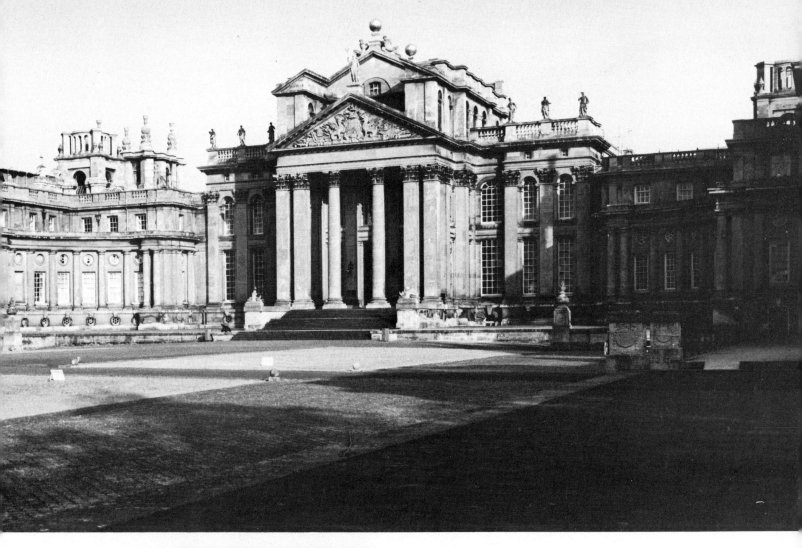

STOWE

The south front of Stowe in Buckinghamshire (*left*) overlooks a park by Capability Brown. Several architects worked at Stowe in the course of the eighteenth century. The south front, executed in 1774, is the work of Robert Adam and Giovanni Battista Borra. Adam relaxed his anti-Palladianism enough to build a columned porch on a high base.

The Palladian bridge at Stowe (*below*), ca. 1745, was copied from the one at Wilton (1736), of which Lord Pembroke and Roger Morris were the architects. They adapted the design directly from that which Palladio had executed for the competition of the Rialto Bridge in Venice. It is included in *The Four Books* in the Third Book on pages 70–71 and Plates IX and X.

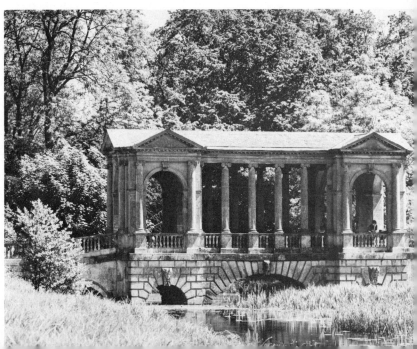

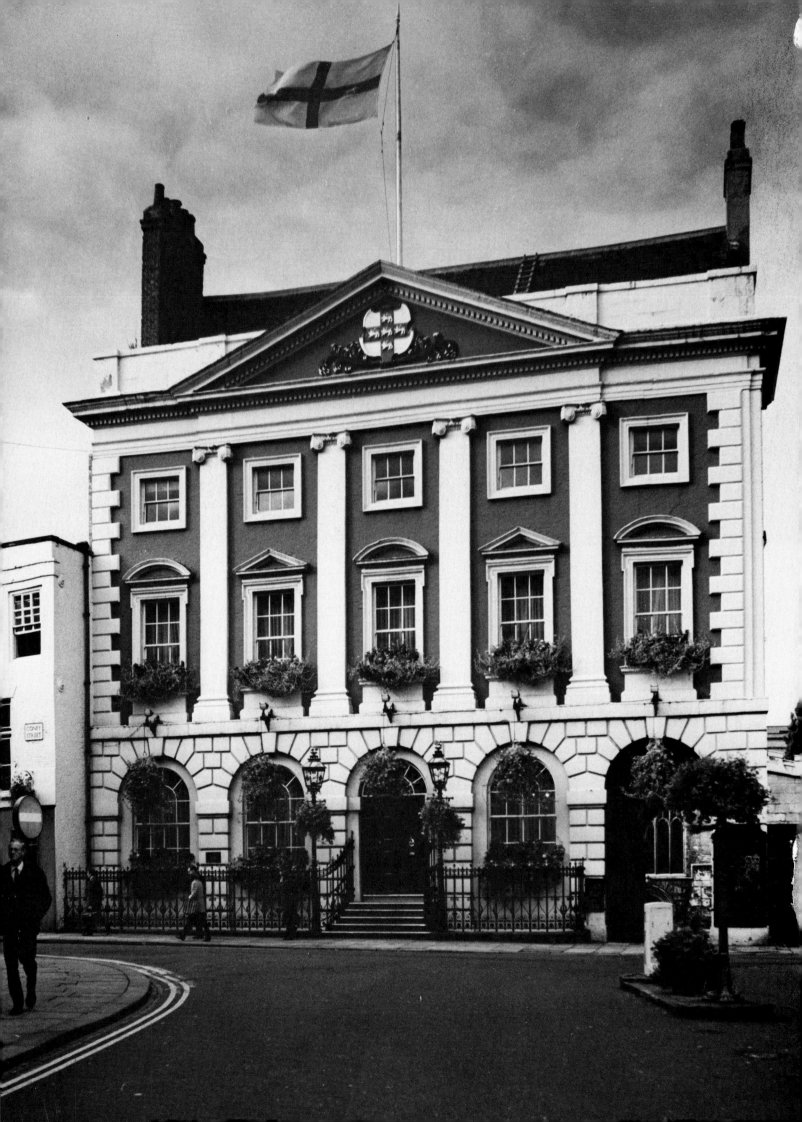

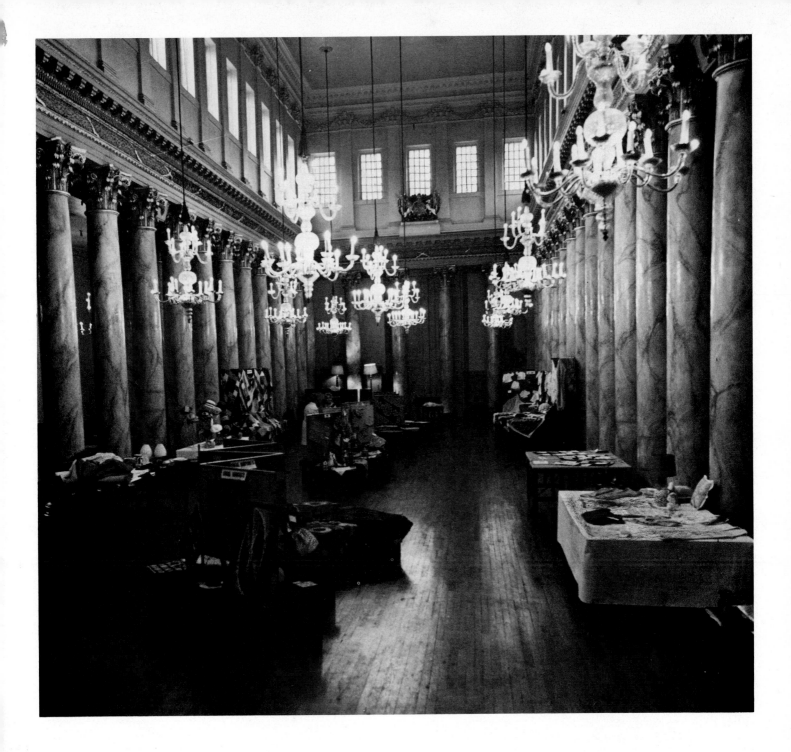

MANSION HOUSE, YORK

Designed by John Etty, the Mansion House (*opposite*) was built in 1725–27. An Ionic order of pilasters over a rusticated base shows how the Palladian ranged well beyond Vicenza.

THE ASSEMBLY ROOM, YORK

The Palladian crusader Lord Burlington tried his hand in this interior (*above*), executed in 1730. His inspiration was the Egyptian Hall, after Vitruvius, illustrated in Book II, Plate XXVIII of *The Four Books*.

PULTENEY BRIDGE, BATH

Despite his denunciation of Palladianism, Robert Adam felt perfectly free to make use of Palladio's best-known instrument, the Palladian window. The bridge (*over*) is the only completed portion (1769–74) of what was to be a much larger scheme.

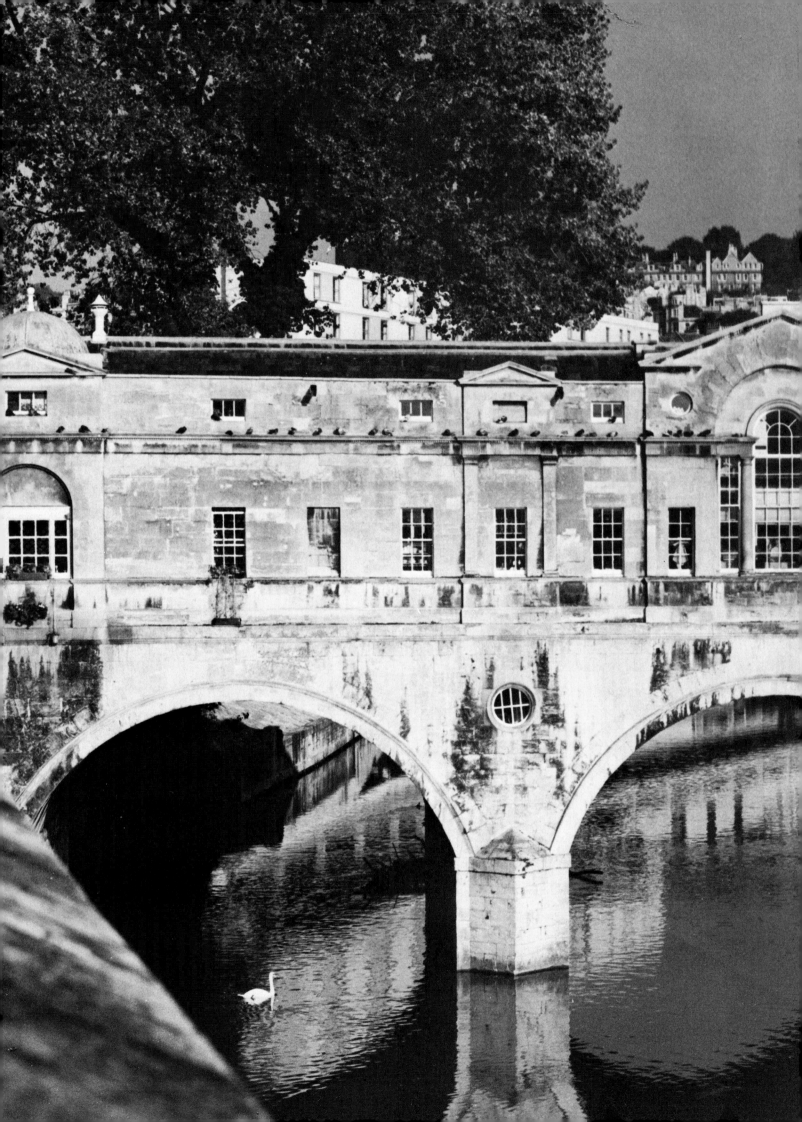

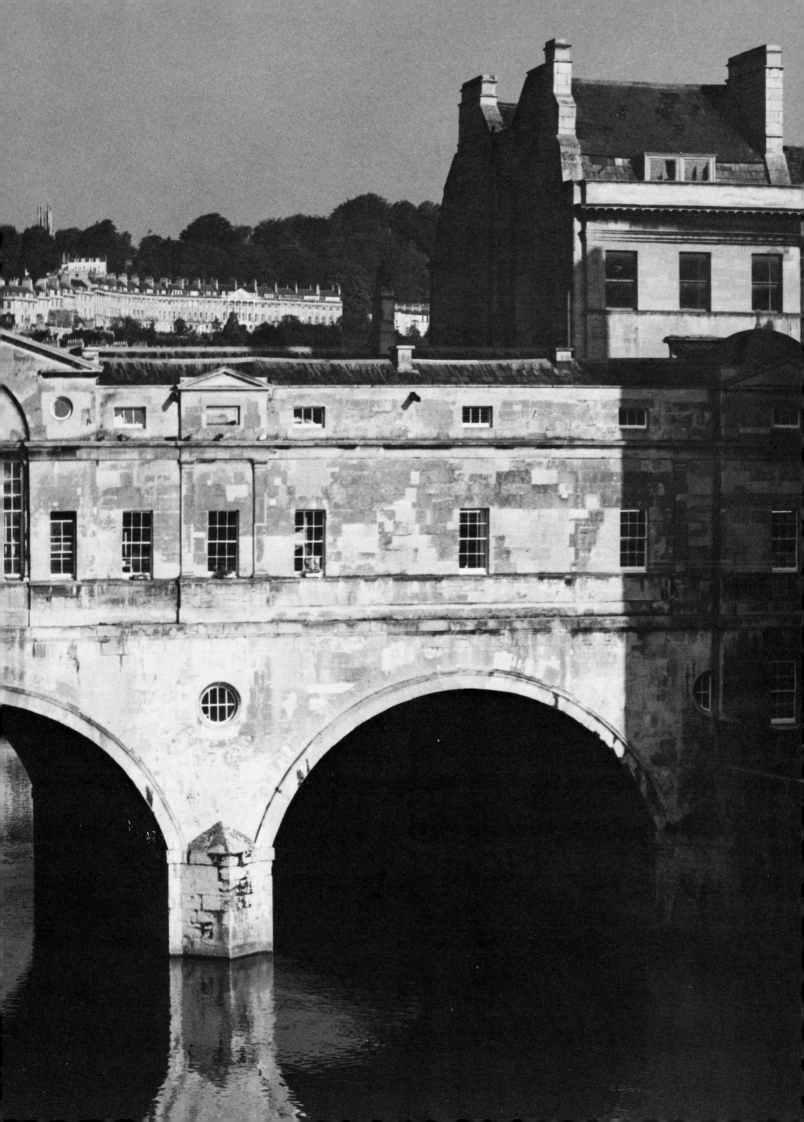

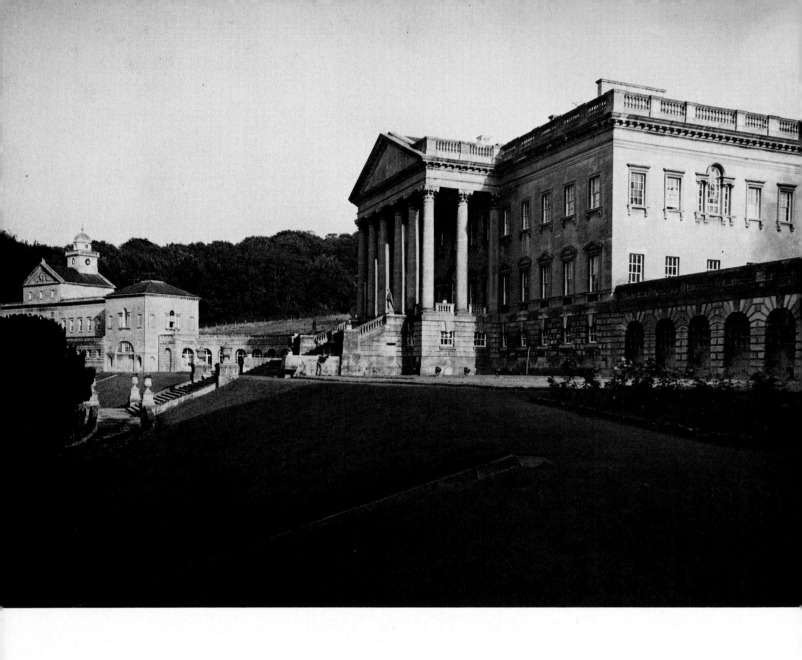

PRIOR PARK, BATH

The work of John Wood, Prior Park was built in 1735–43. The house raised on a high basement, the columned and pedimented porch and the wings tied to the main house by arcades make this splendid coun-try residence Palladian. John Wood brought the message of Palladio to Bath and made it the most beautiful town in England.

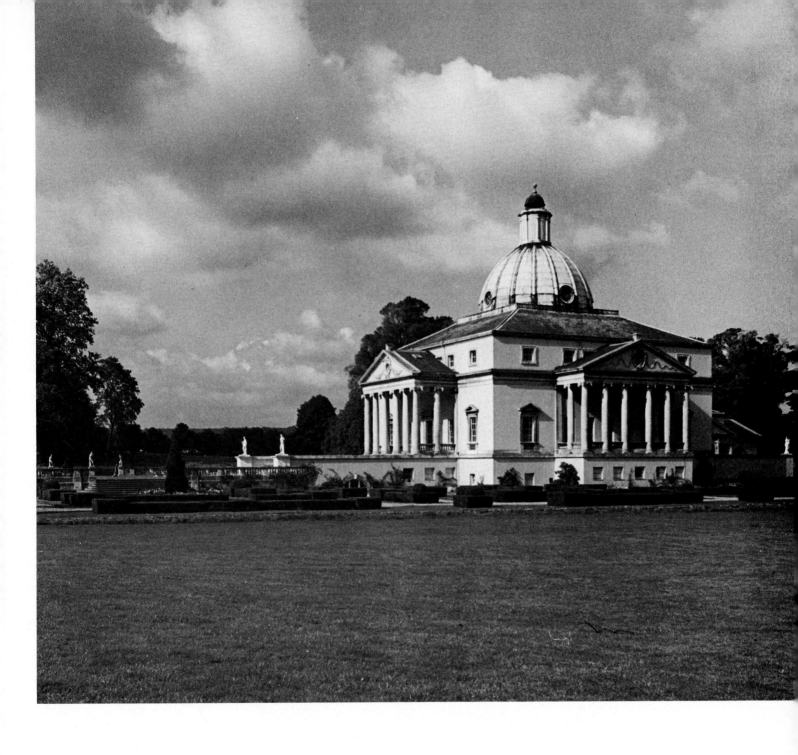

MEREWORTH

Mereworth (1723), in Kent, was designed by Colin Campbell in association with Lord Burlington. Here Palladianism triumphs; Mereworth is clearly derived from the Villa Rotonda. The high dome was taken from Palladio's design found in Book II, Plate XIII of *The* *Four Books*. "Mereworth is so perfect in a Palladian taste," wrote Horace Walpole, "that I must own it has recovered me a little from Gothic . . ."

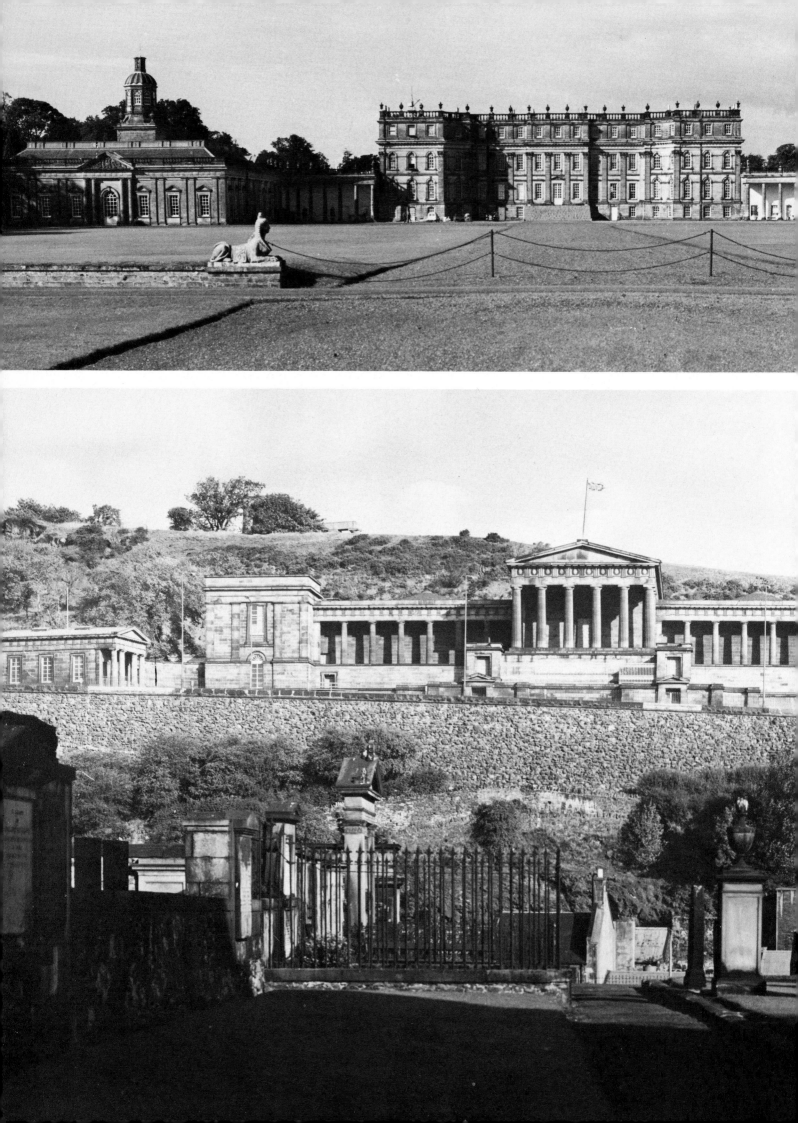

HOPETOUN HOUSE

A "swaggering pile," Hopetoun House (*top*) was built in Linlithgowshire, Scotland, in 1726. What we see here is an earlier house transformed by William Adam, father of the Adam brothers. Certain familiar motifs, such as the main house on a high basement, linked to the wings by curving colonnades, tell of the influence of Palladio.

HIGH SCHOOL, EDINBURGH

Built in Edinburgh in 1825, the High School (*bottom*) is a Palladian form in Greek clothing.

Palladio's Influence in the United States

It is hardly surprising that Palladianism reached these shores in the course of the eighteenth century. Lord Burlington and the several architects of his entourage, Colin Campbell and William Kent, and others, had given new force to the influence. It was only a question of time and of economic growth in the colonies for the books of Palladio and his followers to find American readers. There were fourteen editions of *The Four Books of Architecture* between 1663 and 1738. Colin Campbell's *Vitruvius Britannicus*, which reflected the influence, was published in 1715–25; William Kent's *Designs of Inigo Jones* in 1727. Added to these were the popularizers and the carpenter's handbooks which spread Palladianism.

Books might have prepared the way, but it took one man to give the impetus to Palladianism in this country —Peter Harrison, generally accepted as America's first professional architect. Born in 1716, he grew up in York, where he must have witnessed the construction of Lord Burlington's Assembly Rooms. A sea captain at the age of twenty-three, he was active in the Atlantic trade. He married a Newport girl and settled in the famous town, becoming a merchant and even doing some farming. In 1748 the precocious Harrison turned to architecture, his first work being the Redwood Library in Newport. He also did the Brick Market in Newport and King's Chapel in Boston. Harrison later became Collector of Customs at New Haven, where he died in the spring of 1775.

After the Revolution more, if still few, architects appeared. Among the more prominent was Charles Bulfinch (1763–1844) of Boston. He was one of several architects who worked on the national Capitol, a sign of the esteem in which he was held. He is best known for the Boston State House, built in 1798. Here the Palladian touch is revealed in the columned porch above an arcade and the dome rising above a pediment. But it was not Bulfinch who made Palladianism American so much as Thomas Jefferson. Our third President made Palladio a household word among those with pretensions to culture. As a young man, even when occupied with the law, he had turned to architecture. The first Monticello was begun in 1770. Although Jefferson did not limit himself exclusively to Palladio (as our minister in France in the 1780s, he turned to the ancient Roman and recent French models) the Vicentine remained his prime inspiration. This is evident in the rebuilt Monticello but even more so in the design of the University of Virginia, built in the 1820s, which is by far the greatest example of Palladio's influence in the nation.

After Jefferson, Palladianism merged into the Greek Revival of the Romantic Era. Palladio had been first to place the temple front on country houses; by the 1830s the device had become so commonplace in America that James Fenimore Cooper complained of it. Inevitably the influence of Palladio melted away when client and architect became familiar with the great examples of other schools through the ever-growing quantity of books and increasing frequency of European travel. The Vicentine's work had become part of the classical vocabulary. The Palladian window, for example, was incorporated in cast-iron buildings. ("Cast-iron architecture" refers only to the method by which a facade was constructed; it does not identify a style. Most cast-iron work is, in fact, classical.) Every now and then there would rise an outstanding building revealing the influence, such as John Kellum's Tweed Courthouse next to New York's City Hall.

With the triumph of the classical in the American Renaissance, Palladio remained one of many influences. The architects of this, our greatest artistic era, which lasted from the 1880s to the 1930s, were familiar with his work, as they were with the work of most of the masters. No doubt many of them first saw the use of the pilaster and rustication together in an edition of *The Four Books* and subsequently discovered the decoration in the work of others. The Villard houses, which stand east of St. Patrick's Cathedral in New York City, show such treatment; the architects, McKim, Mead and White, could have seen the combination as easily in a plate of the Papal Chancellory in Rome, credited, in those days, to Bramante. The same is equally true of the Convent of the Sacred Heart (Otto Kahn residence) also in New York City. In this instance the architect, G. Armstrong Stenhouse, was an Englishman who was no doubt weaned on Palladio although, again, the closest model is the same Chancellory.

While the American Renaissance, so heavily depen-

dent on the classical tradition, ended in the 1930s, classicism remains in evidence, as seen in the work of Philip Trammell Schutze of Atlanta. As late as 1962 the Albemarle Paper Manufacturing Company built a Palladian building for its headquarters in Richmond, Virginia. The classical pavilion designed by John Barrington Bayley and recently added to the Frick Collection in New York and the J. Paul Getty Museum in Malibu, California, built on the model of an ancient Roman villa, provide other examples.

At present, Palladio enjoys a fresh vogue. This has been chiefly due to the beautiful models of his work commissioned and sent traveling by the Centro Internazionale di Studi di Architettura Andrea Palladio of Vicenza and of the availability of fine photographs such as those by Joseph Farber, which make up this book. There is a stirring in American architecture. Interested laymen and the professional are looking at the past with fresh eyes. There may well be in our future a latterday Harrison or Jefferson who will build again in the extraordinary manner of Palladio.

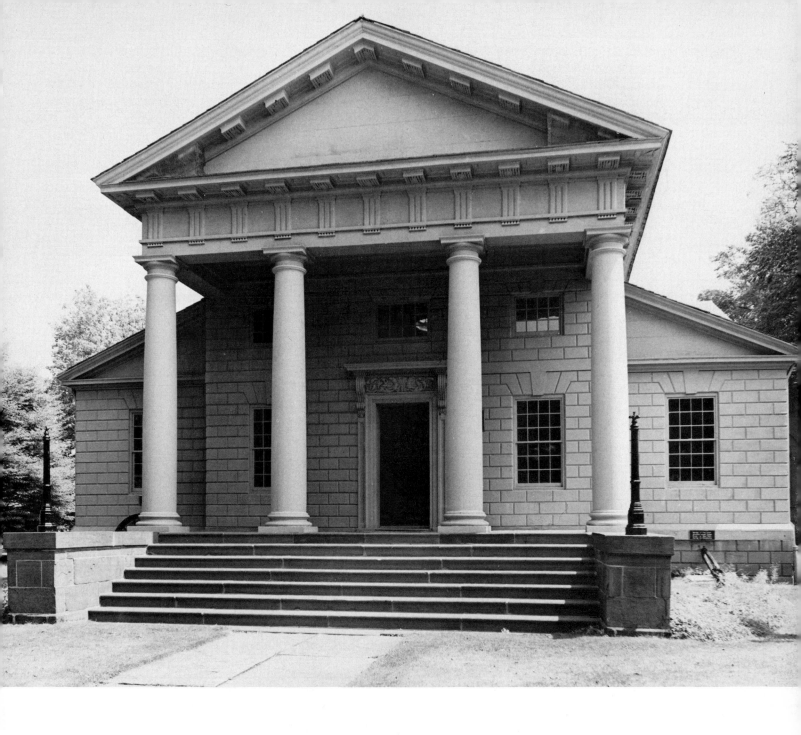

REDWOOD LIBRARY

Peter Harrison adopted the design for the library, built in Newport, Rhode Island, in 1749, from a plate in the fourth book of Edward Hoppus's, *Andrea Palladio's Architecture in Four Books* (1735–36).

The scheme of having a pediment set between two halves of a divided pediment is to be found in the facades which Palladio designed for three Venetian churches.

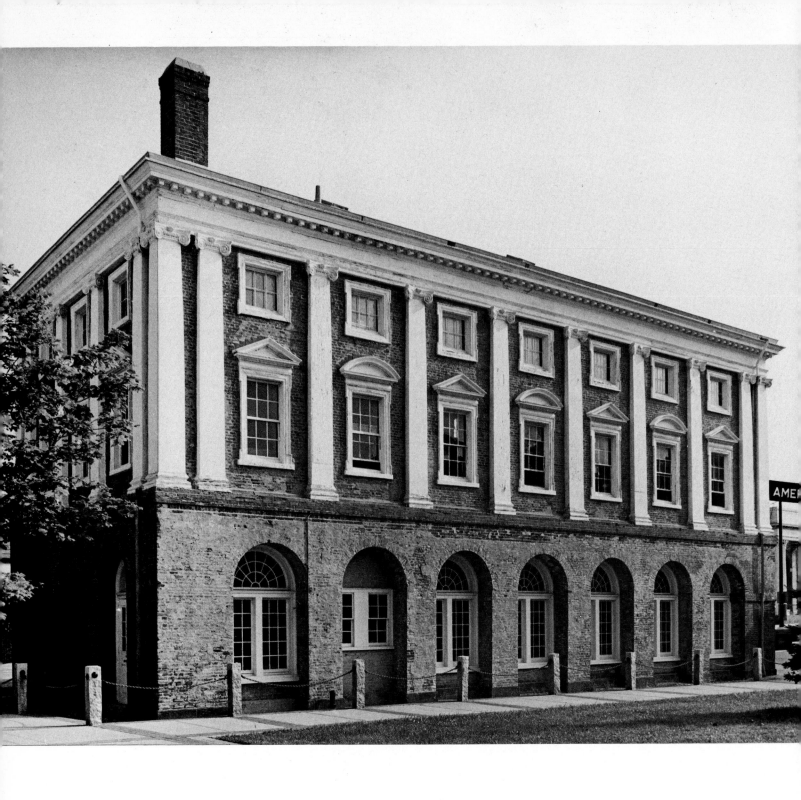

THE BRICK MARKET

Also designed by Peter Harrison, the building was constructed in Newport in 1760. The Palladian device of an order of pilasters on a rusticated base was adopted by Inigo Jones for the front of old Somerset House in London. The illustration of the building, in the first volume of Colin Campbell's *Vitruvius Britannicus* was Harrison's source.

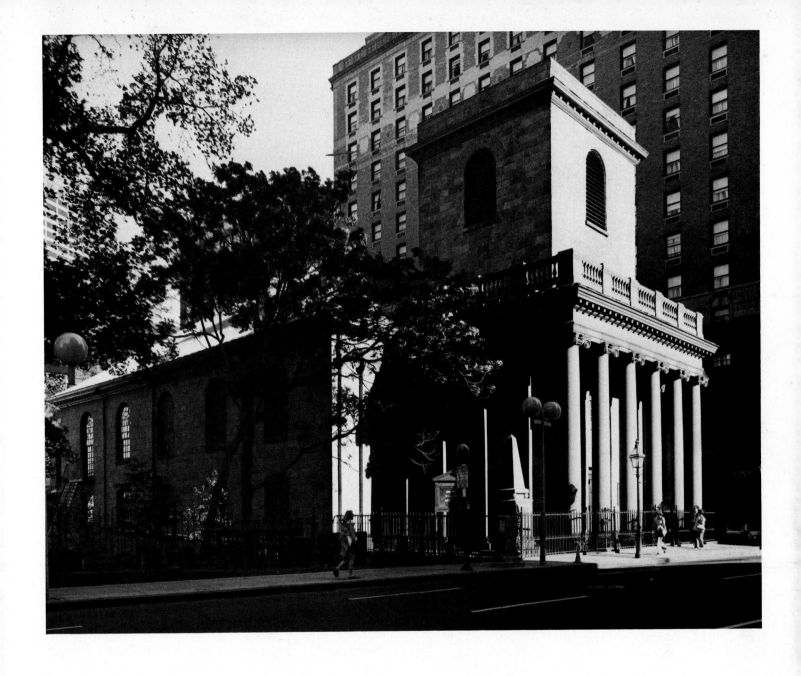

KING'S CHAPEL, BOSTON

The work of Peter Harrison, the chapel was built in 1749–54.

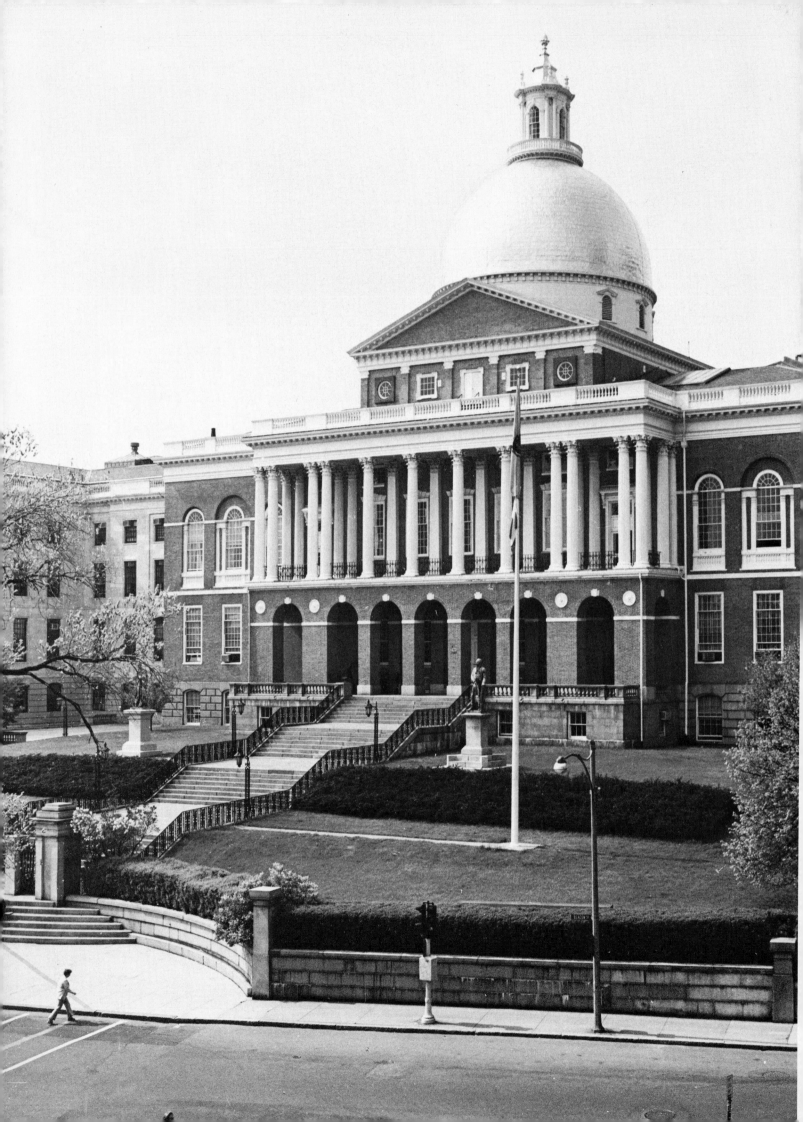

STATE HOUSE, BOSTON

Charles Bulfinch's Massachusetts State House (1797) reveals its Palladian origins in a Corinthian order above an arcade with a pediment and dome.

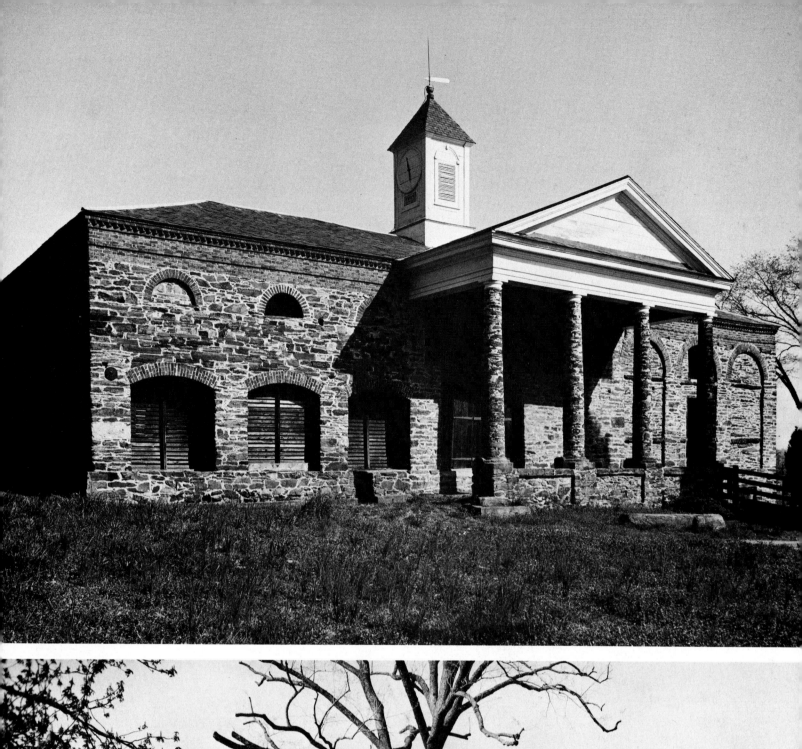
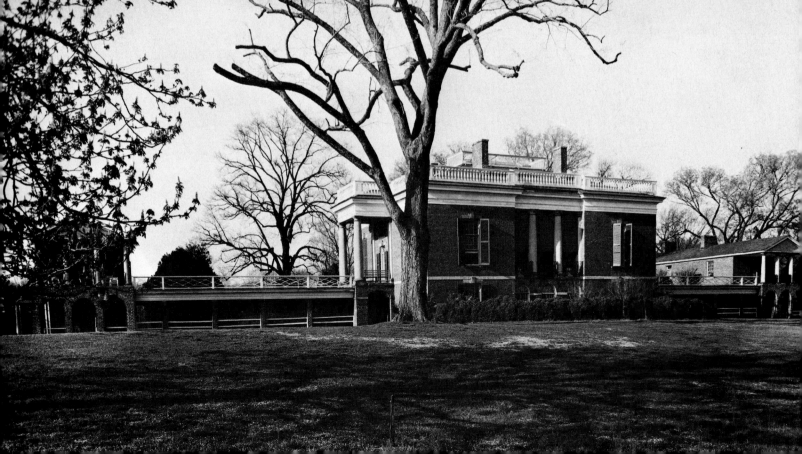

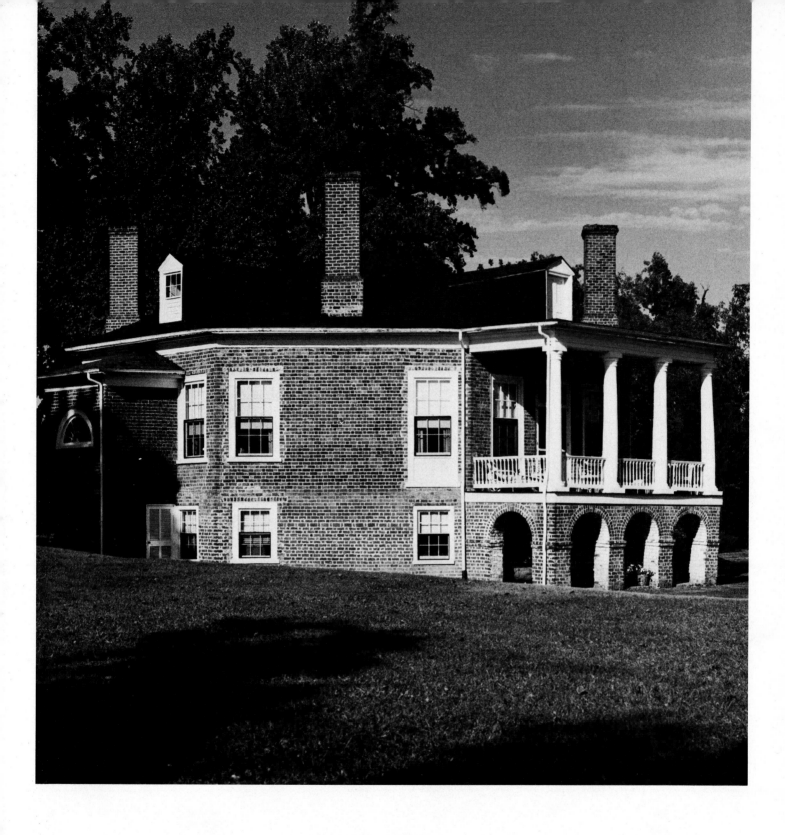

BREMO

The barn at Bremo (*opposite, top*; 1815–19), near Palmyra, Fluvanna County, Virginia, is a simple structure of fieldstone, and was probably designed by the architect John Neilson and General J. H. Cocke, acting on Thomas Jefferson's advice. The templed front, in this instance, adds a grander note to a utilitarian structure.

The main house at Bremo (*opposite, bottom*) also reveals the Palladian influence, both in the composition of the house and in the use of the two wings.

POPLAR FOREST

Thomas Jefferson built this house (*above*) for himself in 1806–19 near Lynchburg, Virginia. It was restored after a fire.

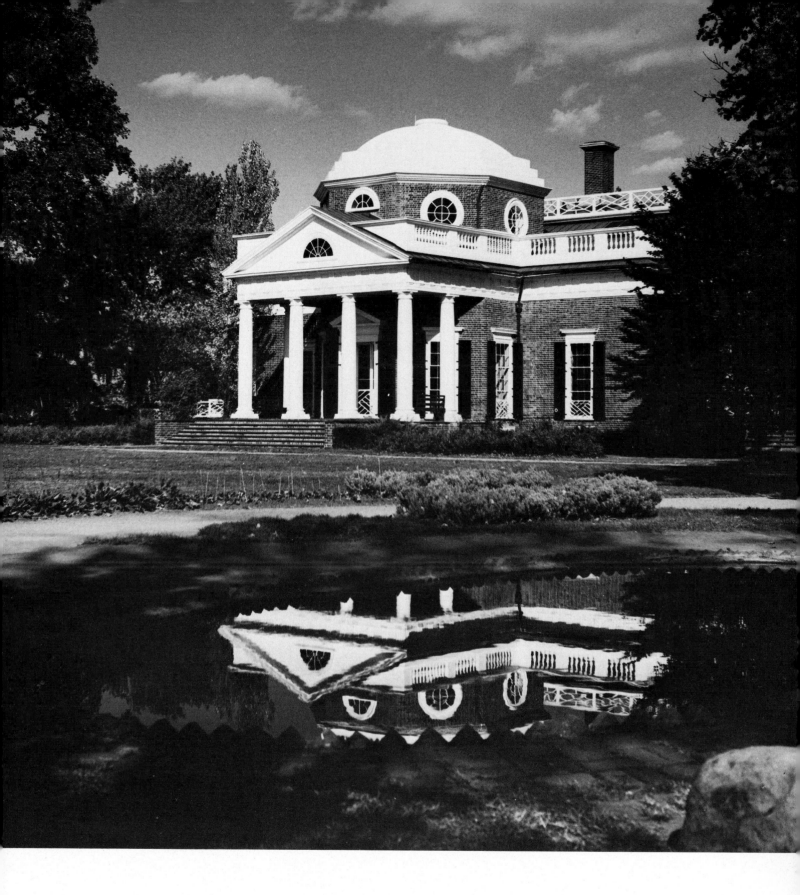

OAK HILL

A Palladian doorway (*opposite*) is viewed from the inside at Oak Hill (1820–23) near Leesburg in Loudoun County, Virginia. James Monroe commissioned James Hoban, the architect of the White House, to design this country residence. Hoban was influenced by Jefferson.

MONTICELLO

The photograph (*above*) shows the entrance and garden front of Thomas Jefferson's famous house, built near Charlottesville, Virginia, in 1768–1809, which took its inspiration from the Villa Rotonda. It was Jefferson's pride; he died here on July 4, 1826.

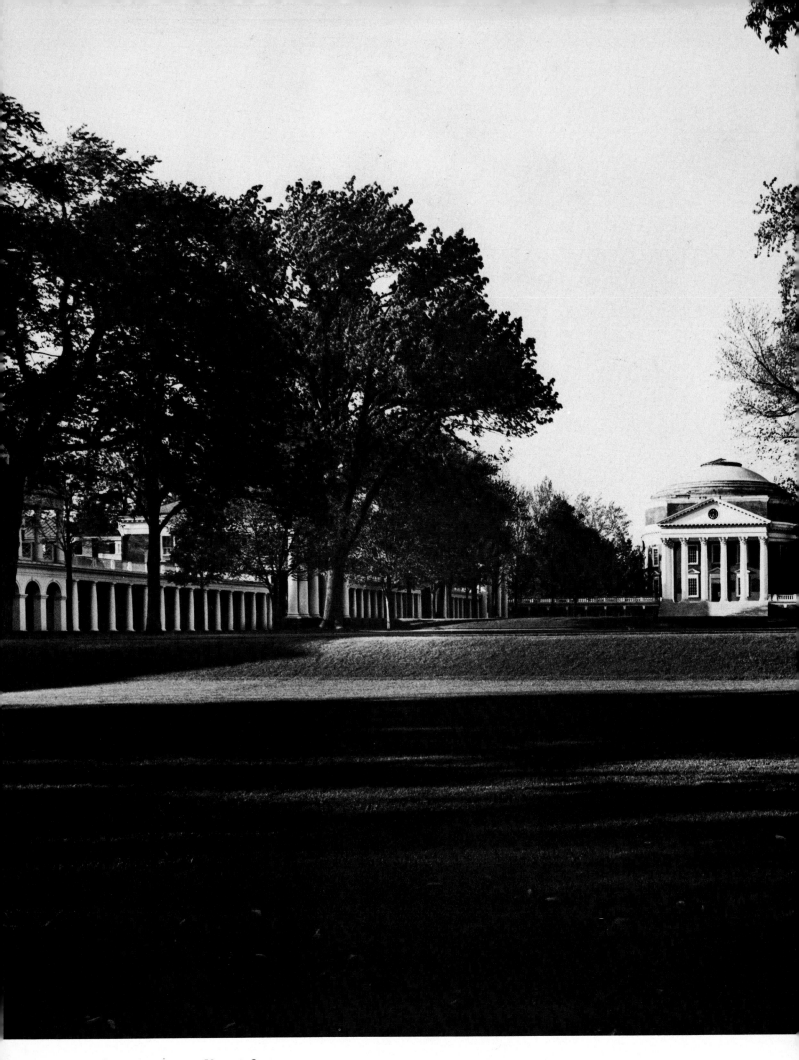

THE UNIVERSITY OF VIRGINIA

Built in Charlottesville in 1817–26, this is
the most beautiful campus in the United
States and Thomas Jefferson's magnum
opus. Had he designed only this he still
would be placed high on the roster of great
American architects. Jefferson's inspiration
was the design for the Villa Trissino. The
scheme is basically a central building,
modeled after the Pantheon, set on a plat-
form joined by two long colonnades. Of all
the college campuses which followed, only
that of Columbia University, by Charles
Follen McKim, approaches in any way the
grandeur of Jefferson's plan.

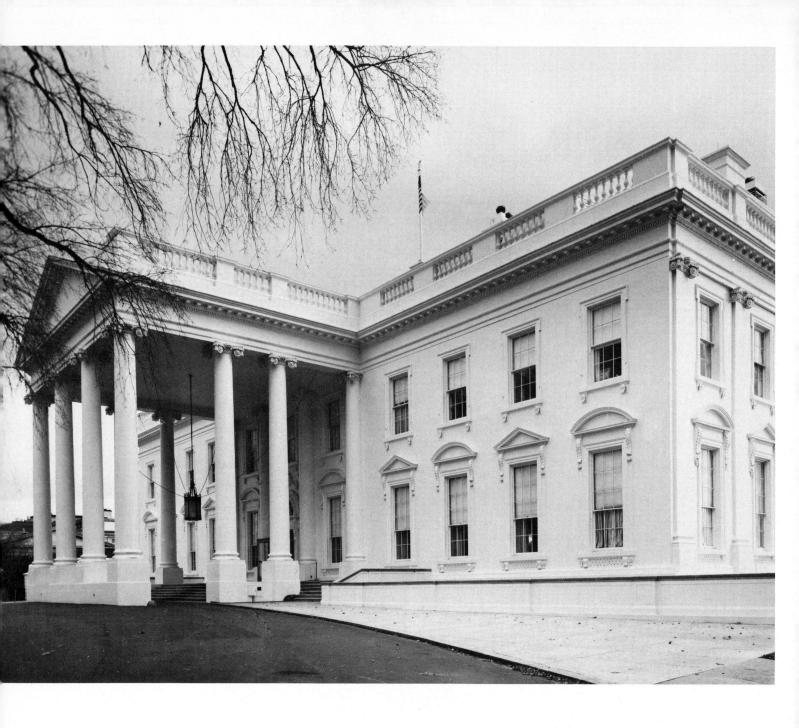

THE WHITE HOUSE

The porch of the White House, designed in 1792 by James Hoban. The young Irish architect—he won the competition for the design at age thirty-four—grew up in a Palladian world.

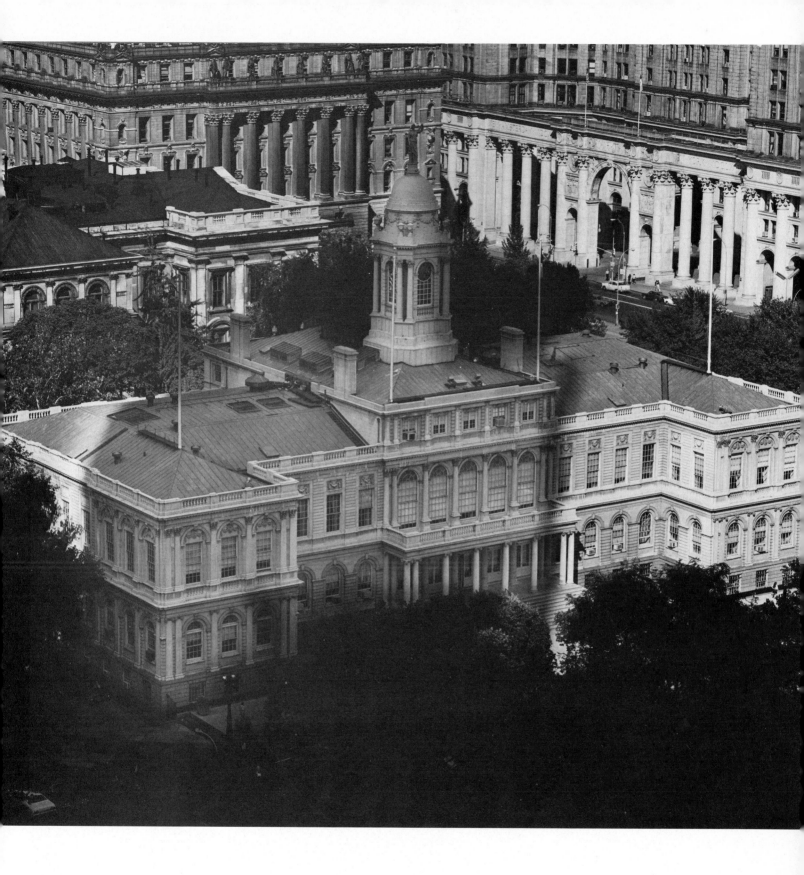

NEW YORK CITY HALL

Built in 1802–11, City Hall was the collaboration of Joseph-François Mangin and John McComb, Jr. The design of the beautiful building, which ranks with the San Francisco City Hall as the finest of its kind in the country, belongs to Mangin. The unusual feature of the front, at least for a French-trained architect of the day, is the double porch and high flight of steps, a scheme which is found in several of Palladio's villas.

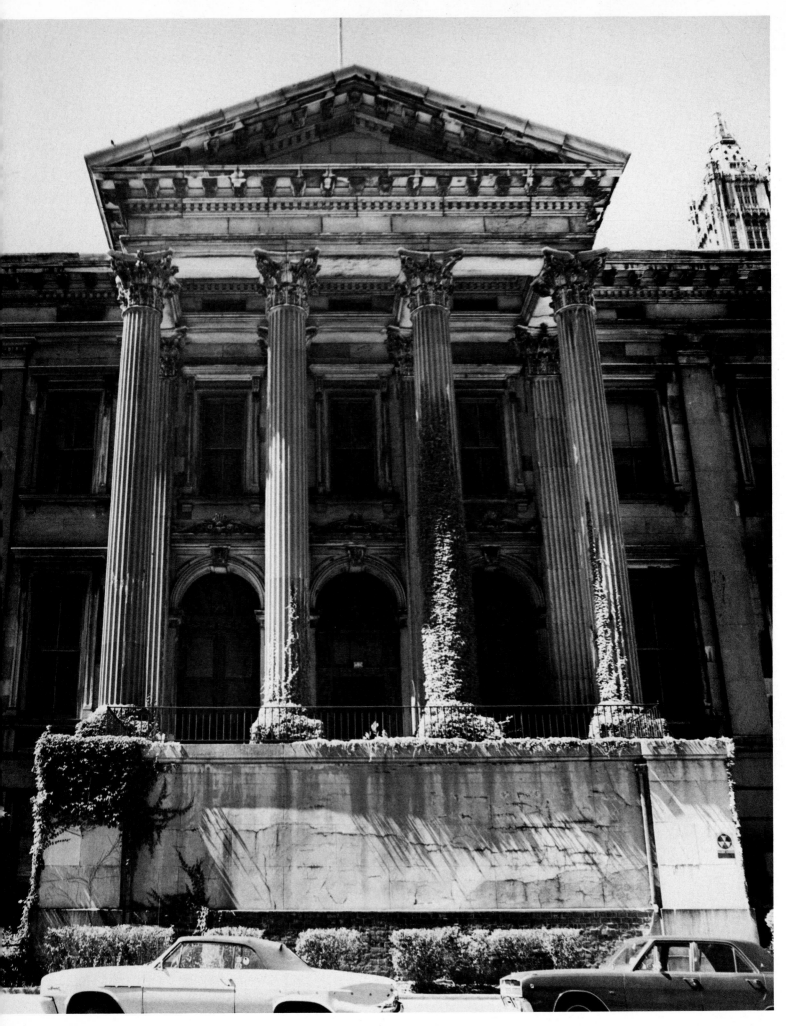

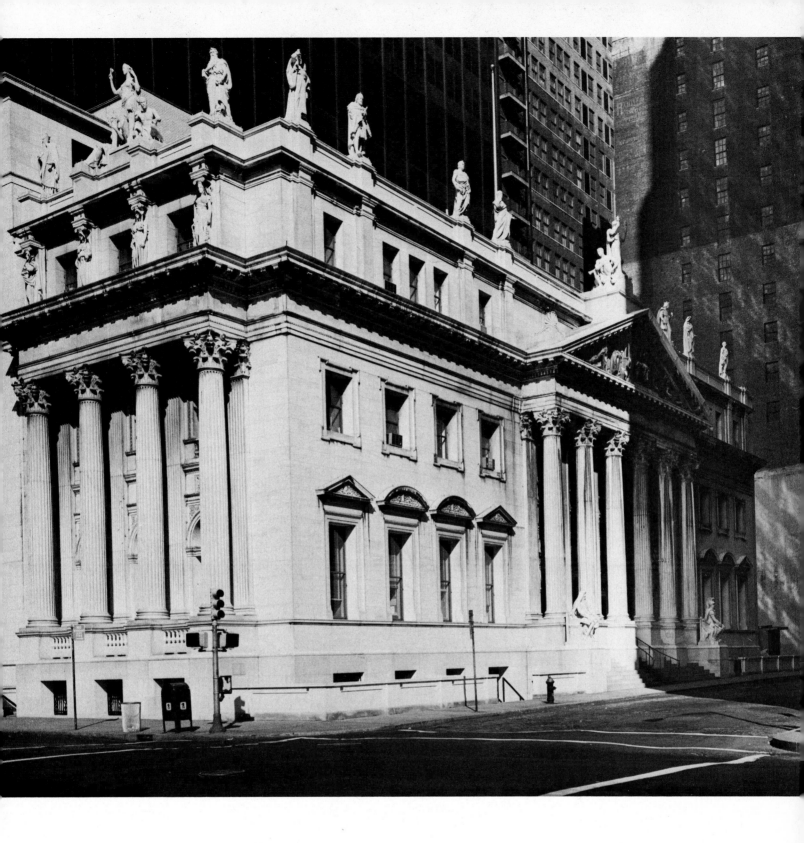

THE CRIMINAL COURT BUILDING

Familiarly known as the Tweed Courthouse, the structure (*opposite*) was built in New York City in 1872 on the designs of John Kellum. It has one of the finest Corinthian porches and pediments in the country. The porch is the part of the building which reveals the influence of Palladio. Threatened for many years, the building was recently saved through the efforts of a proud New Yorker, Paul O'Dwyer.

THE APPELLATE COURT

James Brown Lord designed the building (*above*), erected in New York City in 1900. A Corinthian order adorns two sides, with one standing at the top of a flight of steps. As at the Palazzo Chiericati and the Villa Rotonda, the silhouette is enlivened by statues following ancient Roman and Palladian precedent.

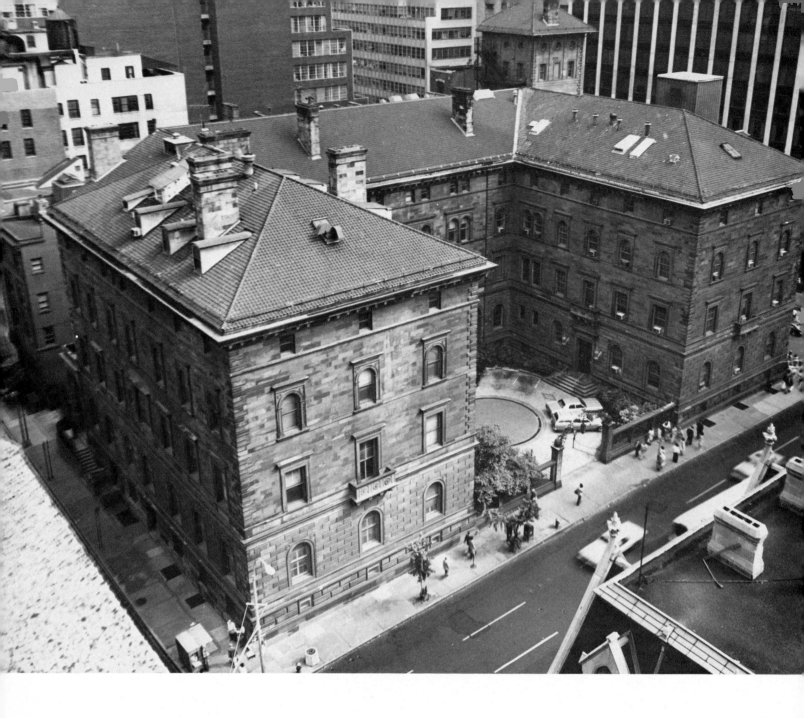

THE VILLARD HOUSES

This, the work of McKim, Mead and White in New York City (1882–86), is one of the earliest buildings of the American Renaissance. The use of the pilaster and rustication, both favorites of Palladio, was very much a novelty for a city residence. The scale, the masterly proportions, the use of the Palladian devices announced an architecture of splendor which was to last until the 1930s. The structure has been incorporated into a new hotel.

THE OTTO KAHN RESIDENCE

Now the Convent of the Sacred Heart, the mansion was built in 1914–18 in New York City on designs by G. Armstrong Stenhouse. The magnificent French-limestone building is one of the private palaces surviving on Fifth Avenue. As with the Villard Houses, the pilaster and rustication are much in evidence. The sources were Palladio and the Chancellory Palace in Rome.

THE FRICK COLLECTION

This private palace was built in 1914 for Henry Clay Frick in New York City by Carrère & Hastings and was transformed into a museum by the architect John Russell Pope in 1935. The shadow of Palladio, seen in the high pilasters and the light rustication, mingles with French influence.

TENNIS HOUSE, PROSPECT PARK

Built in 1909–10 in Prospect Park, Brooklyn, by Helmle & Huberty, there is no better example of how classical buildings, carefully located, can enhance a great picturesque park. The pavilion, with its central Palladian motif, stands on a slope at the south end of the Long Meadow.

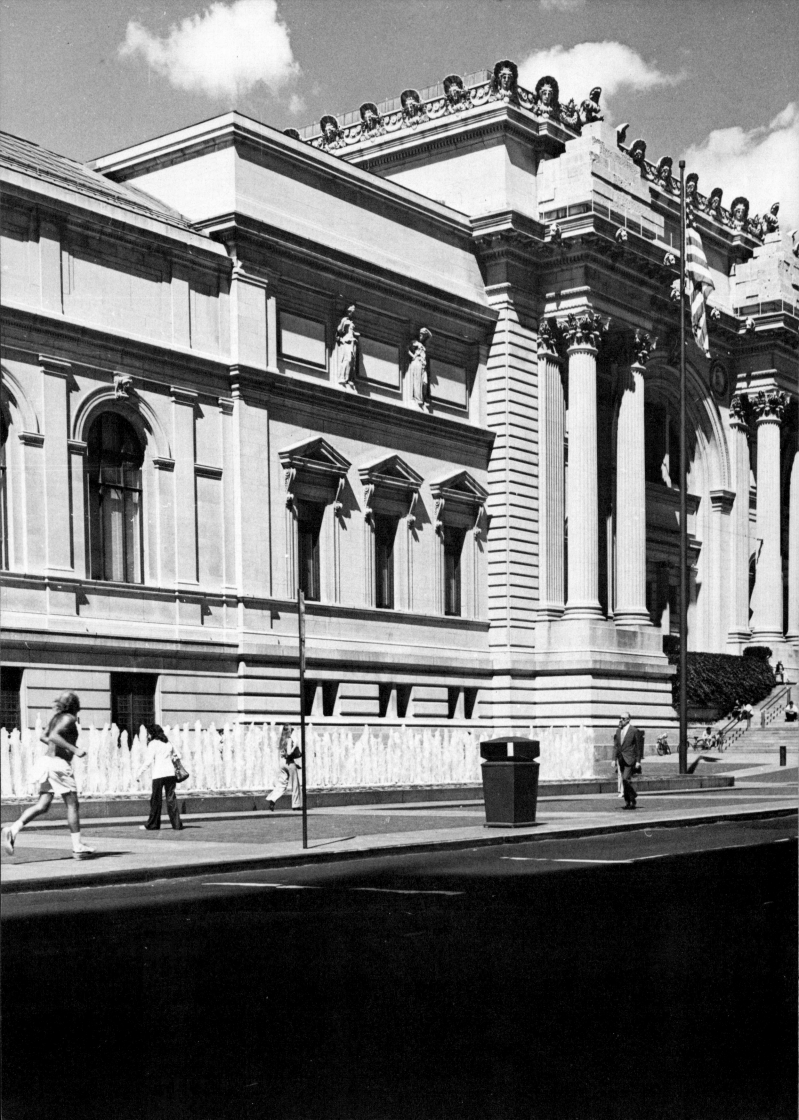

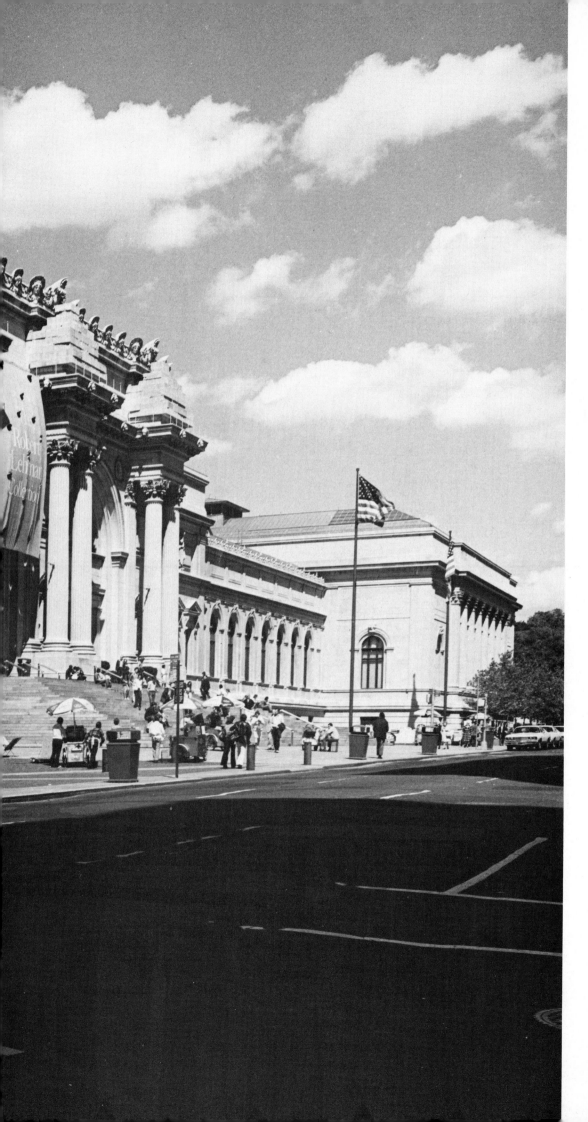

THE METROPOLITAN MUSEUM OF ART

The Palladian theme of a monumental order set on a high base is superbly handled in Richard Morris Hunt and Joseph Howland Hunt's Fifth Avenue facade, erected in 1894. It is one of the finest porticos in New York or, for that matter, the United States.

129